WHEN MARILYN
MET THE QUEEN

Also by Michelle Morgan

Marilyn Monroe: Private and Undisclosed
Hollywood Scandals
Madonna
The Battered Body Beneath the Flagstones and
Other Victorian Scandals

WHEN MARILYN MET THE QUEEN

MARILYN MONROE'S LIFE IN ENGLAND

MICHELLE MORGAN

PEGASUS BOOKS
NEW YORK LONDON

WHEN MARILYN MET THE QUEEN

Pegasus Books, Ltd.
148 West 37th Street, 13th Floor
New York, NY 10018

ISBN: 978-1-63936-149-6

10 9 8 7 6 5 4 3 2 1

Printed in the United States of America
Distributed by Simon & Schuster
www.pegasusbooks.com

This book is dedicated to Marilyn, Sandie, Sally, Andrea and Rebecca. It may have taken us thirty years, but we finally got there, girls!

Contents

Acknowledgements

I would like to start by thanking everyone who has helped with this book over the past thirty years. It's impossible to acknowledge everyone individually, but I do thank you all, most sincerely.

To those beautiful people who have contributed their memories, either by telephone, email, audio tape or letter. Your words have added so much colour to this story, and I am so grateful. Thanks especially to those I have interviewed recently, including Alan, Elaine, David, Jerry, Cary, Jean, Ray, Norma and the members of the Englefield Green and Horsham Facebook groups.

To the staff of Cornelia James, thank you for your kindness and friendship. Your beautiful gift has inspired me every day during the writing of this book, and I will treasure it always.

To Fraser, Joshua, Marco, Hazel, Johan, Ken, Susan, Heather, Suzie, Gabriella, Richard, Ed, Donna, Mary, Dave, Ron, Bryony at the Anna Freud Museum, the late, great John Hazell and everyone who has ever supplied me with a press cutting, document, information, photo, memorabilia or call sheet. I appreciate your help so much.

To my Marilyn family, especially those who knew me back in the days of the Marilyn Lives Society. Your support, love and

excitement spur me on every day, and I will always be grateful for your friendship.

To the team at Robinson/Little, Brown, and especially my editor Duncan Proudfoot and copy-editor Howard Watson. I cannot begin to tell you how happy I am that you made my dreams come true. I am so grateful to you all.

To Mum, Dad, Paul, Wendy, Angelina, Helen, Claire, and family and friends, who have listened to my Marilyn in England obsession for thirty years, and then cheered me loudly and with so much joy, when it was finally commissioned. I love you all more than you'll ever know.

To Richard, for your continuous support and encouragement, during the writing of this and many other books. Thank you for constantly looking for rare Marilyn magazines and photos for my book research, and for only complaining a little bit when my research spilled over onto your side of the sofa!

To my beautiful Daisy, who wasn't even born when I first wanted to write this book. I love that you're a Marilyn fan, too, and I'll always be entertained by your reaction to her quotes! Always remember, my dreams came true because of you.

And to anyone I may have missed – I'm so sorry for the oversight, but thank you, too!

Introduction

Marilyn's trip to England may have lasted just four months, but my journey with this book has endured for three decades. I first began research in 1992, when I still worked full-time, and before I had any books published at all. I felt that out of all the areas of Marilyn's life, the England trip was the most neglected. However, despite my enthusiasm, it just wasn't the right time, and my research gathered dust in several huge files. I have always believed in this book, though, and persevered periodically throughout the years; gathering information and interviewing as many people as I could. Now, after writing nineteen other books – many about Marilyn – the time has finally come to tell the England story.

Working on this book during 2020 and 2021 has been a blessing, and in such a bleak time, it has been a pleasure to escape to 1956 every day. I now know why I had to wait thirty years for this book to happen. I would not have had the skill, resources or experience to handle such a mammoth project when I was twenty-two years old. Now that I'm much older and hopefully a little wiser, I understand the many layers involved in the making of *The Prince and the Showgirl*, and have been able to draw out an interesting, frank, and at times heart-breaking story.

During the summer of 1956, the people of the United Kingdom went crazy for Marilyn Monroe, with nightclubs, fetes and beauty contests, all doing something to celebrate her arrival. The actress was also mentioned in the House of Lords, and women used her name to bring attention to their complaints and causes. By incorporating these stories, it ensures that this book is not just about Marilyn's experience of Britain; it is also about Britain's experience of Marilyn. It is my hope, therefore, that by the time you reach the end of this book, it will feel as though you lived through the 1956 Marilyn fever.

I have loved Marilyn since 1985, but writing this book has brought me closer to her than I could ever have imagined. The England trip was a monumental journey for Marilyn and now for myself. I hope this book will bring you closer to Marilyn, too.

Michelle Morgan

Author's note: *The Prince and the Showgirl* was originally entitled *The Sleeping Prince*, and only changed after production ended. I have therefore kept the original name throughout for authenticity.

'I am dying to walk bareheaded in the rain . . . I think England sounds adorable.'

 – Marilyn Monroe, before the London trip.

Chapter One

Ballyhoo, Tibbs and Spivs

The publicity team assigned to look after Marilyn Monroe sat in a stuffy office, with members of the Ministry of Civil Aviation and officials from London Airport. It was 12 July 1956, and the men were there to discuss security procedures for Marilyn's much-anticipated debut trip to the United Kingdom. The publicity team were concerned – with good cause – that the star's arrival should not turn into a high-risk circus. She would be there in two days, and the publicists were desperate to put procedures in place that would prevent their star client from being crushed in the throng.

Instead of support, however, they were met with laughter, and a vow by airport officials to treat the arrival just like any other.

'We don't think there will be screaming fans, and we don't go in for this publicity ballyhoo,' sniffed one official. 'This is London Airport, not Idlewild, New York.'

It was clear that there would be no movement on the matter, and so the American publicity men said their goodbyes and left the unimpressed Brits to their work. Afterwards, a member of Marilyn's team was approached by a reporter, and the publicist shared his concerns.

'Possibly they don't care if Marilyn is crushed by the crowd,' he shrugged, before going on to express his somewhat dramatic belief

that the destiny of US and UK relations might depend on how the arrival was dealt with.

The jaded reporter listened to the complaint, and then skulked off to phone in the conversation to his editor.

Less than twenty-four hours later, Marilyn Monroe and her new husband, playwright Arthur Miller, arrived at Idlewild Airport, New York, in order to take their 4 p.m. flight to England. Dressed in an ivory jersey dress and holding an oversized handbag, Marilyn sent word that she would not meet the press until any television microphones had been dismantled. This revelation caused chaos among reporters, with some claiming that they were being blackmailed into packing up their equipment. By this time, it was 3.40 p.m., and since the plane was due to leave in twenty minutes, Marilyn had no option but finally to appear in the passenger lounge. She was immediately surrounded by dozens of reporters, each of whom had their own questions to ask.

'What do you want to do in England?' asked one pressman.

'I want to meet Dame Edith Sitwell,' Marilyn replied.

'Why won't you say anything for TV?' asked another.

'I've got nothing to say,' Marilyn shrugged.

Yet another reporter begged the actress to give Miller a kiss. She smiled coyly, while her new husband leant down to meet her height.

'Come on, honey,' he said. 'You can do that.'

The actress gave her husband a peck and the press went wild, causing the couple to be penned in more than they were before. Even though they had been instructed to pack up, the television reporters still mingled with the print journalists, which caused one side to turn on the other. Scuffles broke out when the TV reporters continued to press Marilyn on her decision not to talk to them.

'Never have I seen anything like it!' grumbled one airline official, who wondered if the plane would take off at all.

As the couple tried to fight their way through the kerfuffle, one reporter was sure he heard Miller comment that, 'We both need some privacy and quiet. I hope we find it in Britain. Being married to a girl called Marilyn is like living in a goldfish bowl.' Interestingly, the playwright vehemently denied the comment once they arrived in London.

When the reporters and photographers were satisfied that they had given Marilyn a fitting send-off, the actress made her way to a private lounge to get herself together, and then the couple's luggage was checked in – 27 pieces weighing 861 pounds, 597 of which were excess. Reporters took joy in reporting that the added weight resulted in the equivalent of £426 in charges – more than the cost of the couple's air tickets combined.

That dealt with, Marilyn and Arthur waved goodbye to the crowds, boarded the plane, and it eventually took off in drizzle at 4.22 p.m. The departure of America's greatest star ensured that New York would be a duller place for the next four months, but in the United Kingdom, the excitement was only just beginning.

It was as though Britain believed that Marilyn was coming over to add sparkle to a lacklustre summer, but the reality was far more complicated. Marilyn had been bored by Hollywood and the studio system for several years, and knew that if she didn't do something soon, she would be forced to act the dumb blonde for the rest of her career. In 1954, she explained her frustration to author Ben Hecht: 'I realized that just as I had once fought to get into the movies and become an actress, I would now have to fight to become myself and to be able to use my talents.'

Desperate to be taken seriously as an actress, at the end of 1954 Marilyn walked out of her restrictive contract with Twentieth Century Fox and embarked on a new adventure with photographer Milton H. Greene. This saw the star create her own film company,

Marilyn Monroe Productions, which she hoped would enable her to make all kinds of movies. 'She told me that she wanted to become a really great actress,' Milton said, 'have a chance to appear in good stories, not just be the decoration and sex appeal of musicals and trite dramas.'

'I never tried to be independent just to show my independence,' Marilyn said in 1957. 'It wasn't so much that I objected to doing one kind of role. I merely wanted the freedom to do other kinds of roles, too.'

Friends were worried that the actress had made a terrible mistake by walking away from Twentieth Century Fox, but Marilyn was adamant that she had made the best decision for herself: 'All any of us have is what we carry with us, the satisfaction we get from what we're doing and the way we're doing it. I had no sense of satisfaction at all. And I was scared.'

The bosses at Fox were incensed that Marilyn had declared independence, and demanded she return to Hollywood immediately. She politely declined. Cynical critics laughed at her ambition to become a serious actress, and even went so far as declaring her career over if she didn't run back to the studio. What they didn't realise, however, was that Marilyn was not the weak-willed starlet they imagined her to be. Even in the mid-1950s, the actress knew her own power and exactly how to use it.

'I'm willing to go back to work,' she told journalist Bob Thomas, 'as long as I can get what I want. It's the same thing I've always wanted.' What she had always wanted, was to work only with directors she could learn from, create her own film company, and act in a variety of roles.

After holding out for the whole of 1955, Twentieth Century Fox agreed to negotiate a new – and much better – contract for Marilyn. Just as she hoped, this agreement would ensure that, from now on, she would be able to make movies both for the studio and

for her own company, and she would always have director approval. It was decided that *Bus Stop* would be the first film for Fox, and the first for Marilyn Monroe Productions would be *The Sleeping Prince*, adapted from the Terence Rattigan play of the same name. The latter would be shot in England, with Sir Laurence Olivier as Marilyn's co-star, as well as her director, and his production company would share credit with MMP.

Critics were keen to know why Marilyn and Laurence Olivier were teaming up to make a movie. They were an unlikely couple – the world's most famous sex symbol and its greatest actor – but the truth was rather simple. Marilyn admired Olivier and believed that if she acted alongside him, she would be taken seriously as an actress. Olivier, on the other hand, was frustrated by his inability to bring *Macbeth* to the screen, and felt that this frothy Rattigan romp would be a great distraction.

Both actors would be disappointed.

The Sleeping Prince play was set in 1911 and revolved around the Grand Duke Charles (aka the Prince Regent), who invites a young American showgirl called Elaine Dagenham (aka Mary) to have dinner with him. The Prince has high hopes for the evening, though his attempts at seduction fail, particularly when his eccentric wife turns up and takes a shine to Elaine. Throughout the play, Elaine has a theory that the Prince does not have enough love in his life, and they eventually fall in love with each other, though circumstances prevent them from going on with their relationship.

In 1953, Laurence Olivier and his wife, Vivien Leigh, opened in *The Sleeping Prince* at London's Phoenix Theatre. It was a huge success, but this meant that when Marilyn announced her intention to play Vivien Leigh's part on film, the press was quick to question whether Leigh approved of the American actress partnering with Olivier. Leigh slapped down any negativity. 'I cannot think of anyone

better than Miss Monroe,' she said, and then declared Marilyn to be 'an absolutely brilliant actress', worthy of acting Shakespeare.

Laurence Olivier agreed. When asked if Marilyn could act in a Shakespearean play, the veteran actor replied, 'Yes, I certainly think she could. She would have to decide on the part for herself.'

Playwright Terence Rattigan was thrilled that Marilyn Monroe Productions had bought the rights to his play. During their first meeting, the writer was impressed that Marilyn had the ability to say exactly what she wanted in just a few, choice words. He went on to describe her as, 'The most charming boss any man could wish for. She is a delightful blend of guilelessness and guilefulness.'

In February 1956, a press conference was arranged at the Plaza Hotel in New York to announce the making of *The Sleeping Prince*. Marilyn and Olivier linked arms, laughed at each other's jokes, and seemed to all the world as though they were made for each other. When asked why he wanted to work with the actress, Olivier replied, 'She is an expert comedienne. Therefore, she must be a good actress. And she has the extraordinarily cunning gift of being able to suggest one minute that she's the naughtiest little thing alive and the next that she's beautifully dumb and innocent. So – the audience leaves not knowing quite what she is.'

During the conference, Marilyn's dress strap broke and had to be fixed with a pin. A genuine accident, or a cleverly arranged PR stunt? Nobody knew for sure. Regardless, when Olivier returned to London, he was excited for the work ahead: a special letterhead was created to write joint letters; Rattigan and Olivier made plans to rewrite the play into a movie; and the latter was so enraptured with his co-star that he worried he may be about to fall in love.

'She is very sweet, very charming, very talented and very easy to get on with,' Olivier said as he landed at London Airport. 'I am not in the least surprised to be playing against Miss Monroe. I am delighted. It seemed a very good idea to make a film with her.'

Marilyn was just as complimentary. When asked about the movie several weeks after the announcement, she exclaimed, 'We think we'll get started in August, and are so delighted to have Sir Laurence Olivier as my leading man and director. He's my dreamboat!'

Soon, Olivier's dreams of falling in love would be thwarted when the actress married playwright Arthur Miller and brought him with her to England. Marilyn would then learn that her co-star was anything but a dreamboat but, for now, she continued to believe the film would be the opportunity of a lifetime. She had no reason to believe otherwise.

Even before the New York press conference, some of the actors who had worked on the play wondered if they'd have the opportunity to reprise their roles on screen. Rosamund Greenwood wrote to Rattigan in January 1956 and expressed how keen she was to play her old part of the queen's lady-in-waiting. She asked that Rattigan put her name forward for casting, and told the playwright that she was going to try and contact Marilyn directly. Her perseverance paid off, and Greenwood did feature in the film. She was joined by Paul Hardwick, Jeremy Spenser and Richard Wattis, who all reprised their roles from the Olivier/ Leigh version of the play.

Actress Cathleen Nesbitt wanted to act the part of the Queen Dowager, and Rattigan was happy to pass her name to Laurence Olivier. However, the director had another actress in mind – Dame Sybil Thorndike – who had acted in the play during a recent tour of Australia. Sybil had enjoyed a long and successful career – she turned seventy-four during the making of *The Sleeping Prince*. She happily accepted the role.

Dame Sybil described Laurence Olivier as 'a dear little boy, very forceful and determined'. The actress had worked with him when he was just a child, and took credit for giving him his first

professional job: 'He and Carol Reed, the film director, carried my train in *Henry VIII* at the Empire Theatre,' she said in 1962.

When reporter Cecil Wilson visited Dame Sybil in her dressing room at the Phoenix Theatre, London, he found that the actress was excited to work with Marilyn. Although she couldn't remember any of the titles, Dame Sybil did assure Wilson that she had watched at least some Marilyn movies. 'I adored Miss Monroe's performances,' she said, 'and I think she will be simply wonderful to work with.'

Young actor Jeremy Spenser was cast to play King Nicolas, a role he reprised from the play. The teenager was an officer cadet at Eaton Hall; a handsome lad who drove a white sports car and dreamed of travelling to the States to study with director Elia Kazan. He was given time off from Eaton Hall to play in *The Sleeping Prince*, and had recently met Marilyn in New York. 'She's very nice,' he told the *Cheshire Observer*. 'I'm looking forward to working with Marilyn Monroe tremendously.'

Young, blonde actress Vera Day had been in showbusiness for around a year when she walked into Laurence Olivier's office to discuss her role in *The Sleeping Prince*. Vera took one look at the actor and fell in love, though when he saw her, it was less love and more panic. 'Oh dear,' he exclaimed. 'She's so like Marilyn.' Vera thought the compliment was wonderful, but it caused a headache for Olivier, due to his leading lady's dislike of working with anyone who had lighter hair than her own. 'So, with brown wig, I was privileged to work on the movie of the year,' remembered Vera. 'Everyone was buzzing with excitement at the prospect of the arrival of Marilyn Monroe.'

The crew was to be made up of highly skilled professionals, many of whom already knew – or had worked with – Laurence Olivier. Academy Award winner Jack Cardiff was hired as cinematographer; screenwriter and producer Hugh Perceval was executive in charge of production; and actor/director Anthony Bushell would be associate

director. Jack Harris was hired as editor, while Edward 'Teddy' Joseph was production manager. The camera operator would be Denys Coop, and the job of soundman was given to John Mitchell.

Newcomer Colin Clark was employed as a third assistant director; a gofer and tea boy in essence. He wasn't the only assistant on set, but he was the most vocal. Many years later, he wrote two books – said to be about his experiences on the film – but while making *The Sleeping Prince* he was not especially popular. He was the Eton-educated son of the famous art historian Kenneth Clark and already an acquaintance of Laurence Olivier, and his involvement seemed to be something of an ego trip. During the making of the movie, several members of the unit were left to wonder what Clark's contribution actually was, since his two main priorities seemed to be winning Marilyn's attention and aspiring to have senior players visit his family estate.

Beatrice 'Bumble' Dawson was asked to create the women's costumes. First, she visited the library to study books on Edwardian costume and art, and then headed to the Museum of Costume in Sussex. Inspirational trips to vintage stores on London's Portobello Road followed, and then meetings with dressmakers, before finally sharing her ideas with Laurence Olivier and production designer, Roger Furse. Once they had offered their thoughts, Beatrice sat down and sketched her designs, with the strains of flamenco music playing in the background.

It was decided that Marilyn would wear two dresses during the film: one briefly at the beginning when Elsie Marina (as the character of Mary/Elaine had been renamed) is introduced to the Prince, and the other – a tight, white chiffon and satin gown with pearls – worn throughout the rest of the movie. For the first costume, Beatrice revelled in the challenge of creating something truly special for Marilyn that would 'match her hair. I hope we shall be able to get honey-coloured charmeuse (a crepe satin) and that

will be covered with black Chantilly lace. With them she will wear the enormous hats of the period.'

In late April, the designer travelled to Los Angeles to meet Marilyn on the set of her current movie, *Bus Stop*. Before leaving London, Beatrice spoke of her enthusiasm to reporter Jean Bartlett. Describing herself as 'absolutely thrilled', the designer noted that she had watched Marilyn in several films, including *How to Marry a Millionaire* and *The Seven Year Itch*. 'I think she has the most wonderful figure,' she said. 'Just right for the low-cut, tight hobble-skirt dresses I have designed for her.'

During the ten-day visit to the States, the actress approved the designs for her gowns, but disliked the hat sketches. 'Marilyn's face was much more delicate than I imagined,' Beatrice said. 'So, I had to redesign it.'

The designer returned to her Belgravia flat, and got to work on the other designs and colour schemes for 30 principals and 140 bit-part dresses. This included ladies' gowns in various shades of pink, white and red for a lavish ballroom scene; the hope being that the costumes would create a delicate rose pattern when filmed from above.

Once the designs were perfected, the sketches were taken to L. & H. Nathan, and under the watchful eye of director John Gudenian, the wardrobe was put together in their workrooms at 12 Panton Street, London. Described as 'The Premier Costumers since 1790', the staff at L. & H. Nathan were experienced at working on huge film wardrobes. However, the outfits made for *The Sleeping Prince* were particularly exciting, due in part to the fact that Marilyn Monroe would be wearing some of them.

The men's costumes were to be designed by Roger Furse, who had worked with Olivier on *Richard III*. During discussions with Gudenian, it was decided that Olivier's costume must reflect the Prince's stern, stoic character. Gudenian came up with the idea of

using heavy, regimented material that would keep Olivier rigid at all times. Everyone agreed that this was a fantastic suggestion, and the seamstresses at L. & H. Nathan got to work.

As well as casting, crew hire and wardrobe preparations, there was also the matter of rewriting the play into a movie. Rattigan and Olivier began straight away, but from the beginning there were conflicts and control issues. Rattigan believed that the writing would involve a discussion on what needed to be done, and then he would return home to write the new scenes. Olivier balked at such an idea and announced that he would be fully collaborating on the task at hand. The two argued over dialogue, and Rattigan wondered if Olivier would prefer it if the play had been written by a dead playwright instead of himself.

The two men headed to Gleneagles to thrash it out, while Marilyn wrote from Los Angeles to say how much she was looking forward to the project. Rattigan still wasn't sure how the script would turn out, but wrote back to the actress, telling her that it was all coming along well. On the subject of toning down Marilyn's character so that she was less political than she was in the play, Rattigan explained to columnist Thomas Wiseman: 'You could hardly expect Marilyn Monroe to depict a political theorist. Shall we say that, as played by Miss Monroe, she will be a girl whose thought processes do not work quite so fast.'

Marilyn Monroe Productions requested copies of the script, which were eventually shipped out on 5 May 1956. By now, the Prince's wife had been rewritten into a mother-in-law, and the female lead would be known as Elsie Marina instead of Elaine. Word came back that Marilyn thought the script was delightful, and that she and Milton were excited to work on the project.

Olivier and Rattigan were thrilled, but then news came that the script violated the Motion Picture Production Code because of the attempted seduction of a chorus girl by a prince. Rattigan

was furious, and on 15 June he wrote a three-page letter to Olivier, stating that he was bewildered and outraged by the decision. The two men met a representative from the censor, in early July, to persuade him that their script did not 'treat seduction too lightly'. The rep agreed, and Olivier and Rattigan were relieved.

But the possible code violation wasn't the only problem. By this time the script had taken on a life of its own, and was far too long – and expensive – for the screen. Olivier got to work on editing numerous scenes, particularly one depicting the 1911 coronation, which was far longer than it needed to be. Once again, he and Rattigan clashed, and the playwright fought to keep the entire scene in the finished script. Olivier conceded, and finally the script was finished, though later, critics, fans and Marilyn would side with the actor with regard to the length of the coronation scene.

In order that the four-month trip could be a success, it was imperative that Marilyn have a secure and comfortable place to live. Staff at Laurence Olivier Productions stepped in to help Marilyn's people find the ideal location, and signed a contract with Mr and Mrs Cotes-Preedy of Tibbs Farm, Ascot. Mr Cotes-Preedy was a well-known barrister, and his wife was a former dress designer who worked under the name of Eileen Idare.

Mrs Cotes-Preedy was a sixty-four-year-old society lady who drove a Rolls-Royce and spent her time collecting antiques for her already overflowing home. One reporter described her as a 'hummingbird. She is a petite, darting figure who likes to wear bright colours. Her hair is beacon-red and she talks in little gasps.' An eccentric woman, Cotes-Preedy insisted she saw days in colours – Tuesday was white, Wednesday was blue, and Thursday was cherry red. When she was offered £100 a week for Marilyn Monroe's rental of Tibbs Farm, she was overjoyed and – as it turned out – extremely vocal about it.

In his 1995 book, *The Prince, The Showgirl and Me*, third assistant director Colin Clark wrote that he rented Tibbs Farm personally, as a way of fooling the press. The idea was that the news would leak to journalists and then the property could act as a decoy, while Marilyn nipped off to her real accommodation in Surrey. However, this story is flawed. Clark claims that the house rental was agreed on 13 June, after he arranged the transaction with Mr Cotes-Preedy himself. Actually, Tibbs Farm was rented in April 1956, two months before Clark says he started working for Laurence Olivier Productions.

The deal was brokered by Sybil Tufnell, who was famous for being the first female estate agent in the country. Tufnell couldn't have cared less that she was renting a home to Marilyn Monroe. Used to dealing with movie stars and royalty, the RADA-trained former actress was once quoted as saying, 'We take the same trouble over a client who wants to rent a £3-a-week cottage as someone with thousands to spend.'

According to a newspaper report printed the day before Marilyn came to England, the actress chose Tibbs Farm after reading about Ascot in a book about the Duke of Windsor's love affair with Mrs Simpson. This was a romantic story for the media, but likely untrue. More realistic is that her people (and Olivier's) thought the home was ideally situated, with good connections to both London and Pinewood Studios. The house had nine bedrooms – five for guests, and four for staff – and was loaded with antique furniture and a variety of chintz. It also came with twenty acres of grounds.

On 25 April 1956, it was leaked to the press that Marilyn had rented the home and would move in shortly after the Aga Khan had stayed there during Ascot week. This disclosure was disheartening enough, but then the next day, the *Daily Mail* printed photographs of the interior and exterior of the home, and reported that wisteria climbed beneath Marilyn's bedroom window.

Eager to get in on the Tibbs Farm action, the *Daily Mirror* sent legendary columnist Donald Zec to inspect the property. There he found an excitable Mrs Cotes-Preedy, who talked to him while mixing two dry martinis in a cocktail shaker. She allowed Zec to lie on what would be Marilyn's bed, and informed him that an electric blanket would be installed, since she'd heard a rumour that the actress slept in the nude. She also wondered if she should organise a huge welcome party, and was already thinking about a guest list. Zec came away from the meeting with the impression that 'everyone at Tibbs Farm is in a tizzy'.

Next came another article, this time in the London *Evening Standard*. Once again Mrs Cotes-Preedy was interviewed. During the chat, she revealed that she had been talking to the police about security measures for Tibbs Farm, and hoped there would be enough space in the house for Marilyn's clothes. Revelling in the attention, Cotes-Preedy then exclaimed, 'When we decided to let the house to Miss Monroe, we never realised that it would become a matter of national interest!' Whether she knew it or not, Cotes-Preedy had just revealed exactly why Marilyn could not live there.

It wasn't just the British press who were interested in Marilyn's home. Photographers from American magazine *Photoplay* descended on Tibbs Farm, and took pictures of Marilyn lookalike, June Cunningham, perched on what would be Marilyn's bed. They then took shots of the dining room, guest bedroom, bathroom and a full view of the back of the house. Even the pets got in on the action, when Miss Pads the dog and Miss Tibbs the cat posed for pictures. The photos eventually ran in the October 1956 issue of *Photoplay*, but by this time Tibbs Farm was a forgotten subject and the photographs irrelevant.

Representatives of Laurence Olivier and Marilyn Monroe Productions decided to rent another house for Marilyn's stay, and once again Sybil Tufnell handled the deal. A perfect replacement

was found in Parkside House, a green-shuttered, white-walled Georgian mansion in Englefield Green, Surrey, which was owned by Charles Garrett Moore (Lord Drogheda), and his wife, Joan. It was rented out at £120 a week, and the owners would move into their London bolthole when Marilyn was in residence.

The lord thought that Parkside House had character, though it had no particular beauty. In reality, it was rather grand. There was an oak-beamed drawing room with open fireplace and opulent pillars, a library and a boudoir furnished with an upright piano and a red-striped Regency couch. Upstairs, the master bedroom was redecorated in white, complete with matching furniture and bed. The drawing room opened onto a huge garden complete with rose bushes, elaborate hedges and statues, and the property was located at the edge of Englefield Green but bordered Windsor Great Park, close to the Queen's residence at Windsor Castle. It was a perfect abode for Marilyn, and this time it was kept secret from everyone but the people involved.

Happy for Mrs Cotes-Preedy to continue talking about Tibbs Farm, it was decided that she would not be informed of the Parkside House rental. By this time, her imagination had gone into overdrive, and she seemed to think that she and Marilyn would become best friends. She told reporters from the *Sunday Dispatch* that the two of them had been invited to many parties and events. 'I really don't know what to do,' she said, for fear that if she didn't invite her, Marilyn might think England was rather dull.

But despite Mrs Cotes-Preedy's over-enthusiasm, it was actually Marilyn's business partner, Milton H. Greene, who arrived at Tibbs Farm on 7 July – a week before the actress was due to land. The idea was that he'd be joined several weeks later by his wife and their son, but Mrs Cotes-Preedy was still under the impression that Marilyn would stay there too. When she heard a rumour that the entourage would be the only ones to live at Tibbs, she left her

Kensington apartment and headed straight to Ascot. According to Cotes-Preedy, Milton H. Greene assured her that the rumour was false, and Marilyn would arrive soon. She saw no reason to doubt him, and so headed back to London, fairly content.

Meanwhile, Greene was becoming something of a celebrity himself. Anxious to know more about the man behind Marilyn's film company, and hungry for some scoops, several reporters headed to Tibbs Farm. They were met first by the housekeeper, who informed them that Greene never answered the phone and certainly didn't do interviews, and then they bumped into lawyer Irving Stein, who claimed that the photographer had gone to Devon and would not return until later that evening. That story changed, depending on who the reporters spoke to at the property. Eventually they even questioned the gardener's wife, who told them she didn't understand anything about Milton's whereabouts. 'But then, they're not like ordinary people,' she said.

On 9 July, a *Daily Sketch* reporter told readers that he had trekked down to Tibbs Farm and met elderly neighbour Mark Cottons, who was waiting impatiently for Marilyn's arrival. 'I may be 80, but I'm not too old to look,' he said. 'I'll be nipping across to have a peep when she comes in, Saturday.'

Cottons wasn't the only one who looked forward to the weekend. On 12 July, Mrs Cotes-Preedy told Marilyn's representatives that she had ordered enough flowers to fill forty vases, and would travel to Tibbs Farm on Saturday 14 July to arrange them. She then made an appearance on the BBC television channel to tell viewers all about it. Still, nobody in Marilyn's entourage dared to tell her that the plan had changed, and it wasn't until 13 July – just one day before the actress's arrival – that Cotes-Preedy finally learned the truth.

That morning, Milton H. Greene admitted to the Tibbs Farm cook that Marilyn would not be staying at the house after all. Shocked, she immediately rang her employer and broke the news.

Mrs Cotes-Preedy was incensed and spent the rest of the day talking to reporters from various newspapers.

'I'm furious,' she told a journalist from the *Daily Mail*. 'I've been made to look an absolute fool. They must have known about it before I went on television. I wish I'd never heard of Marilyn Monroe.' She then ranted about the amount of publicity she had been able to garner for the actress, including clippings, 'a foot thick'.

To Noel Whitcomb at the *Daily Mirror*, Cotes-Preedy complained she had 'been fooled like hell. They have made me look completely foolish.' She claimed that she shunned publicity but thought it 'churlish' to turn down media offers, and blamed Marilyn's representatives for instigating the publicity. Whitcomb dashed straight to the offices of Laurence Olivier Productions, where a representative told him he had no idea what Cotes-Preedy was rambling on about, and that the decision for Marilyn to stay at Parkside had been made a long time ago.

Arthur Jacobs – Marilyn's fast-talking, chain-smoking, Coca-Cola-swigging publicist – was furious with the Tibbs Farm fiasco, and falsely claimed that nobody knew where Marilyn would be staying during the trip. As far as he was concerned, she may even stay at the Savoy Hotel.

Around the time she found out about the cancellation, Mrs Cotes-Preedy fell and suffered a concussion. Still, that didn't stop her entertaining two reporters from the *Daily Sketch* as she lay on her bed and chain-smoked cigarettes. 'I don't like people making a fool of me,' she said, and then claimed that while she still thought of Marilyn as charming, the people organising her trip had handled things badly. But she wasn't worried about the financial implications because, as far as she was concerned, 'The damn people are paying. It's just bad business.'

Mrs Cotes-Preedy may no longer have been excited about Marilyn's arrival, but it was as if the United Kingdom had been waiting since

history began. In the years leading up to the visit, there had been a surge in interest, created by films such as *Gentlemen Prefer Blondes*, *Niagara* and *The Seven Year Itch*. Teenagers pinned her posters on to their walls; women asked their hairdresser for Marilyn's famous 'do'; and men – young and old – fantasised about one day meeting someone just like her.

But it wasn't just the general public who went overboard for Marilyn. Nightclubs, theatres and summer camps played host to all kinds of contests and lookalike galas. In March 1956, a Marilyn Monroe wiggle competition in Airdrie, Scotland, 'caused scenes which had to be seen to be believed', with hundreds of dancers rioting outside the Town Hall after they were refused entry. The police were called to calm things down, but when the competition finally got underway, the eight young women who had entered the contest refused to take to the stage. The master of ceremonies went backstage to persuade them to come forward and 'the vast enthusiastic audience cheered the gallant females to the echo', finally crowning Airdrie's own Isobel McLean as the girl with the best Marilyn wiggle.

On 7 June 1956, Peterborough Town Hall held a night of dancing, and between musical sets from Arthur and the Bandwagoners and the Piccadilly Incident Film Band, there was a knobbly knees contest for the fellas and a Monroe lookalike competition for the girls. Then a week before Marilyn's arrival, the Grantham Social Club advertised a special night dedicated to the star, with a 'prize for the girl who gives the best impression of the Marilyn Monroe wiggle'. The club erupted with tunes by the likes of Elvis Presley and Bill Haley, and young women donned their best dresses in an attempt to impress the judges with their Marilyn impersonations.

As soon as it was announced that Marilyn would come to England, her name was brought up in Westminster. During a debate in Parliament about the state of the British film industry,

Labour MP Mr Stephen Swingler stood up to address the House of Commons. 'If Miss Monroe chooses a British actor as her idol,' he said, 'who are we to say that we have not got the talent in this country to get a bigger and more attractive film-making industry.'

Some vocal coaches made a good living by giving advice on how to adopt Marilyn's voice, but not everyone was pleased with the outcome. In 1955, a group of teenagers entered a folk-song competition at the Arbroath Musical Festival in Scotland. 'I detected a slight influence of the Marilyn Monroe intonation in one of the singers,' complained judge Maurice Jacobson. 'You must all remember that simplicity is most important, especially in folk songs.'

The year before, in 1954, students at Queen's University in Belfast had a discussion about the charms of Marilyn versus those of cookbook writer Mrs Beeton. The actress – described as 'the ultimate triumph of alliteration' – won the debate, though some lecturers complained about the 'ill-mannered and boorish behaviour from certain sections of the audience'. Another discussion, which could have been described the same way, took place in the House of Lords during a debate on television versus the British film industry. Explaining that he knew nothing about the film-making business, one lord brought laughter into the House when he quipped that the phenomenon of Marilyn Monroe was 'much easier for most of Your Lordships to understand'.

Marilyn's image and career excited many people during the mid-1950s, but not everybody was so keen. In February 1954, a priest gave a sermon in the north of England in which he complained about the Americanisation of Great Britain. He described the young men and women who enjoyed Hollywood movies as 'a collection of spivs . . . yahoos and listless, shifty-eyed, tailor-dummied youths and painted trollops who worship not at the shrine of the Son of God, but of St Ava Gardner or St Marilyn Monroe.'

Two years later, the priest was surely furious to discover that those same 'spivs and yahoos' were about to descend on London Airport in a bid to catch even the tiniest glimpse of St Marilyn Monroe . . .

Chapter Two

A Peroxide Hydrogen Bomb

On the morning of Saturday 14 July, 1956, British teenagers danced in their bedrooms to 'Heartbreak Hotel' by Elvis Presley and 'I'll be Home' by Pat Boone, and occasionally tuned in to the news to see if Marilyn had arrived yet. As the plane headed towards England, Allan 'Whitey' Snyder fixed her make-up, and warned that the British press would likely be all over London Airport. 'I told her that she should handle herself in style. Well, she did,' he said.

Meanwhile, officials at London Airport were concerned to discover that one hundred photographers and fifty reporters had turned up to welcome the actress to the United Kingdom. Disturbed by reports of the hysteria when she left New York, the officials shuffled the press behind barricades that at least one journalist likened to sheep pens. When rain started to fall, and the TWA aircraft was an hour late, the barricaded personnel chafed and muttered their dissatisfaction.

Officials stared at their watches and complained when internal airport staff spilled onto the tarmac for a better view. Everyone was instructed to be on their best behaviour, and even a team of workmen were told that under no circumstances should they say

anything to the famous arrival. This request later became a moot point when Marilyn shouted a breezy, 'Hello!' at the men as she strode past.

At 10.40 a.m. the plane touched down and finally came to a halt. The door opened, the steps were positioned, and more barricades were hauled onto the runway and placed next to where Marilyn would eventually walk. The photographers positioned their cameras, the tips of the reporters' pencils waited silently on their notebooks, but the actress did not disembark. Instead, various passengers and crew appeared, and then a woman from the airline disappeared into the plane, carrying a bouquet of flowers and a sweater. Then just as everyone was about to give up, Marilyn – wearing dark glasses and the same beige dress that she'd worn in New York – appeared in the doorway and smiled.

The waiting crowds completely lost their minds.

'Her blonde hair was bright, her heels as high as stilts, and she wore a splendid jersey dress,' wrote a reporter from the Sunday *Observer*. 'She looked very happy.'

As the rain began to fall, Marilyn slung a raincoat over her outfit and carried her flowers down the aircraft steps. She was followed by Arthur Miller, wearing a crumpled suit and carrying a briefcase. The couple were met at the bottom of the steps by various unsmiling officials, and then escorted into the basic arrivals hall to be welcomed by none other than Sir Laurence Olivier and his wife, Vivien Leigh. The stars greeted each other warmly, and Marilyn leaned over to Leigh and told her how happy she was to hear that Leigh was pregnant.

'I envy you,' Marilyn said.

If the photographers had been excited outside, by now they were wild. Cold, wet and impatient, the men jostled for the best view of Marilyn, and some balanced on high windowsills for the ultimate view. Various reporters were elbowed in the back, others

were grabbed by the collars of their raincoats, and one or two were even seen falling over – and nobody attempted to help them up. Marilyn smiled, Miller adjusted his glasses, and the Oliviers grinned awkwardly. They may have been used to press attention, but this was ridiculous even by their standards.

'It was hysterical,' remembered publicist Jerry Juroe, who was part of the Arthur P. Jacobs company, the firm in charge of press relations during Marilyn's time in England. 'Everything was hysterical with Marilyn. But becoming a part of her team was a special position. I became part of the inner Hollywood circle because of working with Marilyn.'

The Millers were shuffled off to deal with the mountain of luggage, and then they returned to the area reserved for the press conference. By this time there were between three and four hundred pressmen and women all crammed into the tiny space along with huge arc lamps. Four chairs were set out for the famous couples, and the media was arranged in an arc, but they quickly moved in closer until there was barely any room to breathe. One newspaper compared it to the VE Day celebrations, and described Marilyn as, 'The girl with the wiggle and the waggle.'

Tired from the flight, the actress could be forgiven for not feeling much like wiggling or waggling, but she smiled regardless and obeyed every shout to look this way and that. The reporters soaked it all up, though Arthur Miller looked lost and out of his depth. One reporter managed to ask the playwright what he thought of the welcome. 'Well, of course, it's not like this every day,' he replied.

When Marilyn unexpectedly announced that she had no intention of speaking into a microphone, everyone in the room was stunned.

'We can't hear you!' shouted one reporter, while another jumped onto a chair and yelled at the actress to speak up. This encouraged others to do the same, and within seconds reporters

and photographers were balanced on tables, pushing and shoving to such a degree that the only photos they could possibly take were of each other. The atmosphere now changed from one of excitement and curiosity to rowdiness and irritation, and several photographers were pushed up into the corner. A press agent begged everyone to take a step back and stop the hysteria, but it was no good. Extra police had to be called in to control the massive surge.

Two waitresses stood behind a nearby snack counter, and one even told off reporters when they stood in her line of vision. 'I want to see the way she walks!' she exclaimed, though her cries went unheeded. An enterprising official decided that the press conference was no longer safe, so shooed the waitresses away and hustled the Millers and Oliviers behind the snack bar. Safe from the throngs, Arthur sat down and lit his pipe, and Marilyn took her place on a raised dais under a row of small palms. Olivier laughed and announced that if anyone had any questions for Marilyn, they should shout them to him and he'd pass them along. The reporters grimaced; one sarcastically asked if Olivier was acting as some kind of interpreter; another journalist knocked a sugar bowl with his elbow; and then finally the press conference began.

There was a multitude of unheard questions, but Harry Procter from the *Daily Mirror* managed get close enough for a few private words. To him, Marilyn explained her desire to travel down the English country lanes, as she had been told that they 'are the loveliest in the world . . . Of course, I want to see many things in London, including the little fellow with the bow and arrow in Piccadilly Circus – I've always wanted to meet him.'

Marilyn would probably have been happy enough speaking privately with Procter for the entire conference but, as a whole, the press pack was restless. There was more pushing and shouting before one journalist was finally heard above the crowd. He begged to know how long Marilyn would be in Great Britain.

Olivier listened carefully, whispered the query to Marilyn, and then she gave her answer. The actor nodded and then turned to the waiting press.

'She says she's here for about fourteen weeks.'

There was a pause for notes, and then the shouts began again.

'What do you think of an English press conference?'

Olivier relayed the question, and then this time Marilyn shouted her answer.

'What?' bellowed the reporter. 'Very ordinary?'

The actress shook her head, and then it was revealed that she had actually said the press conference was orderly, not ordinary. Nobody knew if she was being sarcastic, but she did refuse to comment on how a British press conference compared to an American one.

Marilyn had the jaded journalists enthralled. A newsman from the *Aberdeen Evening Express* was impressed with her ability to remain calm during what he considered to be an ordeal: 'She certainly seems to be well accustomed to crowds, for she was unperturbed by all the excitement – as though she was in a private drawing room talking to her kid sister.'

Reporter Kenneth Pearson was less impressed: 'She speaks as though afraid of waking anybody,' he said.

After much to-and-fro, it was discovered that Marilyn didn't wish to use a microphone because it was an ordeal; that she was serious about the subject of Dostoevsky; wanted to see as much of England as possible during her stay; was hopeful of having every weekend off work; and had no idea where she would be staying that night. However, unwilling to take that as an answer, one enterprising reporter sneaked out of the building, found Marilyn's waiting car and asked the chauffeur where he was headed.

'Parkside House, Englefield Green,' the driver replied. The journalist jumped into his own car, and then the news spread around the arrivals hall. So much so, that by the time Marilyn had

managed to pull herself away from the press conference and leave for Surrey, there were dozens of cars and motorcycles on her tail.

In the once-frantic cafeteria, only several shocked journalists remained. One muttered to another, 'She's like a drug. I went on snapping her long after I'd used up all my films and plates.' Another thought carefully about the events of the past thirty minutes, pulled out his notebook, and scribbled frantically: '[Marilyn] burst through the grey clouds and gentle drizzle like a peroxide hydrogen bomb.'

It was an image everybody wanted to have of Hollywood's most revered star, but one that would prove hard to maintain.

As Marilyn's car drew up outside the white, Georgian facade of Parkside House, the staff lined up to greet the couple and presented the actress with a beautiful bouquet of flowers. They had all worked long hours in the weeks before Marilyn's arrival: touching up paintwork; redecorating the bedroom; organising menus; and making sure the garden and house exterior looked fancy enough for a Hollywood star.

Now Marilyn was here and, as she greeted her new staff, members of the British press were not far behind. One of them was Donald Zec, who had previously met Marilyn in Hollywood and had become a fan and champion of her career. The actress greeted him warmly, linked his arm and posed for photographs. Zec took an appreciative look at her dress and quipped that it was rather tight.

'It fits,' Marilyn laughed, and then introduced the journalist to her husband. Zec noted that while Miller was somewhat gaunt and lanky, he had a firm handshake, and Marilyn seemed happier than ever.

'He's my man,' Marilyn told Zec. 'I just adore him!'

Marilyn, Miller, Olivier and Leigh posed for photographs at the porch of Parkside House, and then another press conference – to a select number of invited reporters – was held inside the florally

decorated drawing room. Parkside owner Charles Moore was happy
to show Marilyn and Arthur around his home, though his version
of a tour guide left a little to be desired. Moore pooh-poohed every
room, describing them all as 'boring'. Miller got the impression
that the lord was trying to lengthen the tour by giving unnecessary
details, but even a member of the aristocracy couldn't delay the
journalists waiting to meet Marilyn in the drawing room.

When she walked in, the actress announced, 'I'm here!' and the
noisy room fell silent. For once the journalists were stuck for words,
though one did manage to note that, as Miller followed behind, he
resembled 'a gaunt, balding figure in a linen jacket'.

Marilyn was asked what she thought of the sprawling Parkside
House. She looked around at her surroundings, and then admitted
that she had actually expected to find a small English cottage. The
pressmen laughed and took the opportunity to enquire as to what
she thought of the British actress, Diana Dors, who had often (and
unfairly) been described as Britain's answer to Monroe. This time
Marilyn gave a slight smile, before declaring that she had never met
her, nor watched any of her films.

One reporter was eager to know what Marilyn would do on
her days off.

'I am going to buy a bicycle,' she said. 'You see, I was brought up
in the town, so I love the country – the birds and the bees and all
that sort of thing. And a bicycle is the only way to enjoy it.'

Olivier's voice boomed from the back of the room, 'I'll lend you
mine, sweetie!'

'Will it be a tandem, Marilyn?' one journalist asked.

Marilyn threw her arms up in delight. 'Oh dear no!' she replied,
which prompted Miller to share a story of once riding a tandem,
only to discover that he was the one doing all the work.

The questions covered almost every subject imaginable. Yes,
Marilyn planned to go shopping, and she would like to buy leather

suitcases, 'because I've heard they are so good here'. A mackintosh would be a must, though she didn't plan on buying much in the way of fancy attire. 'I like very informal clothes,' she said. 'I don't care much for jewellery.'

The topic then turned to whether or not Marilyn would meet the Queen, and her face lit up. 'That would be very nice, indeed,' she smiled.

Most of the questions were aimed at the actress, though one or two managed to find their way to Miller as well. He was asked what he was currently working on, which provided a nice segue into asking what he thought of Marilyn as an actress, and whether or not she would star in one of his works. Miller took the questions in good faith, and replied that although he never wrote plays for any particular person, he'd certainly be glad for his wife to act in one.

The questions continued, but an exhausted Marilyn was eager to bid everyone farewell. She looked at Miller, told him she was tired, and then the two got to their feet. The couple said goodbye and then, one by one, the journalists filed out of the Parkside House drawing room.

Before Laurence Olivier left Marilyn and Arthur to recover from their transatlantic flight, he spoke to her about plans for the next day. There was to be a press conference at the Savoy Hotel, when the British media would have another opportunity to welcome Marilyn to England and bombard her with questions. Olivier hated press conferences and begged her to be on time so that he didn't have to entertain the journalists alone. The actress assured her co-star and director that she would do her best, and then finally the Oliviers left and the Parkside House door was closed.

As Sir Laurence's car swung into Wick Lane, the butler walked down the drive, threaded a chain through the slats in the gate and padlocked it closed. Local adults sniffed that the gate had never been locked before, but the children didn't care. For the next four

months, the handles on the locked gate gave them a perfect platform on which to stand and peer over the top.

Their cries of 'We want Marilyn! We want Marilyn!' became such a normal part of life that a sign would be propped up regularly, advertising what time Marilyn was scheduled to make an appearance.

Deryck Bazalgette was the head gardener at Parkside, and lived with his family in a cottage in the grounds. Shortly before Marilyn's arrival, Deryck was told that someone very important would be coming to visit; that the next four months might prove to be difficult with regard to press intrusion, but that they were not to talk to anyone about it. His daughter Cary recalled being intrigued as to who this visitor might be, and when eventually told that it was Marilyn, she was excited. Her father's reaction wasn't so animated. 'Who is Marilyn Monroe?' he asked, much to the amusement of his family.

Worried that perhaps there wouldn't be enough staff to care for Marilyn and Arthur at Parkside, Deryck's wife Ruth was asked if she would mind working in the house. She agreed and, for the next four months, Ruth was in charge of ironing Marilyn's clothes, and on the first evening also served dinner.

'My stepmother came home very excited,' said Cary. 'She and all the staff had been sitting in the kitchen, when Marilyn came through the green baize door.' The door in question was popular in houses that had a family and servants, and acted as a separator between the two distinct spaces. The green baize covering the door was there to deaden the noise from either side, and for a member of the household to cross the threshold into the servants' area was a huge deal.

'Sorry to disturb you,' Marilyn said to the shocked staff. 'But could we please have some candles?' Her voice was quiet and shy, and none of the servants could believe that the new mistress of the

house had just joined them in the kitchen. They provided her with what she was looking for, and then the actress went back the way she came, through the green baize door.

The day after her arrival, Marilyn enjoyed a quiet morning in bed at Parkside House, adjusting to the time difference and getting used to the constant presence of her new staff. The actress was not used to a large group of servants in her day-to-day life in Hollywood or New York. Living in small apartments, hotel rooms or the homes of friends, Marilyn largely took care of her own space, even when there was help available. 'I live very modestly,' she said in 1952. 'I've no servants, do all my own cooking and housework, honestly I do.'

Milton H. Greene's wife, Amy, noted that while living with the family in 1955 Marilyn had always done her fair share of chores. 'She made her own bed, kept her room tidy, brought down her clothes on washday. If she slept late, she would make her own breakfast, rinse off the dishes and put them in the dishwasher. Neither Sadie, our maid, nor I had to wait on her.'

Despite a lack of experience of a full-time staff, Marilyn always showed kindness to those charged with looking after her. Florrie Mitchell worked at Parkside, looking after the estate's vegetables and chickens. She also lived in a small flat on the property, and saw Marilyn frequently during her stay. Forty years later, she would say she had forgotten all about the actress during the intervening years, but in 1956 she felt Marilyn was 'a warm, open person with no airs or graces', and introduced the actress to her teenage nephew when he visited Parkside.

One of the servants – Marianne Geltner – later wrote that she and Marilyn became quite close during these early days, and would sometimes talk in the evenings about all manner of topics. Apparently, Marilyn even gave her some stockings after she caught the servant taking an old laddered pair out of the bin. Geltner wasn't

the only person to whom Marilyn showed kindness. Housekeeper Dolly Stiles brought her ten-year-old daughter Beryl into Parkside, and Marilyn came downstairs, spoke to the child and later presented her with a personalised, signed photo.

A full staff, comprising, among others, a butler, cook and housekeeper, was always going to be a challenge for Marilyn to get used to, but having a personal bodyguard in the form of ex-policeman Roger Hunt was something else entirely. Hunt was employed to follow Marilyn wherever she went, but during the four months in England she would tire of his continued presence, and there would be times when she gave him the slip, much to his chagrin.

In addition to Hunt, there was also a revolving round of security provided by the Weybridge division of the Surrey Constabulary. Two officers worked eight-hour shifts, patrolling the grounds in the hope of keeping the paparazzi and other looky-loos at bay. They would soon realise just how hard this would be, but, for now, the officers wanted to know what they should do if they did find an intruder on the property. Their sergeant thought for a moment and then replied, 'Take him in the shrubbery and give him a little smacking – we don't want no bother!'

As Marilyn woke up to her first morning at Parkside House, the residents of Englefield Green were bubbling with excitement. Never before had the driveway been so attractive to admirers young and old, and locals at the nearby Sun Inn wondered aloud if they would be visited by their new neighbours. Landlady, Mrs Frances Bacon, was excited as well, and decided to send a telegram to Parkside, formally inviting the Millers to the establishment. 'Everyone would be delighted if Marilyn came here,' Bacon told reporters.

While Mrs Bacon was compiling her telegram, the ladies at the Egham telephone exchange were buzzing that Marilyn was in town. Pamela Burns remembered all of her friends being eager to

be the first one to connect the actress to a number. Nearly sixty-five years later, Pamela does not recall who was the first to do the deed, but does know – with some regret – that it wasn't her.

Just over a month later, it was another telephone exchange that made headlines when the Salisbury switchboard fired fifteen-year-old Margaret Harding, apparently because they deemed her overweight. The girl complained to her local MP and then went straight to the press. 'All the girls at the exchange think it is nonsense,' Margaret said. 'Does it mean that if we haven't got Marilyn Monroe figures, we are not good enough for the Post Office?'

Although it was a Sunday, Laurence Olivier was hard at work in London for much of the day, shooting a scene at the Foreign Office. In the days leading up to the shoot, a memo was sent to employees stating that because the movie was set in 1911, they must refrain from parking modern cars in the courtyard. This they did, though while the shoot was hoped to be a discreet affair, the arrival of a film crew around Horse Guards Parade caused excitement among the throngs of summer tourists and London visitors.

Crowds gathered around, and when somebody made mention of *The Sleeping Prince*, the onlookers immediately thought of Marilyn. As they craned their necks to catch a glimpse of the famous visitor, most fans were left disappointed because the only principals on set were Olivier as the Prince and Richard Wattis as Northbrook – the Deputy Head of the Far Eastern Department. Together they filmed just a couple of lines of dialogue before the scene was brought to a close. Only time would tell if all the scenes from *The Sleeping Prince* would be shot with so little trouble.

While Olivier worked in London, Marilyn stayed at Parkside to look through illustrations of the sets and costumes, and then, after a Sunday roast for lunch, the actress changed into a dress she had chosen for the Savoy press conference. It was a daring number

made up of two pieces of black cloth joined in the middle with netting. The design meant that everyone could catch a glimpse of the famous Monroe waist, and was sure to cause a sensation in the press the next day. 'It's not my idea – but it's my midriff,' Marilyn jokingly told reporter Donald Zec. Two months later, replicas of the outfit would appear in the autumn collection at Rowell's store in North Shields, priced at £3.

It was time to leave for London, and as their chauffeur-driven car waited on the driveway, Marilyn and Arthur exited Parkside House. It was a warm, sunny day, but Marilyn wore a raincoat over her shoulders and carried white gloves and a clutch bag. Arthur Miller wore a suit and the semblance of a smile. They were greeted on the driveway by members of the world's press, and the photographers lost no time in snapping photos of the famous couple. They seemed happy to oblige, and posed next to the rose arch in the garden and in front of a blossoming tree. Marilyn smiled widely, and at one point even tickled Miller's ear. The famously publicity-shy playwright managed to look somewhat content as they spoke first to the pressmen and then to a group of curious locals gathered outside the property.

Unfortunately, the attention in Englefield Green meant that Marilyn was late for her appearance at the Savoy Hotel. Impatient reporters mumbled in the opulent surroundings, and Lord Olivier slumped in a chair and seethed. Famously shy of the media, he now found himself at their mercy, and with no sign of Marilyn, he had to listen to their questions about his marriage and personal life – even if he had little intention of answering them.

Time marched on, and the reporters stared at their watches and demanded to know where Marilyn was. Olivier smoked another cigarette and admitted that he had no idea. Outside, the actress's car pulled up outside the Savoy, but there were so many fans crowded into the Strand that she was unable to get out. Marilyn waved at her

screaming admirers – made up mainly of women and teenagers – but this only served to excite them even more.

Finally, the chauffeur took the decision to move the car to the Embankment entrance, and even though many of the fans followed, Marilyn managed to escape and slide into the hotel thanks to a human chain of policemen. An old lady was heard to cry, 'O-ch! Isn't she wonderful!' while others smiled and shouted their approval.

Approximately forty-five minutes after her scheduled appearance, Marilyn strolled into the room and the reporters fell silent. Olivier greeted her with a semi-smile, and then they – accompanied by Arthur Miller – sat beside a table with a display of flowers. Marilyn sipped a cup of tea, Olivier offered to act as a go-between if Marilyn could not hear the questions, and then he and Miller lit cigarettes.

More than one reporter wanted to know exactly why Marilyn had kept them waiting.

'I am so sorry we were detained,' she replied, 'but we were detained by people from your own profession.' She gave a massive smile, told the reporters that she loved London already and, from then on, had the room under her spell.

As with the two press conferences prior to this one, the journalists were keen to speak about Marilyn's personal life rather than the making of *The Sleeping Prince*. She was asked how her marriage to Arthur Miller would affect her acting career. Marilyn smiled and managed to avoid the question. 'Naturally I want to improve in every direction possible in my acting, and I think everything that is happening to me, personally and professionally, is very beneficial.'

One gentleman of the press was brave enough to ask Marilyn what it was like to be married to such a quiet man. Miller's eyes narrowed and he gruffly denied that he was any such thing. Marilyn smiled and offered the revelation that she had never been happier, and then Miller declared his new wife to be, 'the most unique person

I have ever met'. He then denied that he'd have any part to play in her career, and got back to staring at the chandeliers dangling from the ceiling above.

The reporters were eager to hear what Marilyn planned to do while in England. The actress rattled off a list of dreams, including visiting the continent, riding through the countryside, travelling to Stratford-upon-Avon, and living a quiet life at Parkside House. Making *The Sleeping Prince* was not in her list (though she may have thought that was obvious), but Marilyn did reveal that she would one day like to play Lady Macbeth and act in *The Brothers Karamazov* by Fyodor Dostoevsky. She even mentioned that she would love to act on the British stage, opposite Laurence Olivier, in something like *Pygmalion* by George Bernard Shaw.

When a journalist from the *Daily Express* managed to ask Marilyn about her new marriage, she assured him that she would be aiming for a quiet life from now on: 'It's an absolute necessity to separate the public glare from private bliss to make our marriage a success.' When asked how she would go about doing such a thing, the actress replied, 'I don't know – I'll just go about it. A person's private life . . . Well, it's up to a person to keep it private.'

Considering they could ask anything, some of the questions proved to be flippant and mildly irritating. Marilyn answered all with patience and class: yes, she had enjoyed breakfast in bed; yes, she also ate lunch; no, she did not intend to give up wearing bathing suits; no, she would not discuss politics and religion; and on being asked her definition of an intellectual, she politely told the reporter to look it up for himself. 'She slapped down some tricky questions with some smart answers and was applauded,' wrote one reporter from the *Daily Herald*.

One writer asked if Marilyn had any keep-fit advice for British girls. 'From what I've seen, they don't need any,' she replied, diplomatically.

Next came the subject of whether or not Marilyn still wore nothing but Chanel No. 5 in bed, as she had claimed in one of her most famous quotes. The actress hesitated and Olivier stepped in.

'You use Chanel No. 5?' he asked.

'Instead of pyjamas? I might try Yardley's Lavender now,' she laughed.

The answer to this question received the biggest applause of the day, and one reporter had to admit that while Marilyn may refer to her dress as 'simple', the wearer most certainly was not.

At one point during the conference, Olivier got to his feet just in time to see Alan Gardner and Owen Summers from the *Daily Sketch* wheeling a Norman bicycle into the room. The two men had caused something of a scandal when they informed the Savoy's public relations team that they would be bringing a bicycle into the hotel, and even when they received permission from the directors, they still had to get past the doorman. Eyeing the reporters as they wheeled the bike towards him, the doorman pleaded with them not to ride it down the corridors. 'We assured him we wouldn't,' reported the newsmen, 'because, for one thing, it's a ladies' bicycle.'

The journalists reached Marilyn's table, and she smiled in surprise. The men explained that they had heard of the actress's wish to cycle in the back lanes of England, and asked her to accept the gift with the compliments of the *Daily Sketch*.

'Oh, it's lovely,' Marilyn gushed, 'but we haven't room in the car.' She ran her fingers over the blue and white frame, and then asked the men if they would mind bringing it to Englefield Green. The journalists assured her that they'd be happy to hand deliver the bicycle, while Arthur Miller laughed and Olivier leaned forward for a better look. As reporters crowded round her, Marilyn jokingly scolded someone who got too close to her bike, and then promised the *Daily Sketch* representatives that she would be out and about on it in the weeks ahead.

What nobody knew at that point was how Marilyn's cycling hobby would soon cause chaos in Parkside House. Bike manufacturers were so excited to hear about the actress's fascination with bicycles that they all decided to send her one, and by the end of the next week there were so many rammed into the house that Marilyn worried she would fall over them. 'You can hardly move in the hall for bicycles,' she said.

The Savoy press conference may have been reserved for media only, but somehow Private First-Class Paul William Guisinger from the US Army managed to sneak into the proceedings. Explaining that he had come over from Germany especially to see Marilyn, the young man asked if the actress had any plans to entertain soldiers overseas. In 1954, she had sung for the troops in Korea, and later described the trip as one of the greatest moments of her life. Now a soldier stood nervously among the crowd and waited for an answer. Marilyn smiled and told him, 'I'd love to – but I can't promise anything immediately.'

Press conference over, Marilyn bade everyone goodbye and then noticed a crowd of fans standing outside. She threw open the window, leaned out and gave them an almighty wave. The crowd screamed and waved back, and one man leapt into a tree in an effort to gain her attention. Another attempted to climb a statue, while three women shrieked with joy and hugged each other with excitement. Young serviceman Ray Johnson was in the crowd that day: 'I had just come home from the army on leave for the weekend, in the hope of seeing Marilyn in the flesh. There was such a crowd of people there that, unfortunately, I was stuck at the back. Then suddenly the windows were flung open, and there she was. She looked stunning in the simple black dress with the transparent midriff. Sadly, cameras were rare in those days, so I have no photographic evidence, but the memory of that day is just as clear, sixty-five years later.'

As Marilyn greeted her fans at the back of the Savoy Hotel, it was as though the whole of the United Kingdom had fallen madly in love with the blonde bombshell from overseas.

'Her off-the-cuff quips, her giggle, plus her sincerity, made the conference a triumph for her,' wrote a reporter from the *Newcastle Journal*. He noticed that the normally jaded journalists applauded Marilyn five times, and they left feeling 'charmed and delighted'.

On 16 July, Mr G. H. Nugent, Joint Parliamentary Secretary to the Ministry of Agriculture, Fisheries and Food, took to the stage at the National Whaling Commission in London. There he announced that Marilyn had 'obviously come to England to dispute the saying of our great literary man, Dr Johnson. He adjured us never to believe in round figures. One has only to take one look at her to see the truth that round figures do exist. Even without the assistance of a by-product of your industry, which has helped ladies' figures.' While many people had no clue what Marilyn had to do with a whaling commission, the crowd roared with laughter and cheers, and a woman translated the speech for a large group of Russian visitors.

As Mr Nugent received his applause, Marilyn readied herself for yet another press conference – the fourth since her arrival. Once again, the venue was at the Savoy, though this time Marilyn dressed demurely in a high-necked suit with a silky black blouse. Olivier was with her, but Arthur Miller was elsewhere in London, making tentative plans to showcase his play, *A View from the Bridge*, at the Comedy Theatre.

Before the event began, John Gudenian and Madame Macower from L. & H. Nathan popped into the Presidential Suite, fought their way through the throngs of reporters, and made their way to an adjoining bedroom to take Marilyn's measurements for her *Sleeping Prince* costumes. Gudenian found Marilyn to be pleasant and shy,

with a real interest and knowledge in costume design. He later shared his memories with his daughter, Miranda. 'He was not prepared for the reserved and almost child-like actress whom he encountered,' she said. Marilyn was tinier than Gudenian had imagined, and as he and Macower compiled their set of measurements for her costumes, he was surprised by her vulnerability.

Work done, Marilyn changed back into her conservative outfit, and the press conference began. It was almost a re-run of the ones that had gone before and contained the same kind of questions, though this time Marilyn seemed more relaxed, witty and comfortable. Even Olivier managed to crack a smile – relieved no doubt that this would be the last interview before going headlong into the making of *The Sleeping Prince*.

During the event, Marilyn told reporters that she had just completed a fitting for her film costume and that, in the future, she'd love to work with Marlon Brando and Richard Burton. When she disclosed that her favourite composers were Beethoven and Berlioz, one sneaky journalist stood up and enquired, 'What specific Beethoven symphonies interest you, Mrs Miller?'

'I have a terrible time with numbers,' she replied. 'I know it when I hear it.'

The room applauded her answer, and Marilyn's hands flew over her ears as she laughed.

Another reporter asked what it felt like to be a sex symbol, and the actress shrugged. 'A symbol? I feel much more like a person . . . Alive!'

Marilyn revealed that she would love to start a family; she wanted to learn to cook; the one food she hated was olives; the best way to tone her figure was through work; and while she didn't consider herself to be particularly intelligent, she did hope that she wasn't as stupid as people believed.

'How do you define the American way of life?' asked one reporter.

'Well, how do you define the British way of life?' Marilyn retorted, and the room burst into applause once again.

Once press conference number four was done, Marilyn headed to Claridge's for lunch with Miller, and then home to Parkside House. Little did she know, just several miles away, a huge security breach was being planned.

Chapter Three

The Sleeping Showgirl

Shoreditch Training College was located several miles from Parkside House and, like most locals, the students who lived there could not wait to get their own glimpse of Marilyn. The Englefield Green schoolchildren may have been happy to hang around the gates in the hope that she would come out to speak with them, but the older students were not so patient.

As soon as they heard that she would be staying at Parkside, there was much discussion about how the young men could attract Marilyn's attention. One of the more enterprising students decided that the best time to visit the house would be late in the evening. That way Marilyn was more likely to be inside, and the children and journalists at the gates would be long gone. This plan was okayed by the other students, and more suggestions were thrown into the hat. Perhaps there could be music! Trumpets? Yes, trumpets would be perfect. What about some songs, too? Songs would certainly gain Marilyn's attention. The students were excited by this idea, and so voted in favour of some singing with musical accompaniment.

The adventure gained a great deal of support around the college, particularly as the students had finished their exams and therefore felt they had nothing to lose. And so, at some time between 8 and

9 p.m. on the evening of 16 July, a group of eighty young men met at the front of the imposing college building in order to make the two-mile hike to Marilyn's house.

The group was buzzing but, unfortunately for them, news of their excursion had reached more than just the youngsters. Marching on to the campus came college principal, Ted Marshall, who pleaded with the students to abandon their plan and go home. A few members of the group heeded his warnings, but most were far too animated to even think about cancelling. So, instead of listening to Marshall, they skulked past him and into the road.

As the students headed away from the Cooper's Hill campus, one attendee was still inside. Realising that he was running late and needing to catch up, the enterprising student hopped into Principal Marshall's Jowett Bradford estate car and zoomed off down the drive. The vehicle was stopped by police shortly afterwards, and the driver asked his name. 'Ted Marshall,' he replied, before continuing his journey. The car was later found abandoned near Parkside House, much to the chagrin of Mr Marshall, who apparently 'went wild, and threatened all sorts of sanctions'.

By the time the group turned into Wick Lane, it was dusk and their excitement had reached fever pitch. Chants of 'We want Marilyn! We want Marilyn!' could be heard echoing down the lane, before finally they reached the locked gate of Parkside House. Had the students anticipated that the entrance would be secured? Probably, but that was not going to stop them.

One youngster told reporters that they lifted the weighty gates clean out of their hinges and laid them flat on the floor. When asked how the gates were back in place when the police arrived, he claimed that they had replaced them before leaving. More likely – but less dramatic – was that the group merely climbed over the gates instead of lifting them off altogether. They then tiptoed up the winding driveway in their gym shoes and, with no sign of

Marilyn's security team, the lads found themselves at the front of the house, and directly underneath Marilyn's window.

'Ready?' whispered one student. The group nodded, cleared their throats and then proceeded to sing Psalm 23.

> The Lord's my shepherd; I'll not want.
> He makes me down to lie
> In pastures green; He leadeth me
> The quiet waters by . . .

Inside her bedroom, Marilyn was in bed with Arthur Miller. The sound of the voices came floating into the room, waking the couple and prompting them to move to the window. Looking down on the spectacle outside, they were surprised to see the group of students, singing, blowing trumpets and brandishing a football rattle. Marilyn was baffled and touched, and wondered if she should go down to see them. Miller assured her that it would go against everything they had been told by their security team, though where they had got to now was anyone's guess.

Psalm 23 exhausted, the students then burst into a rendition of the satirical song 'The Vicar of Bray' before returning to their chants of 'We want Marilyn!' Still nothing stirred in the house, and the young men grew impatient. One loud-mouthed youth had had enough, and shouted that if Marilyn didn't come out to wave at them, 'we'll burst into the place'.

This ambitious declaration was enough to confirm to most of the group that they should probably return to college. The young men shouted goodnight to the closed windows, and then sang to themselves as they backed off down the drive. Before they could reach Wick Lane, however, they were disturbed by police sirens in the distance. Someone had tipped them off and, within seconds, patrol cars reached the end of the drive and several coppers came

sprinting onto the property. Most of the young men scattered into the vast garden, defying the whistles and cries of 'Stop!' before finding their way through the hedges and fences and out to the street.

One former student, Allan R. Pemberton, remembered being terrified that he might be arrested for trespassing, and so hid in some long, damp grass. 'I got soaking wet and I recall clearly seeing the searching lights being scanned over the area where I was hiding. I'm not sure how long I remained in hiding, but when I thought it safe, I returned to the college, where quite a few of the group had already returned.'

Most made it back to Shoreditch in record time, but quite a few students were still missing when the staff checked for absences later that evening. They eventually returned: damp, exhausted, but with plenty of tales of escaping the police by tying handkerchiefs over their faces and hiding in bushes, trees and undergrowth.

The next morning, Principal Ted Marshall called an assembly and told the students how furious he was that they had disobeyed his orders not to visit Parkside. The telling off garnered nothing more than a few sniggers from the crowd, and one former student, Donald W. J. Foot, remembered that, 'those who participated were quite unabashed'.

Unabashed or not, the young men would not attempt anything so ambitious again, but housekeeper Dolly Stiles recalled that the students remained obsessed with Marilyn for some time afterwards, and could frequently be seen hovering around the gate, along with the regular schoolchildren.

Now that Marilyn had been in England for a couple of days, the press conferences ceased and she expected to be able to get on with her work in relative privacy. However, pressmen all over the country had no intention of leaving the actress alone, and seemed to think that public appearances and interviews should become an

everyday occurrence. When it became clear that this was not going to happen, there was a definite shift in how some newspapers wrote about her.

The Times decided not to dwell on the superstar's arrival at all, though the reasons were not clear. Journalists from the *Daily Mirror* were furious and accused the broadsheet of stuffiness: 'The Times did not trust its readers with the news that The Wiggle had reached London,' it said, before complaining that there was a mammoth review of a bulb grower's catalogue, but not a single word about the actress.

The Times was not the only newspaper that remained indifferent to Marilyn's presence. On the day of the actress's arrival, Prime Minister Anthony Eden had given a speech on the subject of national poverty. Eden had pondered that the struggle against inflation was 'the new Battle of Britain', and worried about the country's position in terms of world trade. 'The increased competition in the export market is having serious consequences for some industries,' the prime minister said.

The speech was a serious one, but it was Marilyn who had stolen the headlines the next day, and the *Western Mail* despaired: 'Since then she has been given more newspaper space than is normally accorded to volcanic upheavals, floods, tempests, pestilence, famine and all similar "acts of God".'

One female reporter – Winifred Carr – was not impressed with how male journalists had behaved during the Savoy press conference, and accused them of acting, 'like a bunch of uncouth adolescents'. According to Carr, she witnessed even the most hard-boiled reporters hanging on to Marilyn's words and laughing at her jokes before she had even finished talking. But while Carr was appalled by the men, she did give credence to Marilyn for breaking the modern rules and using a mixture of wit and childlike innocence to mesmerise the press pack.

Carr did not particularly care for Marilyn's outfit, but her slight criticism was nothing compared to what fashion columnist Jean Soward had to say. In an article entitled 'Marilyn so Dowdy', Soward not only condemned Marilyn's look, but also gave a point-by-point critique of what had gone wrong. The article claimed that the actress's arrival outfit 'looked as though she had slept in it, with a skirt so tight she could hardly stagger across the tarmac.' According to Soward, the net midriff of Marilyn's Savoy dress apparently showed off a spare tyre, while even the sensible suit worn at the next event won no style points, primarily because of the black satin blouse.

The 'Dowdy' article caused something of an international incident and the New York Post, the New York Daily News and Hearst's Journal-American all printed rebuttals in their papers. Britain was branded ungrateful, and photographs of Jean Soward were printed and dissected. Readers wrote in to defend Marilyn's honour, and then fashion designer Ceil Chapman stepped in to tell Soward that the actress's low-cut gowns were her uniform, and she would look ridiculous in dresses made for the likes of Grace Kelly.

Several American reporters contacted Marilyn at Parkside House and asked for a comment. The actress told them that she dressed to please men, and then added that any woman who says she dresses to impress other women is only fooling herself. When a reporter questioned her grammar, Marilyn replied, 'I believe I manage to get my message across.'

Soward's colleague Bruce Rothwell stepped in to defend his fellow reporter. 'Take courage, Jean!' he wrote. 'To hundreds of American reporters your criticism came as a breath of fresh air after years of propping up a legend.'

Leonard Rees from Bedwas in south Wales no doubt agreed with Bruce Rothwell's opinion. Frustrated by all of the press attention, he wrote a letter to his local newspaper. 'Why all this fuss about Miss Marilyn Monroe?' he demanded to know, before declaring that she

was subpar compared to the women of Wales. He recommended that fellow readers take a walk around the parks of Cardiff, 'and then Miss Monroe will be forgotten'.

After the excitement of the press conferences, Marilyn began Tuesday 17 July by studying her script. Then, in the evening, Olivier met the Millers at the Lyric Theatre in the West End, where Vivien Leigh was performing in *South Sea Bubble* by Noël Coward.

The play opened at the theatre on 25 April, but by the time Marilyn landed in England, Leigh had announced her impending departure due to her pregnancy. Outwardly, Coward was delighted that the actress was going to have a baby but, in the privacy of his diary, he fumed. He couldn't understand why she and Olivier had waited to tell him the news, and was frustrated that he would have to find a new star for his play. He also feared that Vivien's age would go against her, and should anything happen to the baby, it would surely affect her already fragile mental health. But despite Coward's foreboding, he sent a loving telegram to the Oliviers, and Leigh continued to play out the remaining dates of *South Sea Bubble*.

The appearance at the venue was supposed to be a quiet one, but as soon as fellow theatregoers and passers-by noticed Marilyn -- wearing a flesh-coloured dress and raincoat – word spread. By the time the stars took their seats in row J, most of the audience was in a state of excitement and curious crowds were already gathered outside the theatre.

Milton H. Greene's wife Amy had accompanied Marilyn on many theatre visits in New York, and spoke about the experience almost a year before the London trip: 'Between acts, everyone talks to her. People will call down from the balcony to say they either like her dress or that they don't like it. Or that her hair looks lovely. Or that they have enjoyed her pictures. And she answers them just as though she had known each one, personally, all her life.'

The night at the Lyric was no different. Despite Vivien Leigh being on stage, many eyes strained to catch a glimpse of Marilyn instead. As the play finished, Leigh took her bow, the lights went up, and the audience greeted Marilyn as though she were the star of the play. The actress waved back, and then she, Miller and Olivier were shuttled backstage for a get-together in Vivien Leigh's dressing room.

Arthur Miller wasn't impressed with the production, and later told his friend, the Broadway theatre producer Kermit Bloomgarden, that plays such as *South Sea Bubble* were crude and not well performed. He even expressed his doubts about the production to Olivier, though thankfully the actor took it in good fun, and even seemed to agree with Miller's prognosis.

As Marilyn, Arthur, Vivien and Larry converged on the dressing room, a huge crowd surged around the theatre. With Marilyn's chauffeur-driven Humber Pullman parked at the stage door and Olivier's Bentley at the front, fans had no idea where to wait, and so packed themselves wherever they could find a space. Reporters and the curious tapped on the window of Marilyn's car and demanded that the driver reveal what the plans were for the rest of the evening. Her beleaguered chauffeur wound down the window. 'Honestly,' he said, 'I don't know where I am going from here.'

By this time, it was estimated that at least one thousand people were ambling around the theatre, and staff locked the doors and called the police. When four vans arrived, a pathway was cleared from the front of the theatre to Olivier's car, and at 10.50 p.m., Marilyn and Arthur Miller emerged hand-in-hand from the doors, and Olivier and Vivien followed close behind. A massive cheer went up around Shaftesbury Avenue, fans rushed forward to get a better view, and the actors dashed into the waiting Bentley. As it took off, crowds flooded into the road, causing a traffic jam, and Marilyn's chauffeur was left floundering at the stage door, dealing with reporters who accused him of being a decoy. Twenty minutes

later, the group arrived at Olivier's Lowndes Place apartment for a late dinner, before Marilyn and Arthur headed back to Englefield Green at 2 a.m.

As well as acting in *The Sleeping Prince*, Marilyn also had to sing a song and perform a small dance. In order that she could practise both at home, the actress enrolled the services of a young music student called Alan, who would play the piano at Parkside. It had been Dame Sybil Thorndike who recommended the young man to Marilyn's representatives, and so one day, early in the England trip, Alan arrived at Parkside for the audition. He was nervous and unsure as to how the Hollywood star would receive him, but was pleasantly surprised: 'Marilyn was sitting on the sofa with her legs tucked up under her. As I went in, she gave me that wonderful smile, uncoiled gracefully and came towards me. She put out her hand, took mine and said softly, "Hi, I'm Marilyn!" Her manner was so sweetly shy and modest that I felt instantly at ease. She was such a pleasant and thoroughly nice lady.'

Another Brit to meet Marilyn early in the trip was Jeanne La Chard, who worked for the Arthur P. Jacobs company. 'Officially, I was called a press officer,' La Chard wrote. 'I was in fact a general dogsbody.' Because she was the only British woman on the team, La Chard was targeted by Marilyn. 'I found myself regarded as the authority on all things England,' she said. As such, she was expected to advise her new boss on where to find the best hotels, restaurants, hairdressers and other establishments. La Chard's job was often thankless and stressful, though fifty years later, she had come to see it as an 'hilarious and extraordinary' experience.

Someone who did not find the period hilarious was Laurence Olivier, who was about to embark on rehearsals with his leading lady. On 9 June 1956, just over a month before Marilyn's arrival in the UK, Olivier received a letter from Joshua Logan, the director

of the star's latest film, *Bus Stop*. They had worked successfully together, but Logan had learned many lessons during this time. In the letter – written with Marilyn's knowledge – Logan offered some of what he had discovered. Mainly, to never shout and to be aware of the presence of acting coach, Paula Strasberg.

The director also gave pointers on the personality and working practice of Marilyn's business partner Milton H. Greene, and told Olivier that he should be aware of the photographer's producing ambitions. This was already a hot topic in various newspapers at the time, and one reporter – Milton Shulman – took it upon himself to ask Greene what his qualifications were to produce a movie. 'I got intelligence and taste,' Greene said, 'and you can't buy that in a candy store . . . What I don't know, I ask.'

Olivier sat at his desk in Lowndes Cottage and read Joshua Logan's letter over and over again. He underlined passages of particular note, and then wrote back to say that he had found the letter illuminating and had digested everything. He couldn't imagine ever yelling at Marilyn, though did understand how hard it could be to learn patience. He also told Logan that he was so concerned that Marilyn would be in a strange country with no friends that he had thought about asking one of his female pals to step in. With this in mind, he was rather happy that Paula Strasberg would be in England, if only to provide companionship. Time would tell how joyous Strasberg's appearance would prove to be.

On 20 June, Logan wrote back to Olivier and shared more information about the way Marilyn worked. He stressed how important it was to keep the cameras rolling, as the actress was apt to turn off as soon as the camera did. Olivier should never be hesitant to ask her to speed up, but he should also note that if she forgot her lines, it was mainly because she was angry at her performance. Marilyn was also prone to fear, and if she didn't respond to direction, it was because she didn't understand what the director required.

If this was to happen, Logan suggested Olivier explain the request again, and Marilyn would oblige.

Although Olivier vowed to absorb everything Logan had told him, the actor/director went into his relationship with Marilyn with a great deal of naivety. For years, she had been known for her lateness and poor behaviour on set. The frequent illnesses were a given, and so too were her extreme anxiety and habit of refusing to come out of her dressing room.

Yet in spite of the past evidence, and Logan's instructional letter, Olivier's ego seemed to have assured him that this time it would be different; that he would be the one who could control Marilyn's emotions and shoot everything without fuss. He shared Logan's advice with some of the crew working on *The Sleeping Prince*, but pretty much decided to go it alone in terms of his own approach. History would prove that to be a huge mistake.

The first day of rehearsals fell on 18 July 1956, when emphasis was placed on hair, wardrobe and make-up tests. There had already been a run-through with stand-in, Una Pearl, but now it was Marilyn's turn to see the hair and make-up styles that would help her to create the character of Elsie Marina. The actress's regular make-up artist Allan 'Whitey' Snyder was on-hand to work with Tony Sforzini, and hairstylist Sydney Guilaroff was flown in to look over Gordon Bond's planned hairstyles. All tests would be overseen by Milton H. Greene, and although Olivier was not particularly happy that the photographer was already supervising proceedings, he nevertheless grudgingly consented.

That morning, Marilyn left Parkside House in her chauffeur-driven car and, as she reached the end of the drive, noticed several photographers poised with their cameras. Peter Woods from the *Daily Mail* was one of those present, and later wrote that the actress, 'pouted, crossed her legs, covered her face with her hands and the car shot off towards Pinewood'.

Marilyn could have done without the press attention on her first day at work, and in the months ahead a young woman called Jean Bray would be the reporters' first official contact. Bray had previously worked for the *Daily Herald*, and the Marilyn job came to her in an unexpected way. One afternoon in May 1956, Jean was enjoying lunch in a local pub when she was approached by publicity agent Philip Ridgeway.

The man asked if she would like to work for Marilyn during the making of *The Sleeping Prince*, but Jean thought he was joking, and her first reaction was to say, 'Don't be stupid.' However, Ridgeway explained that he was overseeing public relations for the movie as, at that time, publicist Arthur P. Jacobs was not expected to be in England for production. Jean realised that Ridgeway was serious about the job, so thought about it, and ultimately said yes. It was to be a busy summer, and Marilyn would be her most important client until autumn, when Jean's attention turned to actors Esther Williams and Errol Flynn.

'Marilyn was everything,' said Jean. 'She was a remarkable woman; beautiful and easy to get in touch with. She was intelligent and witty . . . Very good at inventing one-liners. People don't understand that about her, but she was.

'My job was a "tweeting" role – the newspapers would call me up and ask "What does Marilyn think of this, or what does she think of that?" They wanted to know where she was going, what she was doing. I was not allowed on set because of the unions, and this made my job very difficult, and it was a pity for Marilyn, because we weren't able to really work in person. I was unable to get close to her, which was disappointing because I always felt that she needed somebody with her on set.'

Believing that she could be of support to Marilyn if she was allowed into Pinewood, Jean offered to join the 'proper' union, but was told it would take weeks for her to be accepted – if she was at

all. 'I believe I could have really helped Marilyn,' Jean said, 'if I had been allowed to have more access to her.'

Marilyn embarked on her first day at the studio just as a blonde woman attracted attention while feeding ducks in Stratford-upon-Avon. Ever since the actress had mentioned her desire to travel to Shakespeare country, fans had hoped to see her, and now here 'she' was, throwing bread into the river. A curious fan went closer, and sure enough, she had the definite look of Marilyn, and the nearby chauffeur-driven Rolls-Royce seemed like a clue. One fan told another and, before long, Stratford residents buzzed that Marilyn could be paying them a visit.

One of the bosses at the local railway goods office was running errands when he saw a crowd gathered in Hemley Street. When he asked what was going on, he was told that Marilyn might be in town, though even the local police couldn't say for sure. The railway boss went back to work and told his nineteen-year-old clerk, Brenda Porter, about the crowd and the rumour. She was so excited she asked for permission to leave the office, and ran all the way to Hemley Street.

'There were quite a few people in the crowd [and] we all stood and waited for quite a while when a chauffeur-driven car drew up outside Shakespeare's house. A lady got out of the car and the crowd tried to cross the road to see her. There was no one with her, [and] she took video pictures of Shakespeare's birthplace, but very quickly got back into the car. People in the crowd said it was not Marilyn. I can't honestly say if it was either.'

Some fans were hesitant to dismiss the woman straight away, and clung on to their hope that it was actually Mrs Miller in the car. It wasn't, of course, but they swooped on the chauffeur and demanded to know who she was. The driver assured them that the woman was not Marilyn Monroe, but Mrs Horace Dodge of Windsor. Fans were

not satisfied, but the driver refused to answer any more queries, wound up his window, and then he and his passenger disappeared from Stratford.

Back at Pinewood, three young men embarked on a VIP tour of the studio. Somehow, they had got the impression that Marilyn had specifically asked to see them, and as they strolled around the props department and the grounds, they wondered when they would be shown to the actress's dressing room. Unfortunately for them, the nearest they got to meeting a real-life actor was when they were allowed a few minutes on the set of Donald Sinden's latest picture. After that, the three men were shuttled out of the gate, where waiting reporters were keen to ask if they'd spotted Marilyn. Model Charles Macarthur Hardy spoke on behalf of the whole group.

'I suppose if we'd stopped to think, we'd have realised that Miss Monroe had probably never even heard of us,' he said, before adding that he'd just have to tell his grandchildren about the time he met Diana Dors, instead.

Hardy and his friends weren't the only ones trying to infiltrate rehearsals. Reporter Lorna Thomson managed to get past the large stop sign at the Pinewood gates, and found herself in the corridors leading towards the rehearsal rooms. The studio seemed to have an aura of anticipation about it, and a group of clerical staff clattered down the stairs because they'd heard Marilyn was hosting a meeting nearby. The young women sprinted outside, loitered under a window, and strained to hear what was going on inside. Several minutes later they gave up and returned to their desks, just in time to miss Marilyn, who was wandering down the corridor with Laurence Olivier and a consort of studio police.

'I saw her,' Thomson wrote. 'A tiny figure in a tight stone-coloured dress, a cardigan carelessly thrown round her shoulders, a huge pair of dark glasses hiding her eyes, no make-up, and a lanky wisp of blonde hair escaping from under a print headscarf.'

* * *

On 19 July, a table reading of *The Sleeping Prince* was scheduled, and when Marilyn walked into the room she was met by Olivier and the rest of the cast. For anyone working in a foreign country, this would be intimidating enough, but for Marilyn it was made worse because many of her new colleagues already knew each other, and some had worked together on the stage production of *The Sleeping Prince*.

Given the advice he'd received from Joshua Logan, these issues could have been overcome quickly. However, when Laurence Olivier introduced Marilyn to the team, he did so in a way that she considered condescending. Explaining that it would take her a while to get used to the way they worked, Olivier told the company that Marilyn's acting technique was vastly different to the ones her fellow actors had learned in England. His snobbish attitude shocked the actress, and she was immediately on edge. She later told journalist W. J. Weatherby that even though Olivier appeared to be friendly, he came across, 'like someone slumming'.

For the past year, Marilyn had attended the Actors Studio, a drama school in New York headed by Lee Strasberg. The studio was famous for 'The Method', a technique where the student completely immerses themselves in the roles they play. Marilyn believed in the Actors Studio's philosophies, and relished being a spectator at the studio and taking part in private lessons with Lee Strasberg. She had recently acted a scene from the play *Anna Christie*, and it went down as one of the most attended and successful scenes ever performed at the studio.

In spring 1956, Marilyn spoke of her studies to journalist Dick Kleiner. 'It was very stimulating,' she said. 'I find it stimulating to be stimulated. I've learned a lot. I've still got a lot left to learn. What I want to do is grow, develop and expand . . . I mean I want to widen my range.'

The Actors Studio may have been popular in the States, but it was not so in London. Trained through repertory theatre and years of solid acting studies, many people working in the British industry wondered what the fuss was all about.

'To espouse the Method in London,' wrote theatre director and playwright Charles Marowitz, 'is to preach paganism in the heart of Vatican City. People will not stand for it.' He decided that the acting technique was 'the mid-twentieth century's favourite running gag', and predicted it would stay that way.

Not surprisingly, Olivier – with his long association with the theatre – was one of those who remained unimpressed by the method, and those who lauded it. He had read books on the subject and didn't mind those who wished to study it, but at the same time was of the steadfast opinion that the technique should be left at the studio door. Since Marilyn was fully immersed in the method, the chances of that happening were zero.

Another obstacle was Lee Strasberg's wife Paula. While Olivier told Logan that he appreciated Marilyn bringing a companion, the actor/director didn't realise how hard it would be to work on the same set as the coach – especially as her techniques were all method related. As they sat around the rehearsal table, Olivier would recommend Marilyn approach a scene in a particular way, and she would look straight at Paula. Instead of explaining what Olivier required, the coach would offer advice such as 'Just think of Coca-Cola and Frank Sinatra,' or something equally nonsensical.

When Paula had arrived on the set of *Bus Stop*, people wondered what on earth she was doing there, and why Marilyn would rather trust her coach than her director. Paula told journalist Dorothy Manning that she sometimes wondered that, too. 'If I didn't believe that Marilyn had real talent, I wouldn't be here . . . She has extraordinary range – nothing she does seems beyond her. She can give a great deal, if she's allowed to.'

* * *

Rehearsals had got off to a shaky start, and Marilyn already found herself on edge. Sound recordist John Mitchell witnessed how strained things were at the beginning, when the actors rehearsed a seduction scene. The floor was marked with lines showing where different props would be, but it seemed to Mitchell that Marilyn was confused. She asked if her lines could be typed onto cards, and knew so little of the script that the soundman wondered if she had read it at all. That rehearsal was deemed so stressful that the company never went back into that particular room again; the memory of it was just too traumatic.

Alan, Marilyn's Parkside pianist, was not present at rehearsals, but once filming began he visited the set on several occasions. He was told to, 'stand over there and don't breathe', but was still able to see first-hand just how hard it was for Marilyn to accept Olivier's way of working.

'Olivier ran a very strict ship,' remembered Alan, 'as though he was working in the theatre, with rehearsals etc. Everyone was curious to see what Marilyn was like, but some were "sniffy" and thought Marilyn was wrong and amateur because she wasn't from the West End. They had all worked with Olivier before and felt that it was like putting on slippers, but Marilyn just wasn't used to working like that.

'Marilyn kept to herself on the set,' Alan said. 'She would have liked to have mixed with the others but there was a barrier there. She went into it wide-eyed, looking at Olivier as "my hero" but she got very upset by him and felt a lot of contempt for him and the other cast members who never went out of their way to be nice to her.'

In an effort to know her lines and understand the part of Elsie Marina, Marilyn got into the habit of bringing two tiny notebooks into the rehearsal rooms – one blue and one red. Her colleagues

would often see her jotting notes into the books, and on random pieces of paper, but despite the preparations and study, rehearsals would remain a stressful period for all involved.

Chapter Four

Thank You for the Moon

O n her arrival in England, Marilyn expressed how much she wanted to meet two people – poet Dame Edith Sitwell and dramatist Sean O'Casey. The latter was thrilled to hear this news, and told the *Stage* newspaper, 'I would love to see her, and I would like to meet her husband, Arthur Miller, one of the greatest American playwrights.' In the end, despite an invitation to O'Casey from Laurence Oliver, Marilyn was unable to meet him, though she did manage to spend time with Sitwell.

Talking to a reporter from the *Daily Mail*, Sitwell said that although she was currently busy with her work, she would be thrilled to see Marilyn while she was in London. 'She is a delightful girl,' Sitwell said. 'But I can't say when or where we shall meet. If I knew I wouldn't tell you. I don't want a lot of strangers there.'

Marilyn had met Sitwell in 1953, and although the two seemed very different, they found they had a great deal in common. Like Marilyn, Dame Edith had gone through an unsteady childhood. Brought up by uncaring parents who always seemed to have an insult or hurtful comment to share, Sitwell had put up many barriers, which were often hard to penetrate. She could terrify the staunchest of interviewers, but had warmed to Marilyn as the

two shared enthusiastic views on authors, books and philosopher Rudolf Steiner.

By the time the two women said goodbye, they had formed a bond. Marilyn admired Dame Edith's strong personality, especially when it came to standing up to men. Dame Edith, meanwhile, decided that Marilyn had been treated terribly in the industry, but remained enchanting nevertheless. From that moment, Sitwell became a staunch supporter of Marilyn's life and career. 'Of course, I'd be delighted to play literary mother to her,' Sitwell told reporter William Barbour. 'Marilyn is a very seriously minded girl.' To another writer she disclosed that, 'If anybody deserves credit she does. Once a poor girl with no education, on her beam ends – and now look how she has got on.'

Marilyn was thrilled to hear that Dame Edith would like to spend time with her in London, and columnist Eve Perrick offered to arrange it on the understanding that she could be present for the chat. And so it was that sometime during the weekend of 20 and 21 July, Marilyn and Arthur were driven from Parkside House, and taken to the Sesame Imperial and Pioneer Club, located at 49 Grosvenor Street. During the journey into London, the chauffeur took the opportunity to show them two of the Queen's residences: Windsor Castle and Buckingham Palace. The extended journey meant that the couple were forty-five minutes late, but Marilyn was so in awe of the palaces that they were one of the first things she mentioned during her conversation with Dame Edith.

The poet greatly enjoyed spending time with Marilyn once again, but she had made the unfortunate decision to take the meeting in the busy lecture room, rather than in her private quarters. Suddenly, people who would not normally visit the room felt the need to pop in and read their newspapers and books, all the while trying discreetly to catch a glimpse of the famous visitors and overhear their conversation.

Despite the intrusion, the group enjoyed a genial get-together, during which time they drank gin and grapefruit juice, and Marilyn shared stories about the ongoing arrival of bicycles at Parkside House. Arthur thanked Dame Edith for being so kind to Marilyn when they had met three years before, and then the poet introduced her nephew Reresby, who was so overcome that he gave Marilyn a small bow.

Sitwell even entertained her guests with tales of how she had once met Edward VII at her first court ball, which caused Miller to burst into whoops of laughter. Onlookers gazed over their newspapers and adjusted their glasses, but they did not get to meet the famous visitors. Instead, Dame Edith introduced Marilyn to some of the club staff, and then it was time for the Millers to hop into the car and head back to Parkside.

'You see what a nice, quiet girl she is?' Dame Sybil asked her nephew, as they waved the Millers goodbye. On another occasion she commented, '[Marilyn] knows the world but this knowledge has not lowered her great benevolent dignity, its darkness has not dimmed her goodness.'

Another meeting that weekend was with cinematographer Jack Cardiff, who visited Marilyn at Parkside House. As he rolled up to the gate at 10 a.m., Cardiff was shocked when a team of security men sprung out and demanded to see an official Marilyn Monroe Productions pass. He later described the experience as being harder than getting into Buckingham Palace, and by the time he was cleared and waved up the driveway, the cinematographer was in a foul mood.

He had plenty of time to calm down, however, as Marilyn wasn't yet out of bed. Cardiff spent the next thirty minutes chatting with Arthur Miller, and then eventually the actress appeared, barefoot and wearing a robe. Marilyn rushed into her husband's arms, and when she finally noticed Cardiff, she didn't speak to him directly.

Instead, she turned to Miller and told him how lucky she was that Cardiff would be working on her movie. 'He's the greatest in the world,' she murmured.

After the meeting, the two became great friends, and during one evening (it should have been morning, but Marilyn was late) Cardiff took photographs of Marilyn at Parkside – one of which became Arthur Miller's personal favourite. Later, when the cinematographer presented Marilyn with a volume of poetry by Dylan Thomas, she was overcome with happiness. A great lover of poetry and literature, the actress could often be seen absorbed in the book during breaks on the set of *The Sleeping Prince*. During the making of the movie, Cardiff would discover that his new friend was not the easiest person to work with, and several years later he told the *People* that, 'I doff my hat again and again to Sir Laurence Olivier.' But although the cinematographer thought that their work was nerve-wracking, he loved Marilyn, and held their friendship close for the rest of his life.

On the same weekend that Marilyn enjoyed time with Dame Edith Sitwell and Jack Cardiff, twelve-year-old Brian Smith from Kent donned a slit dress, high-heeled sandals, blonde wig and false eyelashes, and then headed off as Marilyn to the Minster and Monkton Flower Show. There he impressed judges Paul Carpenter and Kim Parker, who voted him the winner of the over-tens fancy-dress competition, and he got his photo in the local paper. Brian wasn't the only little boy to take inspiration from Marilyn. Several weeks later, young Fred Greenway from Cwm, Wales, entered himself into the boys' and girls' fancy dress competition at the Ebbw Vale Urban Council's fete and carnival. He not only received many cheers, but also won as Cwm's very own Marilyn Monroe.

And so started a summer of Brits, young and old, doing everything they could to be just like Marilyn. Keen to be able to emulate the star's sultry walk, young women began studying her films and news

footage in the hope of learning how to do it. London dance instructor Robert Howes heard about the craze and saw an opportunity. On 23 July, Howes announced that he and his fiancée Jean Turner had written a pamphlet, which broke down 'the Monroe walk to a series of foot and hip movements . . . I want to prove that what Marilyn Monroe can do, British girls can do as well, or better.'

Jean had discovered that she could move like the actress while dancing the rumba with Howes, and had spent the past several weeks perfecting the movement. She told a reporter that she felt self-conscious practising it in the supermarket, but would feel better if everyone else did it too – hence the need for a pamphlet presumably.

Marilyn would have found the idea of an instruction manual amusing and bewildering. 'All that stuff about how I wiggle when I walk is silly,' she said. 'I just walk. Like anybody else. I've never tried to walk any special way and I've never been told to walk any special way. I walk naturally. I've always walked the same way.'

Rehearsals for *The Sleeping Prince* struggled on and, at the same time, Marilyn was inundated with invitations for events, parties and galas. There were rumours that she would turn up at the wedding of Barbara Lyon, daughter of Ben Lyon, the man who gave Marilyn her first film contract. They proved to be false, as did the story that she would bowl the opening ball at a cricket match, and then head up to Scotland to visit the hills and lochs.

Captain D. E. J. Cooper, Arbroath's publicity and entertainments officer, thought it would be a tremendous idea to have Marilyn attend an extravaganza in Victoria Park. He assured the Millers of a warm welcome, and ended his invitation with the words, 'Bless you both for helping to lift this troubled world of ours out of the eternal rut of strife and conflict.' The response from Marilyn's people was disappointing but inevitable – her schedule simply wouldn't allow a trip to Scotland.

Not to be put off, Skegness businessman Harry Segal was sure he could persuade Marilyn to open his new jazz club in the town. Despite his enthusiasm, the actress could not make it to the Lincolnshire coast, and the opening ceremony was hosted by comedian Benny Hill instead. Meanwhile, the residents of seaside town Morecambe were left in a tizzy when it was rumoured that Marilyn would be present to switch on the illuminations. When approached for a comment, one of the actress's agents denied all knowledge, claiming that no invitation had been received, let alone accepted.

'I do not think she can possibly cope with it,' he said. 'She is at the height of her filming at that time and will be working solidly five days a week . . . There is no question of her not wanting to do it. It is merely a question of her not being able to do it.' However, rumours created fantastic publicity for *The Sleeping Prince*, so the agent added that even though he had already received dozens of requests for Marilyn to appear at fetes, bazaars and dinners, if they were invited to the Morecambe illuminations, he would give it a great deal of support. '[It is] a very worthwhile affair,' he said, although, in the end, Marilyn never did switch on the lights in Morecambe or anywhere else.

Builder's labourer Johnny Smith didn't care about the rejected invitations. All he wanted was for Marilyn to meet him and members of the Penge Teddy Boys, to hang out and eat fish 'n' chips for an hour or two. He told reporters that most of his group had Marilyn posters on their walls, and they would love to see how she enjoyed a classic British meal. Johnny dictated his telegram invitation from a phone box: 'Dear Marilyn Monroe, Me and my boys . . . invite you . . . and Mr Miller . . . to be our guests . . . at our local cinema . . . and to join us afterwards . . . at a fish and chips supper.'

It is unlikely that Johnny got to hang out with Marilyn, but one invitation she did accept was on Tuesday 24 July, when Terence

Rattigan hosted a party for the Millers at his home, Little Court in Sunningdale, Berkshire.

The playwright was thrilled to entertain Marilyn, and made plans for a hundred guests, twenty chauffeurs, waiters, a porter and a chef. He ordered forty-two bottles of champagne, two bottles of sherry, five dozen tonic waters, one dozen bottles of Coca-Cola, seven bottles of Gordon's gin and a variety of other drinks, which all came to £103 – the equivalent of over £2000 in today's money. Vivien Leigh was on hand to give suggestions for the food, which consisted of a magnificent lobster buffet.

As Rattigan sat at his desk to compile the guest list, he jotted down names of people he felt would entertain him more than anyone else. He hoped that Marilyn would find the guests interesting too, though he considered that as a definite secondary factor. Once the first draft was done, he then went back through it, scratching people off until he had what he hoped would be an engaging and pleasurable blend of attendees.

The final guest list read like a Who's Who of showbiz royalty. John Gielgud was present, as was Alec Guinness, John Mills, Douglas Fairbanks Jr, Dame Margot Fonteyn and *The Sleeping Prince* actor, Richard Wattis. The Duke and Duchess of Buccleuch were due to pop in, as were Lady Diana Cooper and Dame Peggy Ashcroft. Costume designer Beatrice 'Bumble' Dawson was also on the list, as was Marilyn's hairdresser, Sydney Guilaroff, and journalists Radie Harris and Louella Parsons. Laurence Olivier was credited as a co-host (and would spend much of the evening seeing that everyone had enough to eat and drink), and Vivien Leigh promised to head to Sunningdale after her performance in *South Sea Bubble*.

On the evening of the party, a policeman by the name of PC Packham was installed at the end of the private road that led to Rattigan's home. He was asked to make sure that no uninvited guests made it into the house, and as each car pulled up, he

carefully checked the invitations, and then allowed the guests onto the property.

What PC Packham hadn't been told was that Marilyn didn't need an invitation, since she was the guest of honour. When her car swung into the lane shortly after 10.30 p.m., he waved it down and asked to see the paperwork. What happened next came as quite a shock to the unsuspecting policeman: 'Some lunatic immediately leapt from the nearside front passenger seat and, actually brandishing an empty wine glass in my face, told me aggressively to get out of the way. It was, to say the least, an unusual greeting; neither did his arrival inspire confidence regarding the other occupants of the car. I relieved him of the wine glass and was desirous of knowing what precisely he was up to.

'"It's Marilyn, you fool," he hissed, "get out of the way."

'Of course! In a blinding flash of the absolute obvious the penny dropped. Everyone in England must surely have known that Marilyn was in town. The tabloids were full of it. I looked in at the open door of the limo. It was, of course, Marilyn and, had any further proof been necessary, she was accompanied by her then husband, Arthur Miller. I told the driver to carry on, closed the door, and they sped away without the little dogsbody, or whatever he was. He was last seen hoofing it up the long drive to the house, muttering as he went dire imprecations on all coppers.'

Journalists had followed Marilyn from Parkside House and, seeing the altercation, bumped their cars onto the grass verges. By the time they managed to run towards the action, the limo had already sped off towards the house, but they phoned in their stories anyway, weaving a fictitious tale that PC Packham had never heard of Marilyn Monroe.

Terence Rattigan's Little Court certainly wasn't as small as the name suggests. Built in the late 1920s, the white mansion stood so close

to the Sunningdale golf club that it had its own pathway into the grounds. Sir John Gielgud later confirmed that it was the closeness of the course that had prompted Rattigan to buy the house in the first place. Although the home was considered fairly modern, the materials used to build it had a fascinating history. The three-storey house was painted white, but the brickwork was Georgian; the roof tiles were rescued from a demolished house; and the iron railings came from buildings in London. The windows were decorated with green shutters, and enormous chimneys stood at each corner of the roof.

As the Millers' car pulled up outside, the couple were met by ornate hedges, rose bushes and steps leading up to the antique front door, which stood underneath a spectacular pediment. Marilyn had long since been a fan of borrowing outfits from the studio, and the Rattigan party was no exception. She was a vision in white; her dress a rejected gown from *The Sleeping Prince*, complete with a pale blue ribbon underneath her bosom. When Laurence Olivier commented that the outfit looked familiar, Marilyn assured him that he didn't plan on using it in the movie, but she would keep it clean just in case he changed his mind.

With her strawberry-blonde hair worn close to her head and strands of pearls dangling from her ears, the actress sauntered through Rattigan's magnificent home with a fur coat slung over her shoulders. She passed the eighteenth-century carved pine staircase, rescued from a demolished mansion, and then made her way into the back garden. There, the mood was set with strings of fairy lights that glittered in the trees, while flickering candles floated on top of the goldfish pond. VIP guests mingled around the greenery and gossiped in two Regency-style pavilions, while in the large room leading to the garden, a phonograph played romantic music.

Throughout the evening, many of the guests made a subtle beeline towards Marilyn, and she greeted everyone who came her

way. For a time, she sat in a pavilion with Dame Sybil Thorndike – one of her co-stars in *The Sleeping Prince* – and the two shared stories of acting and discussed the ancient Roman poet, Virgil. When Douglas Fairbanks Jr came over, he told Marilyn that they had met once before. She couldn't recall the encounter, promised the actor that she would never have forgotten meeting him, and laughingly surmised that perhaps he was mixing her up with the singer, Marilyn Maxwell. Any tension between Marilyn and Vivien Leigh disappeared for the evening, and the two women had lots to talk about in Terence Rattigan's garden. Together they discussed house-hunting in the country (Marilyn was keen to buy a house outside New York) and pregnant Vivien's relief that she could still fit into her party clothes.

Later, as the sun disappeared, and the garden lights made the evening all the more magical, Cole Porter's 'I Get a Kick Out of You' was slipped onto the record player. Marilyn and Arthur made their way into the dance room, and all eyes were on them as they spun around the floor. When the jazz hit 'I Can't Give You Anything But Love, Baby' came on, hairdresser Sydney Guilaroff asked Marilyn to dance, and then Terence Rattigan taught her his version of the Charleston (or as much as he could, given her tight dress). Shortly after, it was time for Marilyn to make a song selection. She chose George and Ira Gershwin's 'Embraceable You' and danced once again with her husband.

Writer Radie Harris caught up with Marilyn towards the end of the evening, and the two women spoke about the lords and ladies who had been introduced to her. 'It's wonderful,' Marilyn said, 'but I wish I could remember all their names. Someone even asked me whether I belong to the Monroe clan. Why, I've never been to Scotland.'

Sir John Gielgud was another A-lister who met Marilyn at the party, and recalled the encounter forty years later: 'Marilyn wore

an Edwardian dress – she had, I think, worn it in the tests for the film – and she held court in a tent in the garden, where everyone queued up to shake her hand. As I was speaking to her, a rather formidable-looking lady in black suddenly appeared at Marilyn's side and introduced herself as Louella Parsons. Arthur Miller kept at a discreet distance. I had no opportunity of talking further with Marilyn, but remember how graceful she looked, dancing with Terry Rattigan as I took my departure.'

Around 3 a.m., as the evening wound down, Marilyn and Arthur Miller said goodbye to their hosts and headed back to Surrey. Shortly after, the actress sat at her desk and wrote to Rattigan on Parkside House stationery. She had found the evening to be quite magical, and thanked him for his memorable dance, as well as the moon, the trees and the gracious people. Marilyn wasn't the only one who adored the evening. Letters flooded into Little Court that week and many mentioned Marilyn, describing her as charming, disarming and enchanting. Terence Rattigan revelled in the success of the night. 'It was such a friendly party,' he said. 'There was no damage at all.'

Marilyn had won over the Little Court guests, but someone who wasn't so interested was Sir Robert Boothby, who arrived at the House of Commons only to find the chamber half-empty. The debate was supposed to be about foreign affairs, but the other attendees looked bored silly. When Boothby stood up to talk, it was to complain about the lack of people interested in 'discussing the destinies of the human race'. He wondered if anyone in the country was interested in anything but 'racing, cricket, Marilyn Monroe and Jack Spot', a notorious gangster.

Laurence Olivier's life revolved around Marilyn, whether he liked it or not. The actor/director still found rehearsals stressful, and had to deal not only with Marilyn's lack of confidence, but also the

constant interference from drama coach Paula Strasberg. Olivier had believed Marilyn would come to him for advice, but when she only accepted help from Paula, the director grew exasperated.

If Marilyn fluffed her lines, Olivier would urge her to try again, but first he'd have to get past Paula, who by this time was either comforting her student or offering solutions that were the opposite of Olivier's. There were times when the actor/director could not get past Strasberg at all, and found himself teaching her the part of Elsie Marina in the hope that she could pass the information on to Marilyn. Often, if Olivier dared explain directly to Marilyn, she would ask Paula what he was talking about. The actress grew frustrated at Olivier's strict techniques and, in turn, he was infuriated when Strasberg took it upon herself to give negative criticism about his performance. After that incident, the actor referred to the coach as 'that beast'.

In an effort to loosen up her charge, Paula often talked Marilyn through a series of hand exercises. Publicist Alan Arnold was interested to know more, but when he asked about these and other acting techniques, Paula gave a rather odd answer. 'I am here as Marilyn's friend,' she said and then denied having any kind of teaching role. As far as the coach was concerned, she was just there to help Marilyn relax. For someone who was not there as a professional, Strasberg was certainly being well compensated. Records show that she was paid $27,286, and the only people who earned more than her on the entire set were Marilyn ($50,000) and Laurence Olivier (£35,714).

Olivier himself would agree that Paula had no official title. As far as he was concerned, the only person who believed her to be relevant as a coach and adviser was Marilyn. But regardless of what official job title Paula had, it was clear to everyone that the actress valued her opinion far more than Olivier's. Even in the rehearsal room, the director could be seen working on his relaxation techniques,

opening and closing his mouth, clenching his fists and twisting his arms this way and that. At this early stage of working, he wished he had kept Paula Strasberg well away from the studio, but by this time it was too late.

Rehearsals finished on 3 August, and then Britain – and Marilyn – went into a three-day weekend. 'Why Do Fools Fall in Love' by the Teenagers featuring Frankie Lymon, blasted out from the radio, but typical of British bank holidays, the weather remained dull and showery all weekend. It was reported that London and surrounding areas witnessed the coldest August Saturday of the century so far, and if Marilyn had any intention of going out on her bicycle, her plans were surely postponed. Gloomy weathermen announced the risk of heavy showers and thunderstorms sweeping the country, and the great British public grabbed their brollies before daring to leave the house.

Still, the unpredictable weather on 6 August didn't stop dozens of young women from heading to the Norfolk town of Cromer, in order to take part in a Marilyn Monroe figure contest. Set up to the east of the famous pier, the competition consisted of several wooden cut-outs that women could squeeze through to discover if they had the same curves as the actress. 'You may be the Marilyn of this resort,' banners screamed. 'How do you shape? Does your figure fit?' The *Sunday Pictorial* competition toured seaside towns extensively during the summer of 1956, and attracted thousands of spectators, competitors and, of course, Marilyn fans.

On the country's return to work on 7 August, John Morris, controller for the BBC's Third Programme, wrote to ask if Marilyn would be interested in appearing in a radio adaptation of the play *Lysistrata* by Aristophanes, translated by Dudley Fitts. Morris had been interested in presenting the play for a long time, but had never been able to find a perfect leading lady for the comedy about one

woman's efforts to stop a war by persuading her fellow women to withhold sex. Now that Marilyn was in England, his search could stop. Or so he hoped. However, before he received any official notification from Marilyn's representatives, the news of a possible BBC collaboration was leaked to the press. One journalist managed to get hold of Marilyn, who told him, 'I am familiar with *Lysistrata*, and I think it has a wonderful title role. I would certainly like to play it someday, but my commitments in *The Sleeping Prince* make it impossible to consider at the moment.'

She said something similar to *Daily Express* reporter, Cyril Aynsley: 'I am delighted that the BBC has paid me such a tribute. But I am working on my film until November. I start at seven in the morning and do not finish until 6.30 at night.'

Marilyn's comments were published on 11 August and then, two days later, Laurence Evans – an agent at MCA – wrote to John Morris to explain Marilyn's situation. Undeterred, the controller wrote back on 15 August, stating that while he understood the actress had to work on the film, he was hopeful that she would consider recording the show at a later date. He received no reply.

On the morning of 7 August – the day that John Morris sent his first letter to Marilyn – the actress exited Parkside House wearing a brown pencil skirt, white shirt and no make-up. Climbing into her chauffeur-driven car, Marilyn was whisked off towards Pinewood for the first official day of shooting. The actress was due at the studio for 6.45 a.m., but when her car pulled in twenty minutes late, it was an eerie sign of things to come. During the four-month shoot, there would only be a few occasions when she arrived on time, though in comparison to some days, twenty minutes late was something of a miracle.

Marilyn was shuttled straight into the make-up department, where she found dozens of good-luck messages, and drank a glass of

milk. Bizarrely, this innocent refreshment caused raised eyebrows later in production, when some claimed that Marilyn was obsessed with milk and drank at least half-a-dozen glasses a day. Would-be medical 'experts' even wondered if that was the reason for some of her health problems, though this claim could never be proved.

Continuity supervisor Elaine Schreyeck encountered Marilyn in one of the Pinewood corridors, and wasn't too impressed: 'A lady rushed past wearing a raincoat, with her hair all over the place. I wondered, "who is that?!" Then I saw her on the set, all dressed up and thought she looked lovely. She looked so young. Like a little girl.'

A *Daily Mail* journalist and photographer also caught sight of Marilyn. They were in Pinewood on business, and as they wandered down one of the stark corridors, Marilyn walked towards them in full costume. The men couldn't believe their luck, and Edwin Sampson lifted his camera and snapped a photograph. Startled, Marilyn hurried on while her security guard, Roger Hunt, leapt forward, detained the photographer and called the studio police.

The men were furious and tried to reason with the guards, but to no avail. The camera was confiscated, the plate developed straight away and then – despite it showing more of Hunt than of Marilyn – the photo was censored by Olivier. The men were removed from the studio. The story was soon broadcast around the country, and reporters were furious. The *News Chronicle* said it understood that Marilyn needed respect, but this was going too far. 'The camera is always suspect in countries ruled by a dictatorship . . . But not, as a rule, in Pinewood Studios. If we are now to have a celluloid curtain, the ultimate inanity has been achieved.'

Part of the reason for the over-reaction to the photographer came from the fact that Olivier had closed the set to everyone except approved visitors. A huge sign, installed at the door of Stage A, read, *'THE SLEEPING PRINCE* – NO VISITORS ALLOWED ON

THIS STAGE UNDER ANY CIRCUMSTANCES', and it was expected that nobody would dare do otherwise.

This decision angered journalists who wanted to visit the set, and things were made worse when the news trickled out that Milton H. Greene and hired photographer Leslie H. Baker were both able to take as many behind-the-scenes photos as they liked. Reporters wondered if the closed set was purely because of Marilyn, but actually it was Laurence Olivier's decision to keep everybody out.

Demanding privacy on set had been a habit of Olivier's ever since he had acted in and directed *Henry V* (1944). Visitors had been allowed on the set of that particular movie, and although they caused no specific disruption, the actor/director had found himself conscious of their presence. He'd had to shoot scenes again, and had banned visitors ever since, though now he stressed that this policy was as much for Marilyn's sake as his own. Unfortunately, in the case of *The Sleeping Prince*, this closed-set scenario only seemed to complicate matters, and there were many instances when reporters and random Pinewood guests would try to infiltrate Stage A, purely for a glimpse of Marilyn.

One such altercation came when an enterprising fan connived with a press photographer to get onto the set. The plan failed, but not one to give up, the fan then dressed as a window cleaner, complete with overalls, and climbed onto the roof, hoping for a glimpse of Marilyn in her dressing room. How he expected that to work was anyone's guess, but he seemed to think it was worth a shot.

The scene to be filmed during the first day was in the Prince Regent's embassy living room. It was a grand set, full of expensive furniture and fittings: a deep pink sofa and chairs, thick red carpet, gold-framed pictures, a chandelier, arrangements of flowers, a standing lamp, and a desk full of the Prince's paraphernalia. But

even with these glamorous surroundings, it was Marilyn who stood out the most. 'She looked so glamorous that even the hard-bitten film technicians gasped with admiration,' revealed one on-set spy.

During this scene, Elsie Marina follows Northbrook (Richard Wattis) into the room and utters the words, 'Gosh! This is all right, isn't it?' The lines were delivered perfectly, and Olivier cried, 'Cut!' However, the rest of the day did not go so smoothly. Marilyn slipped and fell during one take, and then a mixture of nerves and anxiety caused an on-set delay of forty-five minutes. Olivier, and the rest of the cast and crew, found themselves hanging around, fully made-up, and wondering if their actress would find her way out of the dressing room, and back onto the set.

Thankfully for everyone, Marilyn did return, and the last scene of the first day was shot around 6 p.m. This part of the story revolved around Elsie Marina telling off Northbrook for tricking her into a private dinner with the Prince. It went smoothly and then, at 6.20 p.m., the cameras stopped rolling and everyone breathed a sigh of relief that the first day of filming was over. Olivier declared that everything had gone well; Marilyn thanked him and then made her way back up the long Pinewood corridor to her dressing room, before heading back to Englefield Green.

As cast and crew filed out of the studio after that long first day, they couldn't help but wonder if problems with their leading lady's nerves would become a regular fixture during the making of The Sleeping Prince. Marilyn's lateness had been a source of frustration for many directors over the years, and she was certainly aware – and claimed to be concerned – about her inability to be punctual. The actress sometimes said that it was possible she was punishing people for the hard times she had endured as a child, but that explanation didn't win her much sympathy from those who had to wait for her on set.

In 1959 – three years after *The Sleeping Prince* – Marilyn gave another justification for her lateness to journalist Bill Foster: 'It's not really me that's late. It's the others who are always in such a hurry. Seriously, I don't really know why. If I knew, I'd get over it.'

Around the same time, journalist Maxine Block gave her take on the actress's anxieties on film sets: 'This lack of confidence shows up in two ways: a need to be surrounded by an entourage, and secondly, in her chronic lateness . . . Her soul just doesn't fit her body.'

Chapter Five

The Lesson I Want to Learn

On 8 August – the second day of filming – Marilyn arrived twenty-five minutes late, and held up production for sixty-three minutes. At the same time, twenty-four-year-old Marilyn lookalike, Sylvia Wren, was in the seaside town of Morecambe, protesting the result of a national bathing beauty contest. Several of the contestants suspected the show to be a fix, and seasoned beauty queen Sylvia complained first to a local councillor and then to the journalist covering the event.

'I am not saying this because I haven't won,' she said, 'but it is plain for anyone to see that the judges only seem to like country bumpkins. They don't seem to like the glamorous type. They talk about Marilyn Monroe and her type of beauty, and then pick the ones least like her. They only seem to like the ones they can take on Sunday school outings.'

Someone else with a growing dislike of 'Marilyn Monroe types' was Laurence Olivier. In the first week of production, the actress's timekeeping continued to be an issue. It wasn't so much that she was extremely late – although she was never there by her 6.45 a.m. call – but every day there were hold-ups of various degrees, sometimes for an hour or more. 'Marilyn,' wrote Vera Day, 'I'm

certain it was because of her inherent nervousness – would prolong her stay in the dressing-room as long as possible. That made her late on the set.'

Several years later, a psychiatrist would say that the reason Marilyn was late and suffered illness while making movies was because she did not really wish to be an actress. When this notion was put to her by columnist Louella Parsons, Marilyn was furious: 'You, perhaps as well as anyone I know, know how very hard I have worked to become a motion picture star. I love my work; it has brought me much happiness and satisfaction. Any psychiatrist who would make a statement like that cannot be much more than a headline seeker. Such things are supposed to be secret and held inviolate.'

Back in 1956, the blame was placed on Marilyn for the on-set tension but, in fairness, Olivier didn't do anything to help his own cause. First of all, stories circulated that the actor had pointed the camera at his best side in many of the scenes, which amused the cast and crew. Then, there was an issue that the actor was hogging all of the close-ups. Whether or not this was true was irrelevant, since the rumour alone was enough to enrage Marilyn's coach, Paula Strasberg. Before production had begun, Strasberg was Olivier's biggest fan, but now – just weeks into the experience – she had grown to loathe him.

Used to working with hard-nosed British actors, Sir Laurence wasted no time in telling Marilyn that her teeth looked slightly yellow on film. He even went so far as to suggest she whiten them with baking soda and lemon juice. The actress was understandably furious, and told friend and companion Hedda Rosten that nobody had ever had a problem with her teeth before.

Marilyn was a super-sensitive woman who took comments to heart, and it was of major concern when somebody criticised her appearance. She spoke to Sid Ross about the problem in 1952: 'I'm beginning to feel like a piece of statuary that people are inspecting

with a magnifying glass, looking for imperfections – taking apart my dress, my voice, my figure, my acting – everything about me.'

By now, acting teacher Lee Strasberg had arrived in England for a holiday, which complicated matters further. Before production started, he had not approved of the hiring of Olivier as director and worried that his techniques would clash with Marilyn's. His wife Paula had felt differently. She believed that Olivier would be able to handle anything Marilyn brought to the studio, since he was so used to dealing with temperamental Vivien Leigh. Regardless, both parties presumed that when Lee arrived in England, he would be able to give Olivier advice on working with Marilyn, but when he turned up at the studio, Lee found himself off the list of approved Pinewood visitors.

Still, that didn't stop him from interfering by default. Whenever Marilyn couldn't get answers from Paula, she would demand to speak to Lee. Filming would then be held up while an assistant scuttled off to find a telephone, and then Marilyn would have long conversations with Lee in his room at the Dorchester Hotel.

Somebody else who needed to speak to Marilyn by phone was publicist Jean Bray. Still not allowed on the set because of her non-union status, Jean was forced to telephone Marilyn's dressing room and hope that the actress was there to answer her press-forwarded questions. Sometimes she would be able to speak with Marilyn directly, but other times she would converse with Paula Strasberg, who she found to be 'a complete pain. Everyone thought she was a pain, but Marilyn depended on her.'

One person Jean did enjoy talking to, however, was Marilyn's husband, who occasionally visited the set and would answer the telephone: 'I really liked Arthur Miller. He was so supportive and did all he could to boost Marilyn's confidence and get her to work on time. He was very intelligent and very, very fond of Marilyn. He

understood her need to become a serious actress, and did all he could for her.'

The fact that Arthur Miller had started coming onto the set caused confusion among Marilyn's entourage – particularly Milton H. Greene. His wife Amy was in England, but spent her time with the couple's son Joshua, and enjoyed shopping and sightseeing while her husband was at work. Although Amy was occasionally asked to accompany Vivien Leigh to Pinewood, she could think of nothing worse than hanging around there all day. When Arthur Miller was seen more and more on set, whispers abounded that he was looking to take over the business side of Marilyn's work. Nobody associated with Marilyn Monroe Productions appreciated his input, and it wasn't long before Miller himself had wished he'd stayed well away from Pinewood Studios.

The first time Arthur Miller ever laid eyes on Marilyn Monroe was on a Hollywood film set in 1951. 'Arthur sometimes reminds me,' she said, 'that when we first met, I was crying.' Shortly before the episode, Marilyn's mentor, agent and lover, Johnny Hyde, had passed away, leaving the starlet absolutely devastated. Miller saw something interesting in Marilyn straight away, and despite the fact that he had a wife and children on the east coast, the couple spent a lot of time together.

Eventually, the playwright suspected that he was about to fall madly in love with the actress, and he fled back to his family. Something had been sparked, however, and in the years ahead, although Marilyn married Joe DiMaggio and Miller remained married to his first wife, the two still communicated sometimes, often sharing book and theatre recommendations.

In 1954 – while married to DiMaggio – Marilyn was asked to name the men who interested her. Along with her current hus-band, Milton H. Greene, director John Huston and a variety of

other celebrities, Marilyn named Arthur Miller: 'He is one of the few contemporary playwrights who has found a way to successfully mirror our times . . . Yes, I've met him. He's very attractive personally.'

A year later, Marilyn was living in New York, and she and Miller rekindled their friendship. By this time, the Miller marriage was hanging by a thread and eventually imploded. The relationship with Marilyn grew into a love affair, and although fiercely secretive, the pair spent most of their time together.

'I am in love with the man, not the mind,' the actress said years later. Marilyn greatly admired the playwright's talent, and read his plays religiously. 'But I would have loved him for himself without his fine achievements,' she said.

While Marilyn was making *Bus Stop* in 1956, Miller headed to Nevada to obtain a divorce. However, their love affair remained complicated as the playwright was involved in a political wrangle because he refused to name suspected communists to the House Un-American Activities Committee.

Although the couple had discussed the possibility of marriage, they had not set any kind of date. However, when Miller was called to court, he revealed that he would marry Marilyn before her trip to England. The actress heard the news on television, and then reporters descended on her apartment. She was surprised by how quickly things were going but, nevertheless, she married Miller in June 1956 – just weeks before flying to England.

'I have never been so happy in my life,' Marilyn said shortly after. 'This is the first time I think I have really been in love . . . My first interest is in being a wife.'

Perhaps the biggest problem during the England trip was the couple's mistaken belief that this would be an extended honeymoon. On their arrival in London, Miller told reporters that while Marilyn was at the studio, he hoped to work on a new play. He imagined

himself writing and visiting London through the day, and then spending quiet evenings and weekends together in Surrey. Marilyn said more or less the same thing, and each press conference was made up of quotes related to cycling, visiting the countryside and spending time with friends. Things were not to work out the way either of them hoped they would.

Despite being privy to Marilyn's complaints from the set of *Bus Stop*, the making of *The Sleeping Prince* was the first experience Arthur had of seeing his wife working for an extended period of time. Marilyn asked the playwright to come onto the set as part of her support system, but the atmosphere at Pinewood came as quite a shock. Miller was witness to the problems between his wife and Olivier, but if he tried to show reason or explain what he thought the problem could be, Marilyn would take that to mean that Miller was now siding with the 'enemy'.

Everything was further amplified because Paula Strasberg was on call twenty-four hours a day, and would frequently stay at Parkside. In addition to that, when Marilyn had problems, she would often choose to share them with Strasberg instead of Miller, which surely must have been a knock to his ego. Only just married, the couple were not used to living together on a full-time basis, and the London trip was a difficult time to start.

Even at this early stage, Olivier began to feel out of his depth. Despite not requiring Lee Strasberg's presence on set, the actor/ director sought him out at the Dorchester. There he asked for Lee's advice on how to handle Marilyn. The teacher gave the same kind of help as Joshua Logan had done but, back on the set, it was as though Olivier had forgotten – or was loth to remember – any of the advice Strasberg had shared. Olivier had a clear picture of how Marilyn should play the role, possibly based on Vivien Leigh's portrayal in the play, and just couldn't be told otherwise.

Lee Strasberg later wrote about a director who asked for advice on how to direct Marilyn. While the gentleman was unnamed, the description sounds remarkably like Olivier. Strasberg wrote that he told the director to never approach Marilyn with technical direction, as she didn't understand it. Instead, he must explain what he wanted emotionally. According to Strasberg, the anonymous director seemed annoyed, as though the acting teacher was trying to take over his job.

The issue of Marilyn's nerves, anxiety and lack of confidence was made more complicated because of the proximity of her dressing room to Stage A. It wasn't a mammoth walk, but when the actress felt the need to run from the set, the distance was enough to delay shooting even further. Eventually, trailers were delivered onto the stage so that Marilyn, Olivier and Dame Sybil could relax, change and ready themselves without walking all the way back to their main dressing rooms.

Harry Whitmey, sales manager for the firm who sold the vans, wasted no time in speaking to the press about his major coup. In something resembling an advertisement, he disclosed that Marilyn's trailer had cost £525 10s, while the others were over £100 cheaper. 'We had to put them in at the dead of night,' he said. 'It was 2 a.m., and the film company insisted the big scarlet and yellow, red plush and oak one must be ready and warmed up by the time Marilyn arrived.' Afterwards, sales of the trailer went through the roof.

Not making relations any better on set was Marilyn's insistence that she take all of her meals in her dressing room. This would lead to even more lateness, and there were times when her lunch hour stretched on so long that it would be late in the afternoon before they could start shooting again. Olivier often ate in his dressing room, but his ability to return to the set on time made him even more frustrated.

Catering manager Peter Orton confirmed to journalist Brigid Delaney that Marilyn made a point of never going into the Pinewood restaurant. Instead, Marilyn had her own chef, who worked in a specially built kitchen. This self-imposed exile meant that an even bigger barrier was placed between the actress and the rest of the cast and crew, who were all strengthening friendships over lunch.

In fairness to Marilyn, her resistance to the lunch hall was likely due to the fact that when she attempted to eat there on one particular day, it was a disaster. The canteen was buzzing with staff from Pinewood, but the moment Marilyn walked in, silence descended and everyone spent the next few minutes staring at the actress, while pretending not to. Eventually, most people got back to their meals, but by this time word had spread that Marilyn was in attendance, and the whole of Pinewood seemed to be either crammed into the room or queuing up to get inside.

Peter Orton was used to making special meals for many of the visitors to Pinewood, and told Marilyn that he would prepare anything she wished, but after the dining-room incident, she was even more determined to eat in private. When this news leaked, the press made a huge deal out of it because few actors chose to eat alone. Comedian and actor Norman Wisdom was known for enjoying a packed lunch in his room, though he was an exception and did enjoy catching up with his fellow thespians when the tea trolley trundled down the Pinewood corridors.

Marilyn's situation was quite different, since the only people she seemed to have anything to do with at that time were her entourage, which included her friend Hedda Rosten (acting as an assistant), hairdresser Sydney Guilaroff (who had come over to oversee initial hairstyles), make-up artist Allan 'Whitey' Snyder, Milton H. Greene and, of course, Paula Strasberg. But this still didn't stop people from trying to catch Marilyn alone.

Her main dressing room (or suite of three rooms) was directly

next to the office of production secretary, Norma Garment. Norma worked alongside production manager Edward Joseph, who – along with Greene and Olivier – arranged the order of shooting. In the case of *The Sleeping Prince*, this was no easy task: 'I remember Marilyn as being very beautiful, and very young. Her dressing room was arranged, I suspect, to prevent her being disturbed by all and sundry! I saw Marilyn quite a lot, but I never approached her. I behaved as if she wasn't there. My job was considered menial, so I was never directly in touch with her or Laurence Olivier – who I found to be quite grand. Marilyn was inundated with strangers knocking on her dressing-room door, and whenever I encountered her, she was bustling down the corridor, trying not to catch anyone's eye. The set was located several corridors away, so she had quite a walk. I felt quite sorry for her, always being in everyone's eye and being stared at when walking in the corridor. It must have been miserable for her.'

The fascination with having Marilyn at Pinewood was felt throughout the production. Third assistant director David Tringham noticed that, 'as Marilyn walked to the set, the secretaries would come and look out of the windows. Everyone wanted to see her – it was like living in the zoo.'

Interestingly, rumours of troubles on set never reached Norma Garment's office. 'I never heard of any arguments or explosions,' she said. 'As far as I know, it went rather smoothly, though Olivier was very much in charge. He thought of *The Sleeping Prince* as his picture.'

Smooth was not a word generally associated with the making of the movie, and while there were constant rebuttals, jaded journalists refused to believe that there was no fighting on set – particularly when stories leaked from the studio almost every week. 'Lots of people are a bit disappointed in Monroe,' reported a secretary, although this was laughed off by the actresses who played Elsie

Marina's friends. 'It's a wonderful picture to work on,' said Vera Day. 'Marilyn is wonderful to watch.' The actress did have to admit, however, that Marilyn was forever surrounded by people such as Milton H. Greene and Paula Strasberg.

Gillian Owen, who played Maggie, reiterated what Day had to say. 'Absolutely no friction at all,' she said. 'Marilyn seems so composed. And she and Sir Laurence work wonderfully together.'

Dennis Edwards played the Prince Regent's head valet, a character who was seen frequently throughout the film, attending to his boss's needs. Vivien Leigh had once wanted the actor as her leading man, but had then fallen ill and couldn't play opposite him. As a way of apology, she had introduced Edwards to Olivier and his second-in-command, Anthony Bushell, and he was then cast in several movies, including *The Sleeping Prince*. Edwards was on set for about ten days, and while his role was considered small, it did require a large amount of coordination. Edwards remembered: '[It] perhaps entailed a little more skill than is apparent, as it involved delicate timing from a technical point of view – like presenting a shaped eye-glass at just the right moment and angle. Not acting in the strict sense!'

Dennis was witness to many of the breakdowns between Olivier and Marilyn, though almost fifty years later, he played down the fights, saying that, 'most of what I saw and heard was very general – amounting really to my fleeting instinct and just plain gossip.' Marilyn left no particular impression on Dennis Edwards during the making of *The Sleeping Prince*, but although he never really cared for her work, he had to admit that there were times when she did well. 'She always seemed rather pathetic, at times in a nice way too. I've no wish to knock her down, but I know of nothing that might confirm that.'

Edwards may have insisted that the stress on set was mainly gossip, but others are more outspoken about the power struggle

between Marilyn and Olivier. Publicist Jerry Juroe acknowledges that, 'There were breakdowns practically every day. She was the producer, and Olivier was the director, so what Marilyn wanted, went.' 'Whitey' Snyder wrote that he didn't ever see Olivier lose his temper with Marilyn, but Snyder was embarrassed when the actress insisted that scenes be shot over and over again.

In spite of the fact that Marilyn's company had brought the production to Olivier, many of the cast and crew were not aware of that fact until after shooting ended, and some didn't realise until years later. 'We all wondered why Larry cast her in the first place,' recalled assistant Joe M. Marks, 'for she could never remember her lines of dialogue. While she photographed superbly, she had little else to offer even when surrounded by idiot boards with every line of dialogue written on them. She still could not retain dialogue or stage moves.'

Of course, 'Larry' didn't hire Marilyn; it was the other way around. If not for Marilyn's company bringing the project to him, the movie version of *The Sleeping Prince* would perhaps never have been on his radar. While part of the confusion could have been caused by Olivier's over-enthusiastic approach to running the set, some believe it may also be because Marilyn's behaviour was not in keeping with that of a co-producer.

'As the producer, you shouldn't want to hold up production,' said continuity supervisor Elaine Schreyeck. 'Maybe once or twice if you're ill or jet-lagged or something, but not all the time.'

Marilyn did occasionally surprise people in a good way, however. For instance, she had an instinct for knowing exactly how to deliver a line or when to give a perfect facial expression. Even during the most stressful of scenes, there could be moments that seemed subtle in the flesh, but were pure genius on screen. Later, in the editing room, Olivier realised just how enjoyable it was to work with Marilyn's raw material, especially her close-ups and reactions.

One day during the first weeks of production, Marilyn discovered that someone was taking bets on how long it would take her to get a particular scene correct. Alan the pianist recalled: 'Marilyn got wind of this and was not amused at the overt insult to her capabilities . . .'

The scene in question was one that took place towards the beginning of the movie, when the Prince Regent invites Elsie Marina to his embassy for a late supper. During that time, the showgirl witnesses various members of his entourage leave the room by walking backwards. This both intrigues and amuses Elsie, and she attempts the walk herself (albeit in a sarcastic way).

Convinced that it was Olivier himself who was 'running a book' on whether or not she would be able to perfect the scene, the actress went home, studied her lines and movements, and was confident that she could do everything Olivier asked of her. The day of the shoot arrived, and Marilyn delivered her lines, walked backwards out of the door and then closed it behind her, as directed. As Olivier looked on, the door then popped back open and – in an obvious dig at those who were betting on her abilities – Marilyn stuck her head through the gap. 'Pretty good, huh?' she chuckled, and then closed the door. The improvised line fitted into the film so nicely that it was kept in, and Marilyn went back to Parkside, happy that she had proved the naysayers wrong.

That scene was a success, but another – in which Elsie Marina has to wash her hands at the sink in her dressing room – caused a headache for the crew. Olivier loved Marilyn's idea of wearing bloomers for this part of the story, but the sink caused something of a problem. The basin was purely for decorative purposes only, so had to be filled with water before Marilyn pretended to wash her hands. However, the actress insisted that the water must be kept warm at all times, which meant that assistants had to drain and refill the bowl before almost every take.

Events came to a head when Olivier told Marilyn to be sexy during another part of the film. Determined to be taken seriously as an actress, she did not appreciate his demand, nor did she expect him to say it. A year before the England trip, Marilyn spoke to reporter Logan Gourlay about this very subject. 'When a director says, "Marilyn, give us some of that old Monroe sex appeal in this scene," I just don't know what to do. I really don't . . .' She then told the reporter that she was fed up with all of the sex stuff, and that it made her uncomfortable. 'I'd rather be known as just an actress,' she said.

Unsure how to react to Olivier's 'be sexy' request, Marilyn stormed off the set and rang Lee Strasberg. The teacher could not believe that Olivier had made such a statement, and wondered if he had perhaps said it in jest. Either way, Lee deemed it a ridiculous thing to say, and tried his best to calm Marilyn down. Hedda Rosten believed that from that moment on, the actress was suspicious of her co-star and director. Indeed, Marilyn later told journalist W. J. Weatherby that she had found the comment to be condescending, and it had upset her greatly.

Marilyn acted out against what she perceived as Olivier's lack of respect by holding up production, and calling the actor 'Mister Sir' to her friends. In return, he became impatient and moody, all ideas of falling in love with her long-since forgotten.

Thinking that some of Marilyn's entourage might be able to throw some light on why the actress was always late, Olivier approached 'Whitey' Snyder. The make-up artist told the director that he was unable to answer the question. 'She simply vacillates, oscillates and procrastinates,' he said. In an effort to stall the inevitable walk to set, sometimes Marilyn would decide she had to make a call that simply couldn't wait. Other times she would simply refuse to leave the dressing room without offering any explanation at all.

The actress seemed oblivious to the stress caused by her late arrival on set. While Dame Sybil Thorndike was always supportive

of Marilyn's talents, the lateness even got to her once or twice. One day when Marilyn finally appeared, she greeted her fellow cast members with a cheery, 'Hello! Good to see you're all ready!' Dame Sybil replied, 'So good of you to come my dear!' Still, she was not wholly serious in her retort, and those on set noticed that the bigger the problems, the more Dame Sybil wanted to help.

Further trouble came when Marilyn and Olivier began watching the daily rushes together. Sitting in the darkened projection room, the couple clashed repeatedly over the subjects of timing and humour. Later, rumours would circulate that on at least one occasion when Marilyn was indisposed, she was really punishing Olivier after a particularly stressful screening.

There really was no need, however, to worry about how she looked in the rushes. Everyone agreed that despite what might have been happening on the set, Marilyn was always magical on the screen. Several days after filming wrapped, columnist Jympson Harman spoke to an unnamed cameraman who told him that, while working with Marilyn, it was a regular occurrence to look through the lens and see nothing useable at all. However, the 'next day you go to see the "rushes", full of foreboding. And there appears on the screen a perfect little scene – the same you despaired of when you peered through the view-finder. You don't know how it happened, but there it is.'

Marilyn wasn't too concerned about whether Olivier liked her or not, and made no attempt to change his mind. Around the time she made *The Sleeping Prince*, she had the following to say on the subject: 'Some of my earlier fears have been dispelled by discovering how the motion picture business really works. It used to worry me a lot whether a producer, a director or a casting director liked me as a person and I tried so hard to make a good impression. I've since found out that this doesn't matter very much.'

Paula Strasberg had her own ideas as to why Marilyn sometimes appeared unprofessional on film sets, and spoke about it to columnist Louella Parsons, in 1960: 'I think my husband has the solution: he says that nervousness indicates sensitivity and that's what Marilyn has, great sensitivity.' The coach did worry, however, that Marilyn's constant search for perfection came at the expense of her mental and physical health.

In the middle of all the on-set drama was photographer Milton H. Greene, who had come to the UK as Marilyn's business partner and co-producer, but now found himself sympathetic towards Olivier and pushed out by Miller. There had been a time close to the beginning of production when Milton, Marilyn, Larry and Miller had held an informal get-together with guests in a central London apartment, and followed the party with coffee at a café down the street. The small group had got along pleasantly, but now even the idea of getting together outside the studio, seemed laughable and far-fetched.

Shortly before the trip to England, Milton had spoken to reporter Guy Austin about his relationship with Marilyn: 'I saw in Miss Monroe, dramatic qualities that apparently no one else had ever seen in her. But she needed a partner and ally, someone to develop a Marilyn no one had ever realised existed.'

Now, Milton's loyalty was being questioned, and one day when filming ground to a halt, he and Olivier were so stressed that they shared a behind-the-scenes drink. The two men lamented the lack of joy on set, and shared their thoughts about Paula Strasberg. Milton thought the woman was 'a walking disaster', and Olivier believed that the only talent she possessed was being an expert at praising Marilyn. He had even witnessed Paula telling Marilyn that she was the greatest human on earth, and more popular than Jesus. The confused actor had struggled to keep a straight face.

This feeling of bewilderment towards Paula was shared by Arthur Miller, who had disliked the Strasbergs for some time. He believed that Paula had no ability as an acting coach, and the only talent she had was to make herself indispensable to Marilyn. Paula's daughter Susan thought that the criticism of her mother was unfair. In her eyes, the coach wanted Marilyn to succeed, and hated being held responsible for the hold-ups and lateness. Susan felt that Marilyn happily let Paula take the blame for things that were out of her control.

Cast and crew members who liked Paula Strasberg are difficult to find, and some believe that she had something of a Svengali hold over Marilyn. Like her or not, there is no denying that Paula's presence was felt by everyone on set, and the distance between the star and her co-stars was amplified because of the coach's overbearing influence.

Elaine Schreyeck's job was to make sure that everything was consistent during filming: 'I would sit next to the camera, cueing actors who forgot lines, making notes of every shot done, what lens, and what filter. I would time everything and make a note of what the actors were wearing, how they wore their hair, their accessories, their movements etc. Everything had to look exactly the same from one scene to the next. I would write down how many shots the scene took, and time it all on a stop-watch. If we were filming outside, I had to make a note of the time of day, because the sun would be different if we filmed at a different time of day next time, and I also noted the change in weather. Every day I would type everything up and send two copies to the editors.'

One of Elaine's tasks was to cue in Marilyn if she forgot her lines, but that was the only time she was really able to get close to the actress.

'Paula Strasberg kept Marilyn away from everyone,' said Elaine. 'There was a dressing room on the set and she would go off into

there as soon as she had finished her scenes. Paula was a nuisance. Marilyn would do a scene but would look at Paula instead of Sir Laurence, and then they'd get into a discussion – Paula would say, "You are wonderful!" etc. and then they would go straight to the dressing room.' Elaine found herself wondering why Marilyn would ever put her trust in Paula Strasberg when she had Olivier to guide her.

Elaine wasn't the only one who was agitated by Paula. 'She just got in the way,' said third assistant director David Tringham, while publicist Jerry Juroe recognised that 'Paula was always looking for something to poison Marilyn's mind against other intimates. It was very easy to dislike Paula.'

'I'm afraid [Marilyn and I] didn't talk much,' actress Daphne Anderson remembered. 'She was very reserved and spent a lot of time with her drama coach.' With regards to Marilyn's lateness, Anderson said: 'I always put it down to nerves. It must have been daunting to work opposite Sir Laurence Olivier!'

Most of the cast and crew were kept away from Marilyn, but not everyone was intimidated by the entourage. Dame Sybil Thorndike was in her seventies and an adventurous, outgoing woman; she still toured the world with her husband Lewis, and believed that retirement was something that happened to other people. 'Tomorrow is always full of promise and excitement,' was her motto, and she stuck by it. As a result of her attitude and experience, the actress was scared of nobody, and during the making of *The Sleeping Prince*, she was one of a handful of people who was able to get past Paula Strasberg and develop a bond with Marilyn.

Olivier had introduced the two women during the early days of rehearsals, when he accompanied Marilyn to the older woman's dressing room. According to Thorndike, Marilyn was wearing dark glasses and grease on her face. 'Do forgive my horrid face,' she said, though Dame Sybil thought there was nothing to forgive.

Later, during a read-through, Dame Sybil was surprised to discover that Marilyn's words were being read by someone she thought must be a stand-in. The young woman was shabbily dressed, with no make-up and unstyled hair, and Sybil wondered why she hadn't made any effort with her appearance. Once the girl departed, Dame Sybil asked why Marilyn hadn't joined the read-through. 'That *is* Marilyn,' a colleague replied.

Thorndike had encountered many changes in acting styles over the years, and spoke about it in 1954: 'Apart from closing theatres and causing an overcrowding of the acting profession the advance of mechanised entertainment has considerably changed the style of acting. The influence of the screen has tended to make it more naturalistic. On the other hand, there is a higher degree of sincerity. Neither actors nor audience are content with stage tricks. They both prefer them to be hidden and the resulting realism gives the impression that actors live their parts.'

Even though the older actress acknowledged the changing styles, Marilyn's way of acting came as a surprise. Thorndike found her to be shy and sweet, but as they started to work together, she couldn't believe how subtle Marilyn's performance was. It was almost as though she wasn't acting at all, and her timing seemed all wrong. Dame Sybil wondered if Marilyn's performance was enough to come through the screen, but when she mentioned her concerns to Olivier, he invited her to see the daily rushes. There, she saw the full extent of Marilyn's performance and was astounded by the transformation on screen.

'I consider Miss Monroe to be one of the best actresses in the world today,' Dame Sybil said in 1958, two years after the making of *The Sleeping Prince*. 'When I saw the rushes, I was frankly amazed. Instead of Marilyn's timing being wrong, it was perfect; instead of muttering, her enunciation came through magnificently.'

Dame Sybil's son, John Casson, said that his mother was fond of Marilyn and felt sorry for her at times: 'She detected an inherent sadness in her. My mother was very perspicacious in sensing what other people felt or thought.'

Also in 1958, Sybil Thorndike, in the light-hearted way she had, said: '[She is] a very talented actress, but what wouldn't I give to have a figure like that!'

A year later, Marilyn sat down with columnist David Lewin and described the dame as a great woman: 'I loved Sybil Thorndike. She is one of my idols.' Remembering one day when the two women had some time alone between takes, Marilyn told Lewin that she had asked the much older actress how she had so much energy. 'Sybil Thorndike said it came from being happy and in love and not being separated from her husband, and working. That's the lesson I want to learn.'

Chapter Six

The Impossibility of Love

On 11 August, *Picturegoer* magazine printed a scathing article by journalist Tom Hutchinson, entitled, 'Don't fence her in, Larry'. Hutchinson pointed out that ever since Marilyn had arrived in England, Olivier had tried to keep reporters away – particularly at the press conferences, when many of the questions went through him. Now Hutchinson had received word that the film set was closed, and he was furious.

'If Sir Laurence wants all the British publicity he's had so far with Miss Monroe to kick back at him – this is the way to do it! But why do it at all?' He wondered if Olivier felt he had to protect Marilyn as a way of keeping as much dignity as possible, 'But, the way things are going, for DIGNITY you can read DULLNESS.'

As tensions grew on the set of *The Sleeping Prince*, Marilyn found that riding her bike was a terrific way of forgetting her troubles – even for just a little while. In the first weeks of her stay in England, Marilyn had told friends that she desperately wanted to cycle around Englefield Green but could see no way of doing it, given the crowds of fans gathered around the driveway. However, the Parkside staff knew every inch of the property, and it was soon pointed out

that the little gate in the back garden provided discreet access into Windsor Great Park.

As soon as the temperamental British weather cleared up, Marilyn and Arthur were able to slip out of their garden and into the little lane that ran down the side of the park. Once there, the couple could cycle, watch polo matches, have picnics and visit the nearby pond. In the months ahead, the residents of Englefield Green would grow used to seeing Marilyn and Arthur cycling all over the village. Tricia Jones remembered standing outside Parkside House in order to get a glimpse of the star, though, in the end, Marilyn came to her: 'I was standing in the front garden with my brother, when they cycled by. Marilyn was wearing a skimpy white top with even skimpier white shorts. Not the sort of outfit we were used to seeing in our little village; that's why I can remember it.'

One resident was shocked to see Marilyn zipping down Blaze Lane and straight past his house. The memory of the actress was so vivid that it became a favourite story to share with his family. Another young 'Greener' was buying sweets from the local shop when Marilyn popped in during a bike ride. She wasted no time in talking with the youngsters gathered there, and the kids were all fascinated by the star's American accent.

The cycling hobby seemed innocent enough, but it did get Marilyn into trouble on several occasions. One day the couple were biking along the path towards the Savill Garden in Great Windsor Park when they encountered Joyce Jackson, who was walking with her husband, baby and toddler. Also present was her twelve-year-old nephew, who was trailing a long, thin branch behind him. According to Joyce, Arthur Miller was worried that the stick could cause Marilyn to fall from her bicycle. Undaunted, the woman replied, 'Bicycles are not permitted in this park, in this area,' to which Miller apparently retorted, 'But this is Marilyn Monroe, and I am her husband.' On hearing that information, Joyce and her

family stood back to let the Millers through, though the woman was less than impressed with her Marilyn encounter.

Someone else left unenthusiastic by Marilyn's bike adventures was Joe M. Marks, one of the assistants on *The Sleeping Prince*. When the actress didn't show up for shooting one morning, Olivier made several frantic phone calls to Parkside House, and then sent Marks to find her. When the young man arrived at the house, staff told him that the Millers had left on their bikes, with the intention of having a morning picnic in the park.

Marks was frantic as he worried that he could be fired if Marilyn was not found, so dashed into the park in a bid to find her. When he did eventually catch up with the couple, Marilyn denied all knowledge of ever receiving the daily call-sheet, which confused the assistant since he was the one in charge of delivering the sheets to her every evening. 'Marilyn would often mislay them,' said Marks. 'She didn't seem to know what she was doing half the time.'

But it wasn't all doom and gloom at Pinewood. One actor who was delighted to meet Marilyn was comedian and actor Norman Wisdom. During breaks on *The Sleeping Prince*, the actress would sometimes sneak onto the sound stage where Wisdom was working on the film *Up in the World*. Marilyn thought the British actor was hysterically funny, and on several occasions she unintentionally ruined takes. Wisdom later recalled, 'Obviously, of course, once the director has said "action", everyone must remain silent, no matter how funny the situation might be, but Marilyn just could not help laughing and on two occasions she was politely escorted off the set.'

One lunchtime, the two actors bumped into each other in the corridor. 'It was crowded but she still caught hold of me, kissed and hugged me, and walked away laughing.' Nobody in the hallway could believe what had just happened, and when director Bob Asher called Wisdom a 'lucky little swine', the actor couldn't help but agree with him.

* * *

Shortly before shooting began, a schedule for most of the first two months was pinned onto the noticeboard in the production office. From 17 to 23 August, the cast would work on scenes in the sitting room, and then from 23 to 30 August, the action would be moved to the hall, gallery and stairs. The Queen's apartment and hall would take up the time from 31 August to 5 September, and then they would move to a mock-up of Westminster Abbey, before returning to the sitting room on 10–12 September. General embassy scenes would be shot on 13–17 September and then, finally, it would be back to the sitting room on the 18th and 19th. The only day that would not require Marilyn's presence would be for a sitting-room scene on 12 September.

Everyone approved of the schedule, and on paper it looked perfect. There was only one problem – nobody had factored in the delays created by Marilyn's lateness and the hold-ups on set.

'We would all arrive and Marilyn would not be there,' remembered continuity supervisor Elaine Schreyeck. 'We'd wonder what else we could shoot, while we waited. The whole schedule went to pot because of her lateness.'

In the end, and in a bid to help with Marilyn's confidence, Olivier decided to shoot in chronological order as much as he could, but even with that, two schedules were necessary. There was one for when Marilyn made it to the set, and another for when she was absent. Whenever there was a delay or absence, the cast would shoot scenes that didn't include the actress, but considering she was in most of the film, this plan was not only frustrating but also often unworkable.

There were a few scenes that could be filmed with Marilyn's stand-in Una Pearl (shots from afar, from behind, and close-ups of her hands), but those were almost the only ones that could be filmed without the main star. Stressed and unsure of what scenes they would be working on from day to day, Olivier decided it had

104

been a terrible mistake to sign on as director as well as co-star.

Cinematographer Jack Cardiff, however, found the whole thing inspiring. 'I've a tremendous admiration for the way in which [Olivier] manages to cope simultaneously with all the problems of acting without losing his grasp as a director.' Marilyn disagreed, and considered Olivier to be a gigantic let-down.

Even in the early days of filming, the actress believed that there were two groups on the set of *The Sleeping Prince* – hers and Olivier's – and every time somebody said anything complimentary towards Olivier, she presumed that they were on his side. Things were always black and white in Marilyn's world – you were either for her or against her – and if she suspected a criticism, it made her think that the person involved must not like her. With Olivier's forthright direction and questions, Marilyn had made up her mind that the director was against her, and there was nothing anyone could do to change it.

Jerry Juroe had been friendly with Marilyn for the first week or two of the trip, and had even accompanied her to a private screening of an Alan Ladd movie. However, as shooting began, he found himself immersed in the on-set conflict. 'I was part of Marilyn's team in nature, but more part of Olivier's team, because I was closer to him than Marilyn. Marilyn didn't like that and I believe this was the cause of conflict between us.'

It also caused a clash between the actress and Elaine Schreyeck, who couldn't understand why Marilyn had wanted to work with Olivier, and yet caused such lateness and tension on the set. Elaine found herself holding her stomach in apprehension of what might happen next. One day she was asked to speak to Marilyn about her work, but this displeased the star.

'Oh, you're on their side!' she said.

'Marilyn,' Elaine replied. 'I'm not on anyone's side. We're here to make a film.'

Although it may have appeared to Marilyn that Elaine was not an ally, the continuity supervisor would have liked to have got to know her better, but was not given the chance. 'I understood that Marilyn was nervous because everyone had been in the stage play, but they were all lovely to her, and Sir Laurence was too. He was patience itself towards her. Marilyn was always very frightened, but we didn't know why.'

Columnist Elsa Maxwell spoke about Marilyn's fears during the summer of 1956: 'She had the courage to challenge the big movie moguls. She has the ambition to want to know and work with fine artists. But she's also like the scared young thing who stays on and on in the powder-room to postpone everything she has worked for and looked forward to.'

Speaking to columnist David Lewin, Marilyn explained the fears surrounding her job: 'Acting for me is agony and bliss all at the same time,' she said. 'Why am I so afraid? Do I think I can't act? I know I can act but the fear is there and it should not be and it must not be.'

And yet it was.

On the afternoon of Sunday 12 August, *Daily Express* photographer Harold Clements hung around the back entrance of Parkside House in the hope that he would be able to see Marilyn and Arthur slipping out for their regular cycle ride. He was in luck, and clicked his camera just as the Millers left the garden. Undeterred by his presence, the couple carried on regardless, and photographs show a smiling Marilyn wearing dark glasses, a striped T-shirt, cardigan, blue drainpipe trousers and tennis pumps (which had been bought especially from Woodmans shoe shop in Egham). Despite the media intrusion, even Arthur Miller looked fairly relaxed, half-smiling in sweater and long trousers.

At one point the couple came across a polo match and stopped to watch. When Marilyn wobbled as she got off her bike, one observer

made comment to Arthur that his wife's cycling skills looked a little unstable. 'Don't you worry about that,' he replied. 'She's far better on a bike than I am.'

As the couple busied themselves in Windsor Park, Lee, Paula and their daughter Susan Strasberg headed to Notley Abbey, the country home of the Oliviers. The night before the visit, pregnant Vivien Leigh made her last onstage appearance in *South Sea Bubble*. Now she played hostess to the Strasbergs in what the family considered an attempt at peacekeeping. Over lunch, the atmosphere was civil, but there was no warmth between the families. Everyone appeared to be trying too hard, all vastly aware that, just days before, Olivier was seething at Paula's constant presence on the set of *The Sleeping Prince*.

Over dinner, there was no direct mention of the film, though Susan Strasberg wondered if Olivier hoped the visit would prompt a reconciliation between Marilyn and himself; as though maybe the family would go back and educate her on his ways. At the same time, Vivien Leigh appeared manic, rushing around and catering to their every need. Olivier begged her to slow down, but she seemed intent on doing the opposite.

Hours after the visit, Vivien miscarried her baby, and Paula Strasberg blamed herself, after the actress had insisted on running upstairs to retrieve Paula's necklace from a guest bathroom. Vivien took to her bed, while Olivier – ever the professional – headed back to Pinewood to continue work on *The Sleeping Prince*. Journalist Anthony Carthew caught up with him there. 'We are bitterly disappointed,' he said, 'but we both feel it was not wrong for Vivien to go on working as long as she did.' To columnist David Lewin, Olivier expressed how distraught the couple were. 'We are terribly upset. But the main concern now is Vivien. The important thing is that she should make a complete recovery.' That evening he drove back to Notley to comfort his wife.

Noël Coward, author of *South Sea Bubble*, was furious about what he considered to be a silly episode. He hadn't been happy since Vivien had told him she was leaving the play, and in the privacy of his notebooks, he wondered what she had been thinking, getting pregnant at the age of forty-two. He also worried that his play would now flounder for no reason at all.

Rupert Marsh, company manager for *South Sea Bubble*, was far more sympathetic. 'It is a terrible thing,' he said. 'I was told at the theatre yesterday. Vivien has personal friends in the company, and we were told yesterday – we were all terribly upset.'

Elizabeth Sellars, the young actress brought in to take over Vivien's role on stage, was also troubled. It was to be her first evening in the role, and she arrived at the theatre to receive not only the sad news but also a good-luck telegram from Vivien. 'It is difficult enough taking over from a star,' she said, 'but tonight's news made it especially trying.'

During 13 to 17 August, Doris Day was at number one in the British single charts with 'Que Sera, Sera (Whatever Will Be, Will Be)'. Marilyn and Olivier would have been sensible to take the song's advice because, unknown to them, they were soon to experience the most stressful period of the actress's entire England trip.

In an effort to lighten the atmosphere with frustrated journalists, on Monday 13 August Olivier released publicity photographs to the press: one showing Marilyn and a clapperboard, and another capturing her being directed by Olivier. A month and a half later there would be another released, but for now the press ate up the two official glimpses of Marilyn working on the set of *The Sleeping Prince*.

On Tuesday the 14th, publicist Alan Arnold gave Marilyn a newspaper clipping that showed the image of her being directed by Olivier. 'What a terrible picture!' she snapped. 'Who put that

out?' Arnold explained that he thought Marilyn had already seen the photo, and then backed off as quickly as possible. Notoriously critical of her own photographs, Marilyn took her complaint higher, and Arnold found himself reprimanded for showing her the clipping in the first place. He was then instructed to never show Marilyn any photos – officially released or otherwise – in the future.

Shortly afterwards, Arnold showed Olivier a pile of publicity photos, and was surprised when the actor/director exclaimed, 'The less you put out about this _____ picture, the better.' Arnold believed that Olivier regretted taking part in the movie, and that was part of the reason why he maintained a closed-set policy – he didn't want people to witness his disappointment.

Marilyn had never looked more beautiful, but she failed to see it herself. Perhaps it was the fact that she had recently turned thirty, but she seemed preoccupied with not only her face but her figure, too. She would frequently ask stand-in Una Pearl, 'Do I look all right? Is my tummy all right?' She became so paranoid about her curvy stomach that she devised a plan with Jack Cardiff, where he would call out the codeword 'Tom', to remind her to suck in her stomach before each take. In the weeks ahead, the actress's entourage would also get into the habit of going through publicity photos and throwing out any that made their boss look 'plump'. Publicist Alan Arnold became used to seeing piles of photos with blue lines through them, just because they supposedly showed a little stomach.

Surprisingly, when cinematographer Jack Cardiff suggested that Marilyn wear make-up on her hands, the actress didn't overreact. The cameraman had noticed that her hands looked red against her white dress, and given Joshua Logan's advice, Cardiff was worried that Marilyn would take his observation badly. Instead, she looked down at her hands, agreed that they needed to be covered, and said that the redness went all the way back to childhood, when she scrubbed floors in an orphanage.

Away from publicity photos and hold-ups, Olivier's week revolved predominantly around Vivien. She was holed up at Notley, planning a holiday, and accepting the flowers and telegrams – including one from Marilyn and Arthur – that flooded to her bedside. While Vivien opened the correspondence, Olivier was inundated with calls from concerned friends and inquisitive reporters. He fielded most of the nosey calls, but was fairly happy to talk to columnist David Lewin, who wondered if Vivien should have rested more than she did. 'We have tried to blame ourselves for this,' Olivier said, 'We have tried to find a reason for what has happened . . . It is just – just bad luck. Fate.'

By the end of the week, *The Sleeping Prince* unit had completed nine full days of actual shooting time. Considering the delays and disruption on set, this was quite an achievement. However, various newspaper columnists were still aiming barbs at Marilyn and Olivier over their alleged aloofness, and, on Sunday 19 August, it was Arthur Miller's turn. In his *People* column, Kenneth Bailey revealed that the playwright had been asked to appear on the BBC television programme, *The Brains Trust*. Miller had turned down the show, citing that he was too busy with business. Bailey was furious that 'dour Mr Miller' had refused to take part. 'I hope he has a nice bike ride today,' the columnist sniped.

On Monday 20 August it was announced that Laurence Olivier was the recipient of the Golden Laurel Trophy, awarded to an individual whose cinematic work had contributed to mutual understanding and goodwill among the people of the world. He expressed his delight from Pinewood: 'I feel most deeply honoured in receiving this award, the principles of which are so high. If the highest aim of the artist, which is truth, can be said to be realised by one's work in films then I am proud and happy indeed to be cited as having contributed to that end.'

That done, it was time to return to Stage A, where a dinner scene was to be filmed on 20 and 21 August. While in the embassy living room, the Prince leaves Elsie on the sofa while he makes phone calls and reads documents at his desk in the background. Throughout this scene, the showgirl helps herself to food from an extravagant banquet, and then play acts an imaginary conversation between herself and the Prince. It culminates with her over-pouring champagne into her glass, and then bursting into laughter as it cascades all over the table. It is a light-hearted scene, but required a considerable number of retakes due to Marilyn forgetting her lines. This caused something of a headache for catering manager Peter Orton, who had to make sure that the food was still OK to film. He described the work to reporter Brigid Delaney: 'In *The Sleeping Prince* we had to serve a meal as it would have been done in 1911. On the menu were caviar and iced lobster. When shooting stopped half-way through a scene, we had to renew the food and see that the pieces that have been served or cut were put back in exactly the same position.'

Remembering the location of the food wasn't the only challenge with this scene. The caviar was real and had been bought at Fortnum & Mason, for the elaborate sum of £4 per half jar (the equivalent of approximately £85 in today's money). Marilyn was so enthusiastic with the scene that she dropped food down the front of her bodice more than once. Two of her gowns had to be completely remade as a result, and later – in order to prevent further problems of this nature – Beatrice 'Bumble' Dawson came up with the idea of a gown with a replaceable front, which could be easily fixed in the workrooms of L. & H. Nathan.

During the two-day shoot, Marilyn got through five half-jars of caviar and large quantities of cream trifle. Used to eating a light salad while working, this amount of food did not sit well, and there were times when she had to run off set, complaining of a poorly

stomach. Olivier became so agitated while trying to direct the scene that he enrolled the help of his stand-in, who took the actor's place during a far-away shot. Olivier then darted behind the camera in order to direct Marilyn, and the shot of the out-of-focus stand-in stayed in the final print.

Arthur Miller often provokes a negative response when spoken about as Marilyn's husband, but there is no denying that, for a long time, the couple were very much in love. Shortly before their marriage in June 1956, Marilyn spoke to columnist Louella Parsons: 'Arthur's a marvellous person,' she said. 'Not only a brilliant man but a sweet, understanding human being. Louella, I think you know better than anyone the unhappiness I have known. I've never really been happy in my life until now.'

Miller was just as besotted with his new wife, and had invited friends Louis and Bryna Untermeyer to meet her shortly before flying to London. They arrived for Sunday dinner – made by Marilyn herself – and found the actress to be shy and quiet, though pleasant and responsive to humour. Untermeyer told friends that the Millers acted as though they were on their first date, and he had no doubt that they had great respect for each other and were madly in love.

While Marilyn's second husband Joe DiMaggio rebelled against his wife's career as an actress, Miller not only embraced it, but encouraged it. He believed in her, even when she struggled to believe in herself. Over time, Miller would even get used to his wife's lateness, as Marilyn explained in 1958: 'Arthur says, "Look at it this way: You're always late, you won't change; accept it and forget about it."'

But this acceptance was two years in the future, and in 1956, the playwright's new role as a husband seemed to have turned into something of a caretaker. Instead of being Marilyn's full-time

confidant and friend, he now had to make sure that she left the house on time in the mornings, or field calls from Pinewood if she had not. As well as that, there was the problem of Marilyn's ongoing addiction to prescription medication, which was a constant source of anguish during the making of *The Sleeping Prince*.

British doctors were not as forthcoming as Marilyn's entourage had hoped, so to get around any shortcomings, medication such as Dexamyl – a combination drug composed of sodium amobarbital and dextroamphetamine sulphate – was ordered from the States. The drug was designed to suppress appetite and lift the mood, and British Prime Minister Anthony Eden was said to take it for abdominal pain. However, on the whole, the pills were widely abused by everyone from teenagers to exhausted housewives.

The continued arrival of drugs worried Marilyn's long-time make-up artist and friend Allan 'Whitey' Snyder, who believed that Milton H. Greene's involvement in Marilyn's life perhaps wasn't as positive as first thought. Greene's assistant David Maysles was also concerned about the situation. His brother Albert later told biographer Donald Spoto that Milton was 'getting involved in things way above his ability to sustain'.

Arthur Miller told biographer Fred Lawrence Guiles that he believed Marilyn was 'trying to immunize herself against feeling too much' when she took tablets during the day, and described her as 'like a smashed vase'. In addition to that, sometimes her insomnia could not be treated with a couple of sleeping pills, and Marilyn would wake in the middle of the night, weeping hysterically. The corridors of Parkside House were creepy and depressing in the darkness of a sleepless night, and the drug doses became heavier. Miller counted the pills, and watched over his wife.

Surrounded by hangers-on in what should have been the couple's private home, it was a frustrating time for the normally quiet,

solitary Miller, and made worse by the tensions witnessed on the set of *The Sleeping Prince*. Knowing how she felt about criticism, Miller could not share his feelings with Marilyn herself, so instead he wrote his concerns and observations in his journal. Documenting one's feelings is a common reaction for most writers, though these notes are rarely revealed publicly, except when used to inspire work. For Miller, however, the recording of his innermost thoughts was about to prove catastrophic.

Six weeks into the trip, Marilyn was at Parkside, preparing to learn her lines. She looked for her script, but instead stumbled over Arthur Miller's notebook, left open at a pivotal point. Seeing her name, Marilyn read the passage and discovered that her new husband had been writing about his experiences with her, and the results were not positive.

There are several mysteries associated with this episode. First of all, we do not know the exact wording of the prose, and unless Miller's notebook is released to the public, we are never likely to find out. The other issue is whether the journal was left out on purpose, or was it a complete accident? Many have their theories, and Marilyn told the Strasbergs that she was sure Miller had done it to spite her. She was convinced he had left it out intentionally and no one could tell her otherwise. Ultimately, the only person who could know if the incident was deliberate was Arthur Miller, and he never cared to say. But regardless of the intention, one thing is certain – the discovery of the passage sent Marilyn into an emotional spiral, and the repercussions were felt throughout the house.

The Strasberg family spoke about the incident on several occasions. By their accounts, they did not see what was written in the notebook, but Marilyn told them that it was something concerning how disappointed Miller was in her. He no longer felt that she was an angel in his life; did not know how to answer Olivier's complaints about her behaviour; and even compared Marilyn to his first wife – a

woman he had apparently grown to despise. At first, Paula tried to diffuse the situation by offering the explanation that perhaps Arthur hadn't really meant the things he'd written. Ultimately, however, the Strasbergs' already strained relationship with Miller was now effectively over.

Several years later, Marilyn would discuss the incident with her half-sister, Berniece. 'He said he agreed with Larry that I could *be* a bitch,' Marilyn told her. Berniece sensed that Marilyn felt she'd overreacted to the incident, but still it gnawed at her, particularly because of her view that a husband should boost his wife's confidence, not concentrate on her flaws.

Arthur Miller did not care to discuss the incident in his autobiography, but he did write a similar scene in his play *After the Fall* – partly inspired by his life with Marilyn. In the play, two months after the characters marry, the main female character Maggie is looking for a fountain pen. Instead, she comes across her husband Quentin's notebook. It is open on a page that states the only person he will ever love is his daughter, and how he is ashamed of his new wife. Echoing what Marilyn told the Strasbergs, it even compares the negative feelings felt for his first wife with how he now feels about his second. Quentin explains to Maggie that he wrote the passage after she had screamed at him, and that he wasn't really ashamed, but by that time the damage was done.

Arthur Miller told biographer Fred Lawrence Guiles that the Strasbergs had likely remembered the scene from the play more than the actual event. He claimed not to recall the exact words he used in the notebook, but admitted that it did have something to do with Marilyn's working relationship with Olivier. He felt unable to help his wife any more and, 'I was not of any use to her or myself.'

Many people have described the notebook incident as the beginning of the end of the Miller marriage. 'It was the ultimate betrayal,' said *The Sleeping Prince* publicist Jerry Juroe. 'I always

thought that would be a good title for a book about them – *The Ultimate Betrayal.*' Certainly, Marilyn could have felt that way at the time. Living in a strange country, surrounded by people who all seemed to know each other, with their in-jokes and memories, Miller was one of the few people she had been able to trust. Now it seemed as though she was mistaken.

The Strasberg family told several biographers that Marilyn found the notebook six weeks into the England trip. This dating is crucial because it coincides with Marilyn's first absence from the set, on 22, 23 and 24 August. It also came at the same time as an emergency recalled by Jerry Juroe.

During what is believed to have been the early morning of 22 August (just hours after Marilyn finished the caviar scene), Jerry was awoken by the telephone. The caller was Milton H. Greene, who had been spending the evening in London. He requested that the two men travel to Parkside House together because he had received word that something frightful had happened to Marilyn.

Juroe picked Greene up and the two raced to Surrey, not knowing what they would be faced with. When they eventually arrived in Englefield Green, it was discovered that Marilyn had suffered a suspected overdose, and was en route to a local hospital, under the name of Miss Baker. Once she was treated, the actress returned to Parkside House, where she was to recuperate privately.

This incident is hinted at in *After the Fall*, when Maggie first broaches the subject of the notebook. In the scene, she tells Quentin that she wanted to die when she read his words. In a nod to previous suicide attempts, Quentin responds by reminding her that she tried to die long before they had met. There is no evidence to suggest that Marilyn's suspected overdose was a deliberate attempt to take her own life, and it could very well have been an accident after mistakenly taking too many pills. One thing we do know, however,

is that the prescription drugs kept coming, and Marilyn's insomnia continued.

In the days ahead, even the most discreet staff at Parkside couldn't help but notice that there was a sudden shift in both the atmosphere and Marilyn's wellbeing. Alan, the young man assigned to play piano at the house, later recalled that though he didn't know about the diary incident specifically, he couldn't help overhearing arguments and witnessing Marilyn's declining health: 'Marilyn was certainly ill, I could tell. While she often went out when she was supposed to be ill, there were times when she was actually ill, there was no mistake about that. She was miserable and puffy and her temper was short. She had a temper towards Arthur mainly – it was hot and strong.'

The actress never spoke publicly about the notebook incident, but did address the issue of Miller's disappointment, some years later, during a conversation with journalist W. J. Weatherby. She told the writer that she could be a monster at times, and Arthur was shocked when he saw that side of her. 'I disappointed him when that happened,' she said, but then emphasised that if he loved her, he should have been prepared to love that side of her as well.

There can be no doubt that Marilyn often experienced deep emotional pain, and the notebook incident was one of many life events that had contributed to her fragile health. An unstable childhood, complete with an institutionalised mother and absent father, meant that Marilyn had grown up with little self-belief. Yes, she had become one of the most famous women in the world, but her career seemed to be one long fight. From trying to get a dressing room on the set of *Gentlemen Prefer Blondes* through to demanding respect and a decent level of pay for her work, Marilyn's life was rarely easy.

In recent years, Marilyn's own journals and notes have come to light, and several – written on Parkside House stationery – show

her heartache and mood during this time. In one piece, she details watching Miller sleep as she thinks about death. Marilyn wonders if she would rather her lover die, or watch his love for her die. She speaks about pain – his and her own – and reveals that she cannot feel joy. In another note, apparently written in the middle of the night, Marilyn describes how the silence hurts her head, and then in a nod to her insomnia, she talks about the monsters that visit her in the darkness, when the rest of the world is sleeping.

The notes are undated, so it is not clear if they were written before or after she found Miller's own notebook. However, more than one of the jottings appears to be about the couple's love and, in possible recognition of Miller's disappointment, Marilyn writes that having his heart was the one proud thing that had happened to her. Tragically, she admits that being someone's wife has always been a terrifying thought, since she believed it was impossible truly to love another. Marilyn worries about the passing of her youth; how time has changed the way Miller looks at her, but for now he remains asleep beside her.

'My sleep depends on my state of satisfaction,' Marilyn once said. 'And that varies with my life.'

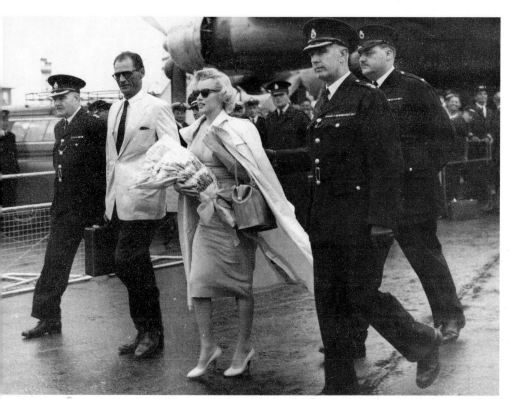

arilyn and Arthur arrive at London Airport, in July 1956. *(Keystone Press/Alamy Stock Photo)*

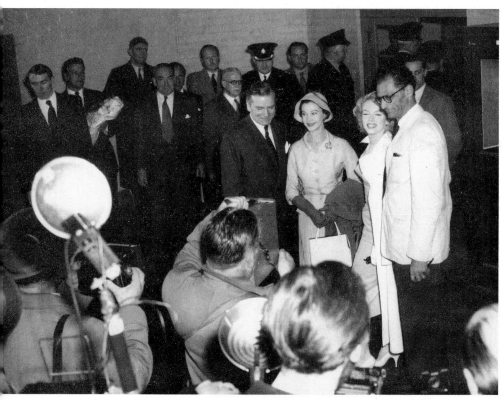

ptimism was high when the Oliviers greeted the Millers at London Airport. *(Keystone Press/Alamy Stock Photo)*

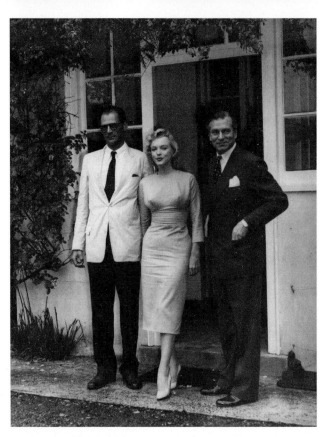

The Millers were surprised to find that Parkside was a mansion. Marilyn had expected a cottage. *(Keystone Press/Alamy Stock Photo)*

Photographers clamber to take photos of Marilyn, Olivier and Miller, at the Savoy Hotel. *(Keystone Press/Alamy Stock Photo)*

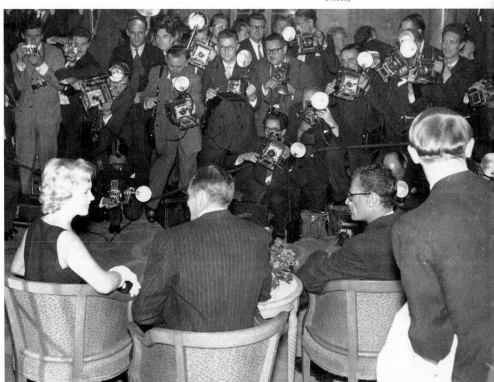

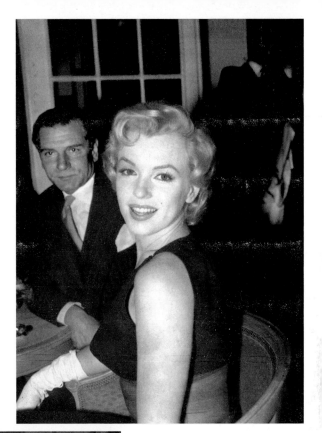

Marilyn smiles for the photographers, while Olivier looks on.
(PA Images/Alamy Stock Photo)

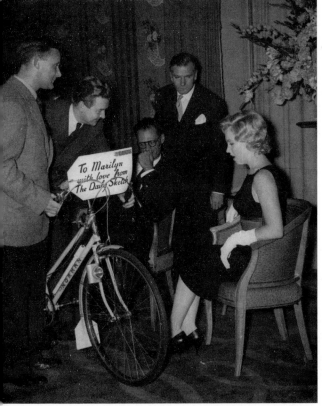

When Marilyn announced that she'd love to go cycling, the *Daily Sketch* was happy to provide her with a bicycle. (*Keystone Press/Alamy Stock Photo*)

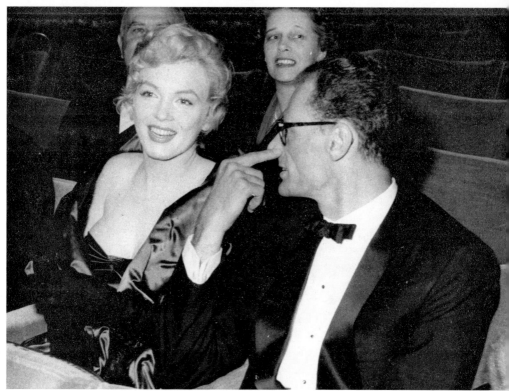

Marilyn and Arthur at the opening of *A View from the Bridge*. *(Keystone Press/Alamy Stock Photo)*

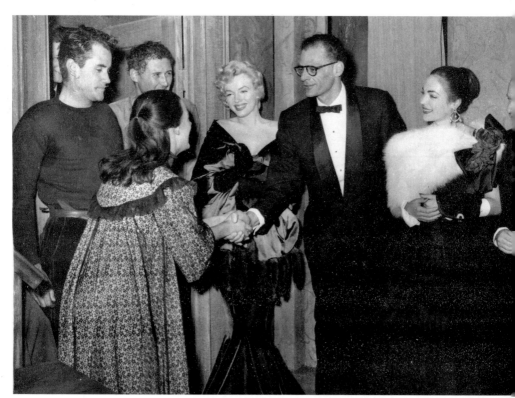

The Millers greet the cast of *A View from the Bridge*. *(Keystone Press/Alamy Stock Photo)*

Marilyn and Vivien Leigh may be smiling, but they didn't particularly care for each other. *(Keystone Press/ Alamy Stock Photo)*

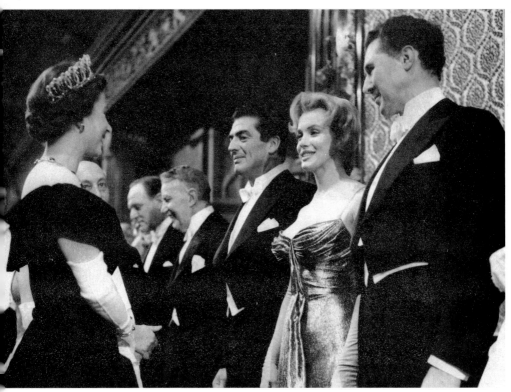

The highlight of the England trip – when Marilyn met the Queen. *(Trinity Mirror/Mirrorpix/Alamy Stock Photo)*

At the Royal Court Theatre, to watch a discussion about British theatre. *(Keystone Press/Alamy Stock Photo)*

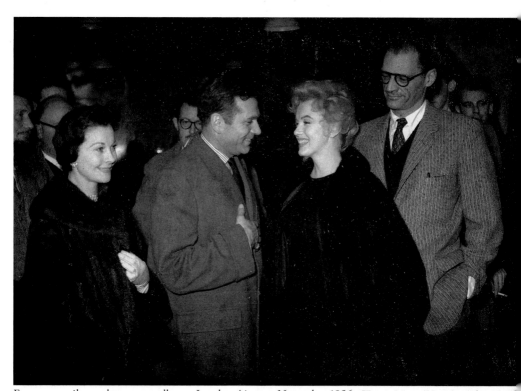

Everyone smiles as they say goodbye at London Airport, November 1956. *(Trinity Mirror/Mirrorpix/Alamy Stock Photo)*

In her role as Elsie Marina. Marilyn
had never looked more beautiful.
(Everett Collection inc/Alamy Stock Photo)

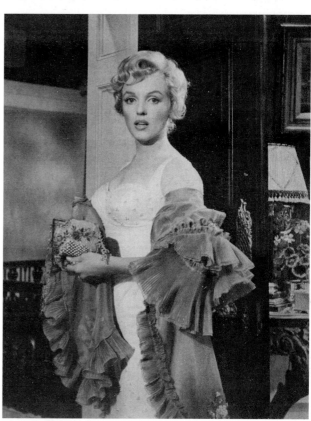

Elsie Marina greets her friends from
the embassy balcony. *(Everett Collection
inc/Alamy Stock Photo)*

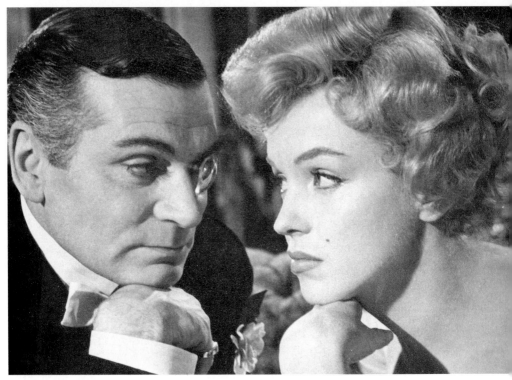

This may be a publicity photograph, but it captures the stars' distaste perfectly. *(Granger Historical Picture Archive/Alamy Stock Photo)*

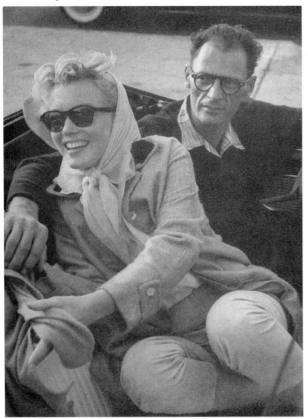

After the England trip, Marilyn and Arthur tried to lead a quiet life in New York and Connecticut. *(Paul Schutzer/ Getty Images)*

Chapter Seven

Ambitions of Royalty

From the very beginning of the England trip, Marilyn made it clear to her entourage that she would like to meet one of the most famous women in the world – HRH Queen Elizabeth II. Her dream was to have tea at Buckingham Palace, and publicist Alan Arnold found the request on his daily to-do list. The publicist promised to bring the task to Olivier's attention, but the actor deemed it inappropriate for Marilyn to meet the Queen, and scrubbed it from the memo.

Marilyn's fascination with Her Majesty grew as time went on, and publicist Jeanne La Chard was her go-to adviser on all things British. Before long, the actress had bought gloves from Cornelia James and Harrods, Rose Geranium perfume from Floris, a dressing gown from Simpsons of Piccadilly, and a towelling robe from Liberty. All of the stores or brands had one thing in common – they were favourites of the Queen and her family.

And then, in the midst of Marilyn's breakdown, rumours were starting to abound that her dream of meeting the Queen might come true in the shape of the Royal Command Performance of the film *The Battle of the River Plate*. 'The choice has not yet been made, but Miss Marilyn Monroe can hardly be over-looked,' said

a reporter at the *Northern Whig*. Sure enough, shortly afterwards, a courier walked up the Parkside House drive, clutching an invitation to the Royal Command Performance. Marilyn was thrilled and accepted immediately. It may not have been tea and scones at Buckingham Palace, but it was a start . . . And it was also a clear indication to Olivier that just because he felt Marilyn Monroe was an unsuitable candidate to meet the Queen, advisors at Buckingham Palace did not.

By this point, Olivier had more important things to think about than Marilyn being friendly with the Queen. Not aware of the notebook and subsequent fallout, the leading lady's absence from the set of *The Sleeping Prince* was not only inconvenient, but also confusing. Some cast and crew wondered if it was a direct result of the sickly caviar scene, while others – including publicist Alan Arnold – considered the option that Marilyn may be pregnant.

On Wednesday 22 August – the first day of her absence after the notebook incident – Arnold went to see Olivier, and found him agitated about what the press would say if they found out Marilyn was missing from the studio. Arnold suggested they could say that the actress had a cold and could not return to Pinewood until she was fully recovered. Olivier thought for a moment and then agreed that it was a possibility.

'But for goodness' sake,' he added, 'no talk of being sick or vomiting.'

Arnold prepared himself for a deluge of calls from inquisitive journalists, but none came that day or the next. Then on Friday 24 August, David Lewin from the *Daily Express* received word that Marilyn was absent and the shooting schedule had been rearranged. He put in a call to Pinewood and, in spite of Olivier's protestations, was informed that Marilyn was suffering from stomach trouble, caused by nerves and 'settling in to English cooking'.

On the same day, Marilyn phoned in sick once again, and although still fragile, travelled into London. Wearing a black, fur-trimmed suit, but no wedding ring, she was tracked down to a restaurant in Coventry Street and, as she tried to eat her lunch, a *Daily Mirror* photographer and journalist snapped away blatantly. Then when she arrived on Regent Street, her dark glasses did nothing to disguise the fact that she was *the* Marilyn Monroe. Within minutes, teenage autograph hunters surrounded the actress, jostling her and spilling out all over the road. Traffic was brought to a standstill, and cars beeped as fans happily ran in front of them for a better look. Finally, nearly a dozen policemen arrived on the scene, and Marilyn was hurried into a nearby department store, where she bought clothes for her stepchildren.

Arthur Miller had been working in London that day, and after the craziness of the shopping expedition, the couple reconnected and visited actor Anthony Quayle. Miller hoped that Quayle would star in the London version of A *View from the Bridge*, and as the two men discussed the role in the actor's flat, Marilyn apologised, explained that she had been mobbed by fans, and went to the guest bathroom to straighten herself up. When she didn't return, Quayle went to see what was wrong and found Marilyn stuck in the bathroom, having accidentally wedged the rug under the door, causing it to jam. Instead of calling for help or trying to straighten the rug herself, the actress had sat down and waited for somebody to rescue her. Over the course of the next few months, Quayle saw rather a lot of the Millers, and found Marilyn to be enchanting, though self-destructive.

While all this was going on, it was announced that the Parkside butler and cook had been fired. The official line was that the Millers were displeased with the couple. 'We were not satisfied with the way they ran the house,' said Miller. 'And we were not used to the kind of food they gave us.' However, in his autobiography,

Timebends, the playwright revealed that the servants had told reporters of conversations that took place in the house. According to Miller, a security man interrogated the couple and threatened them with deportation if they did it again.

Certainly, private details of their stay had been shared with at least one newspaper. In early August, the cook told a reporter that Miller spent his days either sitting at his typewriter or playing the piano, before heading out in the chauffeur-driven Humber to visit Marilyn at Pinewood. The butler – the cook's husband – added his thoughts that it was a shame the Millers couldn't spend more time together.

'They certainly are happy,' he said, 'but they don't get enough time alone for honeymooners.' His wife added that while the Millers were apart during the day, they made up for it in the evening. Around the same time, little details appeared in the press about what time Marilyn went to bed and when she walked around the gardens. Were the Millers afraid that the servants were now going to sell stories of Marilyn's breakdown? It remains unknown, but the timing of the dismissal cannot be ignored, and the couple were eventually replaced by two Italian servants.

On Saturday 25 August, Marilyn and Arthur put aside their differences and spent time together in the garden at Parkside House. Meanwhile, a huge photograph of the actress appeared on the front page of the *Daily Mirror*, which showed her dining in London the day before. When publicist Alan Arnold saw it, he was shocked. For days the cast and crew had idly waited to see if she would show up at the studio, and now here she was, appearing to be 'hugely enjoying life'. Since nobody on set knew about Marilyn's illness, it was astounding for them to see her out and about in London on a day when she was supposed to be working. The cast and crew could only hope that she would be back on set after the weekend.

* * *

On the evening of Sunday 26 August – just days after the journal discovery – Arthur Miller left England and returned to the United States. The timing of this trip could not have been worse, and over the years, some have questioned if Miller was running away because he could no longer cope with Marilyn's health issues. Jeanne La Chard described his departure as unexpected, but actually the US visit had been planned since the beginning.

On 26 July, just twelve days into the England trip, *Daily Express* columnist David Lewin had written about Miller's future plans. Lewin disclosed that Miller planned to return to the US at the end of August, though wondered if the trip would cause trouble for him, with regard to the issues Miller was having with the House Un-American Activities Committee. It was clear to the reporter that the playwright had two choices – either cancel his trip and stay in London until the end of production, or go back to the States and risk not being able to return to the United Kingdom. In the end, Miller felt it was worth the risk.

Marilyn – wearing a raincoat, headscarf and dark glasses – accompanied Miller to London Airport, and as photographer Stanley Meacher lifted his camera, the couple exchanged pleasantries in the back of their chauffeur-driven car. They both managed to smile, and then Marilyn touched her husband's shoulder before kissing him goodbye. As he exited the car, a reporter from the *News Chronicle* asked why Miller was leaving England.

'I'll be back in just ten days,' he said. 'I'm only going back to see my eleven-year-old daughter and nine-year-old son.'

On his arrival in New York, reporters waited to pounce, but were more concerned with Miller's political problems than they were about his wife. Demanding to know if he planned to name names during the inquiry, the playwright shook his head. 'My conscience will not permit me to use the name of another person,' he said,

before adding that he had no plans to make the United Kingdom his permanent home.

On Monday 27 August, the cast and crew of *The Sleeping Prince* were due to film scenes related to Elsie Marina and the Prince's first meeting in the embassy hall. It required the presence of Marilyn, Olivier, Richard Wattis and Paul Hardwick, along with actors playing the footmen and the chauffeur. Marilyn was due at Pinewood by 6.45 a.m., but as she hadn't been seen since 21 August, cast and crew wondered if she'd make it at all. They were pleasantly surprised. Although she did not arrive by her call time, Marilyn did appear at 7.25 a.m. and was impeccable on set. So much so that, for the first time, there were no delays whatsoever.

There were, however, concerns about her health. Publicist Alan Arnold watched the actress on set, 'and saw a woman immensely sad, half alive, missing the man she loves.' He surmised that work was the last thing on her mind that day, and wondered how Marilyn felt, knowing that she'd be going back to Parkside alone for the foreseeable future.

She may have been buoyed had she seen a copy of Roberta Leigh's newspaper column, published on the same day. In it, the journalist wrote about her envy that Marilyn was a woman whom no one could order around. Calling her 'the boss-woman with the greatest impact on Britain at the moment', Leigh spoke about Olivier, Dame Sybil Thorndike and Marilyn working together: 'I've nothing but admiration for a girl who, becoming tired of being the dumb belle of the ball, has the courage to compete with such acting experts as the Knight and the Dame.'

As Roberta Leigh expressed her respect for Marilyn, Michael Gill, producer for the BBC's North American Service, decided that now would be a perfect time to ask the actress if she would take part in a radio programme he was putting together. The show would be a celebration of NBC's thirtieth anniversary, and Gill imagined

himself turning up at Parkside with his tape recorder, where Marilyn would record her memories of childhood radio shows. Unfortunately for the producer, he needed the interview to be completed by the following Sunday and – as Marilyn's representatives had already told the BBC – she had to concentrate solely on *The Sleeping Prince.*

The next day – 28 August – Vivien Leigh left Notley Abbey and drove to London in order to continue house hunting, have lunch with friends, and then see a matinee of the West End production of *The Rainmaker.* Afterwards she popped into Lowndes Cottage, where she spoke to columnist David Lewin about her plans for the future. The actress explained that while she and Olivier would love another baby, they would have to seek advice before making any firm decisions.

'I don't want to do anything now except rest and have a holiday,' Leigh said. But she knew she would have to go away on her own, since her husband would be making *The Sleeping Prince* until November. 'I don't feel like rushing about so there is no question of starting work immediately,' she told Lewin. After the meeting, Leigh headed to Pinewood, where she slipped onto the set of *The Sleeping Prince.* The actress watched Olivier work on the last scenes of the day, and then the couple headed back to Notley.

For the next three days, Marilyn arrived at the studio between 7.20 and 7.25 a.m., and although she did cause several on-set delays on Tuesday and Wednesday, by Thursday 30 August there were no delays at all. Hopes were raised that, from now on, the shooting of *The Sleeping Prince* would be relatively stress free. Unfortunately, they were to prove illusory.

On Friday 31 August, Olivier received word that Marilyn would be unavailable for work. Frantic calls were made to Parkside House and, when they proved unsuccessful, Milton H. Greene and Olivier huddled together, desperately trying to rejig the timetable. Meanwhile, everyone else still appeared on set, unsure if Marilyn would surprise them and turn up anyway. She didn't.

The weekend was a lonely one for Marilyn; her husband still thousands of miles away, and her faith in her work was fading more each day. Not even Hedda Rosten and Paula Strasberg could lift Marilyn's mood, and housekeeper Dolly Stiles remembered that the actress spent hours alone in her bedroom, choosing to receive no visitors.

The August weather had been pretty dismal, with showers and cooler temperatures felt throughout the country, and the first weekend in September was just as unpredictable. Still, the rain had given the Parkside gardens a beautiful green tone, and when Marilyn did occasionally emerge from her bedroom, she could be seen pottering around outside in her trademark capri pants and cardigan, lost in her own thoughts.

Unfortunately for Alan the pianist, Marilyn's frustration and anger were sometimes taken out on him. 'One day I wasn't there when I was supposed to be, and Marilyn exploded at me. I was very careful after that. She seemed very lonely – like she was on her own in a little bubble. Marilyn was often full of fun but at times it was like talking to a black hole.'

Adding to the actress's despondent mood was the security situation at Parkside House, which seemed to have become more draconian in recent weeks. Alan thought that the protection – still overseen by ex-policeman Roger Hunt (aka Plod) – 'was beyond all reason and she resented it. Curtains were drawn in the car; no waving allowed; police at the gate, on the drive and the porch . . . it was far too much and far in excess of reason.'

Also of concern was Marilyn's suspicion that Hunt may be keeping notes about her for Olivier's benefit. She was livid. 'She reacted badly,' remembered Alan. 'There was no more politeness with Plod. He would go hopping mad – he was in cahoots with [Colin] Clark and Marilyn would like baiting them. One day Plod caught me coming back into the house with Marilyn and it was

very unpleasant. "Where have you been?" he shouted at me. "Sorry, what do you mean?" I asked. "I've been out." "Don't be cheeky young man," Plod said.

'I told him that I work for Marilyn – to Plod she was always Mrs Miller – and that if he wanted to know, he should ask her. Plod got very worked up and Marilyn overheard. She came out and told him that he was very much out of order and what I did was none of his business. She told me to go with her into the drawing room, and closed the door. "Never mind him," she said and gave me a kiss. He had started out being an old uncle but there was more to him than that.'

On Monday 3 September – the same day that author Pete Martin's book about her life appeared in British bookshops – Marilyn called in sick again. Olivier was furious and sent press officer Jeanne La Chard to Englefield Green, but she found the actress in no mood to work. Still recovering from the notebook episode, and now without her husband, Marilyn's depression had worsened. La Chard wrote: 'Miss Monroe started to come apart at the seams. I was assigned to get her to the studio on time. Fat chance.'

By now, reporters had received word that Marilyn was sick again, and they didn't hesitate to sneak into the Parkside grounds to get the scoop. Wary of the cook and butler who had been fired, the remaining staff were unwilling to take any chances. 'I'm not allowed to say how serious her illness is,' said one. 'I can't say anything.'

Representatives at Pinewood repeated the story they had used before – that it was all just a tummy upset brought on by nerves or a change in food. This led several reporters to wonder if Marilyn's diet of salads and constant milk drinks was to blame, but they were unable to find out for sure.

Three doctors were called to Englefield Green, among them Arthur Connell, who practised in nearby Sunningdale but occasionally treated the residents of Parkside. In his 1978 autobiography,

the owner of Parkside, Charles Moore (Lord Drogheda), described Connell's care of Marilyn as 'an arduous task', though he opted not to elaborate.

Rumours circulated that Marilyn was pregnant, and the idea of a miscarriage in England is something that is still debated today. However, in 1958, Marilyn visited Hollywood doctor, Michael Gurdin, and he made note of her medical history. A 1957 miscarriage was recorded, but there was no mention of one during the England trip. What his records did reveal was a diagnosis of neutropenia – a low white blood-cell count – which was said to have been found during the making of *The Sleeping Prince*.

Instead of a miscarriage, it would seem likely that Marilyn was experiencing an agonising bout of endometriosis, a debilitating condition where tissue similar to the lining of the womb grows outside of the uterus, often in the fallopian tubes and ovaries. Marilyn had been haunted by endometriosis since her teenage years, and it had often caused her to have excruciating pain during her period.

Throughout the England trip, her entourage would be sent out to find pain relief, but the strict British doctors would rarely give the doses Marilyn was used to taking in the States. Paula took it upon herself to nurse the actress as she cried into the night, but there was no hope of getting her into Pinewood the next day.

On Tuesday 4 September, John Barnard Blaikley arrived at Parkside. He was a top surgeon and gynaecologist, known as 'Honest John', who worked privately and at various hospitals, including Guy's in London. When he arrived at the house, Blaikley spoke to Marilyn and then performed a 'consultation and examination under anaesthesia', which cost a little over £52. It is not known exactly what kind of treatment was carried out on the actress, but it should be noted that Blaikley treated many women with endometriosis and wrote extensively about the subject during his long career.

On the same day as her visit from the gynaecologist, Marilyn made a call to Arthur Miller, and observers noted that she seemed somewhat happier after talking to him. There was a reason for the uplift in her spirits – Miller was on his way back, and arrived in England on 5 September. Travelling under the alias of Mr Brown, the playwright expected a quiet arrival, but undaunted reporters were already at the airport to grill him about the state of his wife's health.

He dismissed rumours of a pregnancy as 'absolute rubbish', and denied that Marilyn had asked him to rush back to Britain, 'But she did tell me she was not well.' And what about the stories of gynaecologists visiting Parkside House? 'I admit I don't know about that,' Miller said, 'but I can assure you there is no baby on the way.' When another reporter pushed the pregnancy rumour, Miller was furious. 'Marilyn Monroe is not having a baby,' he snapped. 'I have returned because she has – stomach ache.'

Apart from a short business trip to Paris in November, Arthur Miller would be by Marilyn's side for the rest of the trip. However, despite Jeanne La Chard's best efforts to get Marilyn out of Englefield Green, the actress stayed away from the set of *The Sleeping Prince* for the rest of the week. Relations between her and Olivier were already fraught, and made no better when Marilyn, Arthur and friend Hedda Rosten were spotted at the Palace Theatre, London, on the evening of Friday 7 September.

Arriving ten minutes late for a production of *The Caucasian Chalk Circle* by Bertolt Brecht, Marilyn – wearing a high-necked black dress – was hounded as the group exited the car. Their arrival caused such a ruckus that theatre manager, Harry W. Briden, wrote about it in his desk diary. According to Briden, members of the press crashed their way into the theatre in order to get a better look at Marilyn, though press reports that the Millers drank gin with Briden in his office went undocumented.

Theatre World described *The Caucasian Chalk Circle* as '2 stories linked by a slender thread . . . Based on a Chinese legend, the first tells of the rescuing of the Governor's abandoned baby by Grusha, a kitchen maid, and the second the rise of a disreputable village secretary to the position of judge.' Masks, colourful costumes and stylised movements were used to provide contrast between the characters.

Marilyn watched the play intently but, afterwards, the press mocked her by saying that she had to ask Arthur Miller to explain it, since she couldn't understand the German language. In an interview with Thomas Wiseman, Miller vehemently denied this: 'The truth is she was very interested and I don't speak German and she'd been talking to a lot of people about Brecht in New York and knew what it was about.'

The theatre trip did nothing to heal the working relationship between Olivier and Marilyn, but it did seem to thaw the chill between the actress and her husband. Fellow theatregoers told reporters that the couple held hands during the performance, and afterwards all occupants of the chauffeur-driven car looked happy. As they drove away from the theatre, even the normally glum-looking Miller was photographed hugging his coat and laughing wildly.

On Sunday 9 September, Marilyn and Arthur drove from Englefield Green to the Comedy Theatre in London in order to announce the forthcoming performances of Miller's play, *A View from the Bridge*. An advert in *Theatre World* declared that the announcement was 'Undoubtedly the most interesting event for the London Theatre during the past months.' The opinion of the *Stage* newspaper was equally as glowing, and promised that the play would be 'One of the most ambitious club theatre ventures to be planned for the West End.'

The project was to be presented by the New Watergate Theatre Club, which showcased performances deemed too controversial

for regular theatregoers (in this case the Lord Chamberlain refused a public licence because the play included references to homosexuality). The idea of the organisation was simple. Those interested in seeing the play could join the exclusive club, and then they would be given access to a maximum of four tickets for any performance. Because it was private, there should be no complaints about content, and there was the added bonus that publicity for the 'banned play' would also help ticket sales. In the end, nine extra assistants were hired just to keep up with the heaps of enquiries and membership forms, and based on that alone, the play looked as though it would be a brilliant success.

It was Arthur Miller's evening, but it was Marilyn the people came to see. Sat on the stage with some of the cast and crew, including director Peter Brook, actor Anthony Quayle and her husband, Marilyn watched as Arthur introduced his play to the audience. Wearing a smart black suit and smoking a pipe, the playwright explained that A *View from the Bridge* had begun as an experiment for 'something just like this venture, for people who love the theatre'.

Columnist William Hickey was keen to know what Miller thought of the censorship he'd faced in Great Britain. 'As a playwright I loathe any form of censorship,' he said. 'But I am a foreigner in your country and so I do not think I have the right to criticise your customs.'

Marilyn was asked if she would attend the opening night of the play, and smiled. 'I hope to be there,' she said quietly. 'I agree with my husband. I think it would be wonderful if we had something like this theatre club in New York.' After that, Marilyn sat back in her chair for the rest of the evening, and let the others speak. Considering the hard times she had been through recently, the actress looked fairly happy, though there were times when she appeared tired and thoughtful – which the attending press made sure to comment on.

Anthony Quayle disclosed that he was excited about the new venture, but thought it 'extremely risky. We are going to need a tremendous number of members.' The audience listened as the principals spoke, and then Ian Hunter, a representative from the New Watergate Theatre Club, stood up to explain that members would likely be screened before they could join. 'Marilyn has been screened already – through her husband,' Hunter said, to a great round of applause.

During an interval, the actress signed the first membership form and paid her five-shilling subscription to the club. The private audience cheered, and then eventually it was time to leave, but as the couple appeared at the stage door, their car was nowhere to be seen. While their entourage scrambled to find it, photographer Douglas Burn took the opportunity to talk with Marilyn. 'I found Miss Monroe easy to chat to in every way, and so was her husband,' he said.

The actress told Burn that she was feeling much better after her recent illness and planned to pop into Quaglino's restaurant before heading home. Since the car couldn't be found, Marilyn said that she and Miller would probably just walk there instead. 'I advised her against it,' Burns said, explaining that she would have to cross Regent Street to get to the restaurant. 'I doubt whether she would have escaped the crowds had she done so.'

The next morning, some of the articles about the event were less than positive. Reporters had been – for the most part – warm in their stories of Marilyn's trip to England, but now there was a definite cooling towards her. The *Daily Sketch*, which had presented Marilyn with her own bicycle less than two months before, was positively cold. Calling her appearance a 'strictly dumb blonde role', they complained about Marilyn's lack of words, and decided that she was there only to help sell tickets. When the *Sketch* reporter had asked Marilyn her opinion of the London performance of *A View*

from the Bridge, she had remained quiet and instead looked at Miller. The playwright told the reporter that his wife couldn't have an opinion yet. 'I mean she's only heard the echoes,' he said.

Marilyn was back on set on Monday 10 September, and it was a fairly positive week. Her timekeeping was not perfect, but she was never later than 8.05 a.m., and on Thursday and Friday she didn't hold up production at all.

By this time, Olivier's friend and journalist Radie Harris had received word of the arguments between the two actors, and took it upon herself to send Olivier a bundle of negative newspaper clippings. The actor told her he had no time to read them or defend himself from destructive press, and that everything was going wonderfully on set. Even the stories of Marilyn's week off were brushed over, when he told the writer that they managed to work perfectly well around her, and that he found the film to be beautiful and exciting.

Around this time, Marilyn's analyst, Dr Margaret Hohenberg, flew in from New York. Dr Hohenberg had been treating the actress for over a year (after a recommendation from former patient Milton H. Greene), and was considered such an influence that she was even consulted on matters of a business nature. Hohenberg couldn't stay in England indefinitely, however, so at some point she took her patient to see Sigmund Freud's daughter, Anna.

A pioneer of child psychoanalysis, Anna Freud lived and worked at 20 Maresfield Gardens, the London home she had once shared with her father, Sigmund. It was an unusual choice to take Marilyn to a doctor who normally worked with children, but Hohenberg knew Anna, and felt that her approach would suit the patient.

Freud's home was a large, red-brick building with three storeys, neatly trimmed hedges and a blossom tree in the front garden.

When Marilyn arrived at the home, she was taken up to the top floor, a space in the attic which contained a waiting area, secretary's office and Anna's long, narrow consulting room.

The therapist's taste in decor was informal, and the space where Marilyn was treated consisted of brown wooden furniture, two couches with earth-toned coverings, bookcases, tables with colouring supplies, and several filing cabinets. One of the couches sat next to a fireplace, with a portrait of Sigmund Freud hanging above, and the entire room was filled with light from the large windows. Unfortunately, no records remain of Marilyn's trip to Anna Freud's office, but we can get an idea of how she would have been treated by looking at the techniques Anna normally used on her patients.

The therapist believed that children should all be treated as individuals in their own right, and sessions did not often involve sitting on a couch. Instead, Anna encouraged her patients to draw pictures and move around the treatment room freely. If the child opted to sit on the rug, Anna would think nothing of joining them there. The therapist's priority was to create an atmosphere of trust and alliance – something that Marilyn had not felt during her time at Pinewood Studios.

Because no records survive, we do not know the exact dates of Marilyn's treatment or how long it lasted. However, we do know that Anna was holidaying in Suffolk that summer, and as it was her routine to be back in London around early to mid-September, we can surmise that the treatment came sometime after this.

The details of Marilyn's association with Anna may be shrouded in mystery, but the therapist must have had some influence, as Marilyn later asked Anna's advice while seeking a new analyst in New York. Furthermore, while she had been interested in Sigmund Freud before 1956, Marilyn began studying him more religiously after her sessions with Anna. 'He's the one I believe in,' she told Logan Gourlay in 1960. In 1955 she had spoken to the same

reporter about therapy: 'I'm not taking a full course. But I don't scoff at psychiatry. It's very useful to know what makes you tick when you come up against an emotional crisis.'

Film-maker Albert Maysles – brother of Milton H. Greene's assistant David – was to meet Marilyn at Pinewood Studios later in the trip. The actress heard that Albert had made a film in psychiatric hospitals in the Soviet Union, and wasted no time in speaking to him about it. 'Wrapped in a towel she asked me, as if to question my credentials, if I myself had ever been psychoanalysed. I thought that was clever of her.'

Away from any problems Marilyn faced at home and at work, the actress found time to create a work of art in aid of a forthcoming charity auction. The actress often expressed herself creatively, but normally only shared her work with her close circle. This time, however, she was willing to let the public see her talent, and came up with an abstract picture of a woman sporting long hair and bending over at the waist.

The artwork has since been christened *Myself Exercising*, and the actress signed it as Marilyn Monroe Miller and dated it September 1956. The broad, yellow strokes of the picture did not appeal to everyone, however, and on 13 November – the night of the auction – there was little interest. However, playwright Terence Rattigan did see the brilliance of the piece and won it with a proxy bid of £40.

Back in September, while British journalists were growing a little bored of reporting Marilyn's every move, fans were still fascinated. However, this interest was to get an unnamed nine-year-old girl hauled into court on the morning of 12 September. The charge? Fighting with a teenager in the street. According to the unnamed fifteen-year-old, she was walking home from work when the younger child started 'taking the Mickey' by calling her names and seemingly imitating her walk. The teenager was not impressed,

and a fight broke out between them, leading to accusations of attacks with a bag, a bottle and a broom. When the matter went to court, the younger child was asked if she had made fun of the teenager. 'No,' she replied. 'I was imitating Marilyn Monroe.' She was asked if the fifteen-year-old walked like Marilyn, to which she replied, 'She walks like a Teddy Girl,' and surmised that Marilyn walked a bit like a Teddy Girl as well. Despite accusations flying from all sides, the case was eventually thrown out, though the nine-year-old's mother was fined and bound over for twelve months, having allegedly assaulted the teenager herself.

Another fan who made the headlines was Willenhall councillor C. J. Andrew, who decided that instead of standard road-safety signs, the council should use photos of Marilyn on her bicycle. 'It is time we put a bit of life into our methods of educating people to keep death off the road,' he told the Darlaston and Willenhall Joint Road Safety Committee.

The *Birmingham Gazette* thought it was a terrible idea, and said as much in the 15 September edition of the newspaper. Claiming that he admired Marilyn, the reporter said that he would like to see her on the screen, 'rather than dominating our already congested streets or confronting us as we manoeuvre a dangerous corner'.

Marilyn had managed an entire week on set without calling in sick, and cast and crew headed into the weekend of 15–16 September quietly confident that they had all turned a corner. The actress was due back on set on Monday the 17th, though first the Millers were invited to a Sunday evening dinner party at the home of theatre critic and writer Kenneth Tynan and his wife Elaine. There were to be fourteen at dinner – including the Tynans and Millers – and a caterer had been hired especially for the evening.

While Marilyn had enjoyed the joyful, jazz-filled Terence Rattigan party, the actress didn't always care for formal, sit-down

dinner parties. Friends who witnessed her at such events would talk of her preoccupation with emptying ashtrays, or a sudden need to find a book on a nearby shelf. Early agent and lover Johnny Hyde was concerned with Marilyn's lack of conversation at dinner parties, surmising that people may think she was dumb if she stayed quiet all evening. She spoke about the problem to journalist Liza Wilson, in 1952: 'I guess there are several reasons I feel more comfortable not saying anything, because I feel they'll only misunderstand me. When I feel a lack of contact with a person, I can't talk with him and still be completely myself.' She also spoke about the issue in 1962 to journalist Alan Levy. 'I have never been very good at being a member of any group,' she said. 'More than a group of two, that is.'

And so it was that an hour before Marilyn and Arthur were due to arrive, Tynan received a phone call from Parkside House saying that Marilyn was unable to make it, but Arthur would come regardless. Several other calls then followed, before a final message from Arthur confirmed that neither he nor Marilyn would be in attendance that evening. Miller apologised, and described his wife as hysterical. 'So is mine,' Tynan replied.

The next day – 17 September – Arthur Miller wrote a letter to Kenneth Tynan, apologising for not attending the party. The playwright described how Marilyn had been working with almost no break since January (when she had started pre-production on *Bus Stop*), and she was basically exhausted. He had felt it unwise to leave Parkside given the circumstances, and begged for forgiveness.

On the same day, rehearsals for A *View from the Bridge* began. This meant that Miller had to spend long hours in London (usually from 10.30 a.m. to 6 p.m.), and even when he returned home, he would spend further hours slumped over his desk in the Parkside drawing room, working on extensive revisions. As a result of this and Marilyn's work at Pinewood, the time the couple were able to spend together was limited.

'It's pretty horrible,' Miller said, 'this stage of getting ideas. I'm very slow at it. And often I have to work right into the night. There is no wife living, who can see her husband staring out of the window and believe he's working. So, you have to work where your wife isn't.'

Whether or not Marilyn was completely understanding of Miller's workload is debatable but, for at least part of the England trip, the couple kept separate bedrooms so that they didn't disturb each other when working late. Despite the workload, however, the playwright found himself relied upon to straighten out problems on the set of *The Sleeping Prince*, and any days off were spent at Pinewood. Shortly after production finished, actress Vera Day wrote about the subject in *Picturegoer*: 'When Marilyn was faced with a script problem, when she wanted advice, when she just wanted comfort, she would dart over to Miller.' Once with him, the actress and her husband would discuss the problems for as much time as she needed, before finally getting back to work.

In spite of the pressures, when columnist William Hickey popped into the Comedy Theatre, he found Miller to be 'unusually jolly', sitting on the stage with actors Mary Ure and Anthony Quayle and director Peter Brook. Together they were discussing the decision to ban the play. When Quayle asked the playwright to show him the lines the censor had 'blue-pencilled', Miller shook his head and explained that it had applied to the entire play.

The playwright was quietly hopeful, but concerned with how his work would be received in England, and shared his concerns with New York producer Kermit Bloomgarden. Miller feared the British just weren't interested in his kind of plays. He had been to the theatre several times with Marilyn, and at least once with Olivier, and had found – for the most part – that the plays considered to be hits were all pretty bad. Still, he persevered with work on *A View from the Bridge*; thought the sets and cast were wonderful; and believed that

Anthony Quayle could bring something interesting to the role of Eddie, the tragic protagonist.

One day during rehearsals, Miller sat in the empty auditorium of the Comedy Theatre, his legs dangling over the seat in front as he puffed away on a cigarette. He had granted an interview to columnist Thomas Wiseman, who wondered if Miller's new life with Marilyn would cut him off from the real world; the place where he found inspiration for his plays. Miller was adamant that he would still be in touch with reality, and revealed that the couple had already planned out their future. They would live in Connecticut, spurn Hollywood, and Marilyn would only make one movie every eighteen months, for a maximum of twelve weeks. 'And the other fifteen months?' Wiseman asked. 'She will be my wife. That's a full-time job,' Miller replied.

The interview was to publicise *A View from the Bridge*, but Wiseman also took the opportunity to ask if everything was OK on the set of *The Sleeping Prince*. The journalist had heard of fights at Pinewood, and that Miller had to act as a go-between for Olivier and Marilyn. 'Why would I act as an intermediary?' he asked. 'That's all part of placing us in categories and the idea that Marilyn wouldn't be able to talk to Sir Laurence, but I would.' He skirted around the rumours of on-set fights, but used his experience on *A View from the Bridge* to express how actors often think they know better than the director. Miller, however, thought Olivier was doing a wonderful job.

Despite any trauma caused by the notebook incident, the play-wright spoke lovingly about his wife. He told Wiseman that Marilyn was a warm person, and that while they may look as though they're complete opposites, they were very similar, especially when it came to honesty. Miller also disclosed that from what he'd seen of *The Sleeping Prince*, it was the best film Marilyn had ever made.

* * *

The first authorised day off for Marilyn in the now revised schedule came on Tuesday 18 September. There were only a handful of such days during the making of *The Sleeping Prince*, and the actress would use them to catch up with her rest, or occasionally escape from Parkside and take in the nearby sights.

After causing a near riot during her first shopping day in London, Marilyn knew she'd have to be careful when it came to future outings. During one free day, Jack Cardiff asked if she would like to visit an art gallery with him, but Marilyn wondered how she could go anonymously. The actress was used to moving around New York in a simple disguise but wondered if this would be enough for London. Cardiff suggested she wear a wig, and the next day, Marilyn arrived at Pinewood clutching a bright orange hairpiece. The shocked cinematographer assured her that if she went out wearing that, she would be followed not because she was Marilyn Monroe, but because people would wonder who on earth was under the horrendous wig.

Marilyn ditched the false hair, raided her wardrobe for some plain clothes, and then she and Cardiff enjoyed an incognito trip to a gallery on Bruton Street. After the success of that, the actress enrolled Alan the pianist to be her excursion companion. On the few official days off, their secret missions would begin at Parkside, though they had to be carefully orchestrated due to the curious onlookers who continued to mill around the gate. Members of the public weren't the only ones who wished to follow her, however: Plod the bodyguard wanted her never out of his sight.

With this in mind, Marilyn and Alan would wait until the security man was busying himself elsewhere in the house, then slip out of Parkside House and quietly make their escape across the back garden, through the bushes and into the property next door. There the chauffeur would be waiting to drive them away from Englefield Green, and Plod would be left alone at Parkside, wondering where they had gone.

For one adventure, Marilyn suggested they visit Salisbury because she had recently seen a print of the cathedral, and thought it looked beautiful. The friends took off in the car, and spent a couple of hours touring the place of worship and sitting quietly in the pews.

On other days, the two would head into London, where Marilyn behaved just as any other tourist did. There was a visit to Big Ben just as it chimed, and Marilyn squealed and pointed, and exclaimed that it was just like something from the movies. At Piccadilly Circus, she fulfilled her dream of seeing the 'Eros' statue, and then when the pair reached Westminster Bridge, the actress pointed and enquired about the statue there.

'Who's the broad in the buggy?' she asked. Alan laughed and explained that it was Boadicea, to which Marilyn playfully replied, 'I think you'll find that her name should be pronounced Boudicca.' The actress told Alan that she was thrilled to see the statue because she had a great love for strong women. Cleopatra's Needle was another delightful find, and then Marilyn asked to visit another location she had recently heard about – Charing Cross.

'I didn't realise you were interested in trains,' remarked Alan.

Marilyn was confused. 'Trains?' she asked.

'Yes, Charing Cross is a train station.'

Marilyn laughed, decided that she wasn't at all interested in trains, and so they visited Charing Cross Road instead; home to dozens of bookshops. 'Marilyn would make a beeline for Foyles bookshop,' recalled Alan, 'and once you got her in there, you would have to drag her out.' After adding to her book collection, the two friends continued on their journey, which included a quiet trip to the National Gallery, where the actress was able to amble around the exhibits in peace.

'Marilyn would wear various disguises – hats, overcoat and floppy hat with a shoulder bag. She always had a book or a poetry volume in the bag. Her bottom didn't wiggle – she used nothing to

associate herself with being Marilyn. Sometimes people would look to see who she was but they didn't recognise her.'

Though some did.

When Alan and Marilyn stopped at a restaurant for lunch, they both became aware of a man looking over at them. The actress was still in her disguise, but readied herself for an invasion. Sure enough, after several minutes, the man rose from his table and ambled over to Marilyn's.

'Do excuse me, Madam,' he mumbled. 'Do I have the honour of speaking to Marilyn Monroe?'

Marilyn shook her head, and immediately adopted a cockney accent. 'No lad,' she replied. 'My name is Elsie!'

The man apologised and went back to his table, though minutes later he was back.

'Do forgive me,' he said, 'but you do bear a deep resemblance to her.'

Once again Marilyn put on an accent and replied, 'Oh, lots of folk have told me that!'

'Marilyn loved voices,' remembered Alan. 'She should have won an Oscar. She was a great mimic.'

Another encounter with the great British public came when Alan and Marilyn visited Trafalgar Square, where a pigeon wasted no time in defecating on the brim of her hat. Seeing the funny side, the actress whipped out a handkerchief and nail brush, and scrubbed the stain in the fountain. That done, another unwanted guest appeared, this time in the shape of an old lady.

'She was about five-foot tall, all in black, wearing a hat with fruit and carrying a shopping bag,' said Alan. The woman circled Marilyn, and then stood right in front of her. 'By this time Marilyn was getting tense, and then the woman poked her between her ribs and said, "'Ere, you're that Marilyn Monroe tart, ain't ya?" She actually winded Marilyn with the poke. Marilyn looked down and in her "Queen" voice said, "Oh thank you, you're so kind. I'm often

being compared to her." "Snotty cow," said the old woman and stormed off. Marilyn was in hysterics laughing.'

Later that evening, Marilyn and Alan arrived back at Parkside House, and a moody Arthur Miller asked where she had been all day. He didn't really appreciate his wife sneaking out of the house with an employee and no security, and seemed disgruntled, distant.

'I learned I'm a snotty cow,' Marilyn laughed, as she readied herself to relay the story.

'Well, we all know that, dear,' replied Miller.

'Marilyn froze,' remembered Alan. 'I could feel the freeze and I made my excuses and left. Miller had no sense of humour . . . I didn't like him and found him very arrogant. He would look at me in a way that seemed like he wanted me to apologise for breathing. That wasn't Marilyn's way. She was lovely with kids and old folk; in fact, she was nice to everybody but had times when she could be "off", and then people just remember that. Arthur sized you up – you didn't count if you weren't in his group.'

On Wednesday 19 September, Arthur Miller received a telegram from producer Kermit Bloomgarden, asking if Marilyn would like to play the role of Athena in Paul Osborn's play *Maiden Voyage*. The production would be staged in New York during the winter of 1956–7, with Bloomgarden as producer.

Marilyn read the telegram when she returned home from Pinewood, and though she was honoured to be asked, she was too exhausted to think about work after the gruelling hours spent on *The Sleeping Prince*. Added to that, she and Miller were still looking for a base in New York, and if they had any hope of settling into married life, they would need some time to decompress. Miller explained the situation and apologised on her behalf.

Undeterred, Bloomgarden wrote back, and this time he enclosed the script and explained that he had wanted Marilyn for the role

as soon as she had walked into his house during a visit earlier that year. Although the actress would never act in the play, she did read the script, and rather liked the part of Hera, the wife of Zeus. She scribbled notes in the margins, and kept the text in her possession for the rest of her life.

Someone else with Marilyn in mind for a project was Dennis Vance, head of drama at the Associated British Corporation, which was part of the ITV television network. Since the beginning of 1955, the actress had made no secret of her desire to play Grushenka from the Dostoevsky novel *The Brothers Karamazov*. However, critics and journalists alike wasted no time in ridiculing her dreams and accusing her of having ideas beyond her grasp. 'It didn't bother me,' Marilyn said in November 1955. 'I knew they hadn't read the book. Or if they had, they had forgotten it. Actually, it would make a wonderful movie. Samuel Goldwyn himself told me that. I'll take his word for it.'

In August 1956, director King Vidor revealed that he and producer Dino De Laurentiis were interested in Marilyn playing Grushenka in their planned version of *The Brothers Karamazov*. Possibly prompted by this news, Dennis Vance made contact with the Monroe camp in late September. He informed Marilyn that he too was planning to make the book into a movie, and the part was hers, 'Anywhere, anytime . . . Plenty of time after the filming of *The Sleeping Prince* is finished.'

It was reported that Marilyn was thinking it over but, ultimately, she turned down the role. 'So sorry,' she said, 'but I only have one week in England after finishing *The Sleeping Prince* and there just wouldn't be time.'

In hindsight, there was simply no way an exhausted Marilyn could have stepped straight out of *The Sleeping Prince* and onto the set of *The Brothers Karamazov*. Still, it is poignant that the offer she had coveted was to come her way while in England, when all

she could think about was heading back to New York. In the end, Marilyn would never be destined to play the role of Grushenka in *The Brothers Karamazov*. When MGM asked the actress if she would consider the part in 1957, she turned them down because she wanted to be near Miller during his political troubles, and wanted to have a baby. An MGM movie was eventually released in 1958, with Maria Schell as Grushenka and Yul Brynner as Dmitri Karamazov.

Deliveries continued to arrive at Parkside House. Some of the letters offered Marilyn work, while others asked if she would appear at garden fetes, seaside pavilions and nightclubs. Hedda Rosten sifted through these and hundreds of pieces of fan mail on a daily basis, and then organised for replies and signed photos to be sent out.

For over a year, Hedda and her husband Norman had been friends with Marilyn in New York, accompanying her to the theatre, the seaside and on shopping trips. She had been excited to come to England as Marilyn's personal secretary, but she discovered that the experience was far from enjoyable, and she soon found herself homesick for New York.

Hedda and Marilyn would often sit together at Parkside and talk about the troubles on the set of *The Sleeping Prince*. Hedda would nod, sympathise and take Marilyn's side, but when alone with Arthur, she confided her worries about her friend's health and tried to solve what she saw as problems within the Miller marriage.

Despite her best intentions, by the middle of September, Hedda was drained. She had grown to believe that perhaps everything on set wasn't as bleak as Marilyn painted it to be, and attempted the bold move of speaking to her about it. Hedda tried to get the actress to see events from a different angle, and offered the notion that maybe Marilyn sometimes took Olivier's words the wrong way. The hypothesis was not welcomed and, from then on, Hedda believed that her faithfulness was being questioned. Although she still loved

and worried about Marilyn, Hedda gave up her role as secretary and headed back to New York.

On Friday 21 September, Doris Day was ousted from the number one chart position, to make way for Anne Shelton's song, 'Lay Down Your Arms'. This could have been a plea to Marilyn and Olivier, since rumours of a rift between them refused to go away and many wondered if they would ever declare peace.

The situation was aggravated on Monday 24 September when Marilyn was two hours late at Pinewood, and caused a delay of almost two-and-a-half hours. When an unnamed source described Olivier and Marilyn as having a 'bust-up', but offered no further explanation, it caused a sensation. The next day a journalist from the *Daily Mail* phoned Marilyn at Pinewood and managed to obtain a statement. 'I don't know where these reports came from,' she said. 'They are completely unfounded.' The same reporter tracked down Olivier, who insisted that the rumours were too ridiculous even to comment on.

On the same day, a different journalist managed to find Terence Rattigan, who was in New York to see the US opening of his play, *Separate Tables*. The playwright laughed and denied all knowledge of in-fighting on the set of *The Sleeping Prince*. According to the playwright, he had watched most of the filming and was extremely happy with the way it was going. He declared that the two actors were 'getting on well', although he did have to admit that filming was proceeding 'a little slower than had been expected'.

For the next two days, Marilyn was on her best behaviour, and on Wednesday 26 September she arrived not only on time, but caused no hold-ups whatsoever. On Thursday she was fifty minutes late but, once again, behaved impeccably on set. However, while the mood was slightly raised, there were rumbles that, on Friday 28 September, three hundred carpenters at Elstree, Shepperton and Pinewood studios were planning to walk out over a pay dispute.

In the end, union leaders convinced the carpenters to stay, and everyone traipsed on set, happy that the day would not be interrupted after all. The happiness was short-lived, however, as Marilyn had decided not to come to work anyway. Once again, Olivier grinned stoically, assured everyone that they could find something else to do, and inwardly seethed.

Chapter Eight

The Kindness of Strangers

It had taken Marilyn a long time to achieve her dream of becoming a worldwide star, and she always gave her fans the credit for her eventual success. As a result, the actress cherished those 'normal folk' who took time out of their day to wish her well, and at times she even got to know her fans by name. Now, as Marilyn struggled through the gruelling work at Pinewood, she once again sought out friendship from those unconnected to the movie business.

Free from the controlling nature of her entourage and the pressures of work, Marilyn revelled in greeting passers-by and those bringing deliveries. Ross Matthews held the coveted job of the Parkside House paperboy, and remembered Marilyn with great affection: 'When I first started delivering the newspapers, I didn't know who lived there. It was just an address. It was a couple of weeks later when I first saw Marilyn and I couldn't believe my eyes. She was beautiful. She just said "Hello," and all I could say was a very muted "Hello" back. I saw and spoke to her several times after that and found her to be a very warm-hearted person with a lovely soft tone to her voice. I wouldn't say my friends were envious, simply because I didn't tell them. Once the word got out that Marilyn lived there, the locals used to stand by the gate, and she would come out

and chat. So different from nowadays. My mum said she remembered Marilyn riding around the village on a bicycle. Of course, I don't remember that as I would have been at school. Such a shame that such a lovely person should die so young.'

Another paperboy, Bryan Godfree, recalled being ecstatic when Marilyn spoke to him: 'She came to her bedroom window and said, "Hello paperboy!" I was so excited that she could find the time to say hello and have never forgotten that time in my life.'

Patricia Slamaker was one of the children who would often ride their bikes up to Parkside and hang around the gates. She and her friends were all rewarded for their efforts: 'Marilyn used to come and talk to the kids through the large gates,' she said. 'She wore a white fluffy bolero jacket and pedal pushers. She was stunningly beautiful with her lovely blonde hair.'

Marion Rees was walking with her family in Windsor Park and saw Marilyn at her back gate, talking to passers-by: 'I was quite young at the time, but I do seem to feel that she was very comfortable to just lean on the gate and chat to perfect strangers. She was dressed in white, with dazzling blonde hair. She was exotic beyond belief for Englefield Green in those days.'

Walking down Bond Street on her way home from work, nineteen-year-old Anne Wallage was surprised to see a fancy black car heading towards her. 'Naturally I looked to see who was in it,' she wrote, 'and remember seeing Marilyn's face and of course her famous blonde hair. Arthur Miller was beside her, and being excited I waved at them, and they both responded, waving back. I consider myself very lucky to have seen such a famous star.'

One day Marilyn and Arthur were on their way home from Pinewood Studios when their car broke down. The chauffeur had no idea how to deal with the situation, but got out and gave a cursory look under the bonnet anyway. Luckily for the Millers, along came long-distance lorry driver, Tommy Hand, who saw the broken-down

vehicle and pulled over to help. The good Samaritan managed to fix the car, but before he was able to leave, the chauffeur informed him that 'the lady' wanted to say thank you.

The back window rolled down and out popped a blonde head. 'My dad leaned down to say hello,' remembered Tony Hand. 'He noticed that the lady was with a sour-faced man, wearing glasses. The man never so much as looked in his direction but the lady was nice and really grateful. She said she was always being accused of being late but this time it wasn't actually her fault, and laughed at her own remark.'

Tommy Hand was not a movie-goer, but did think the woman looked a little familiar.

'Are you an actress?' he asked, and Marilyn replied in the affirmative. 'Are you Diana Dors?'

Marilyn laughed but didn't reply, leading Tommy to think that it must be Dors, and she was amused that he wasn't sure: 'Dad told her that my mum was a really big film fan and she would never believe that he had met her, so the lady offered to give him an autograph to prove it. She asked if he had any paper but he said no, he only had a pencil, so she reached around and came up with a copy of a theatre magazine that someone at the studio had given her. The magazine showed Laurence Olivier and Vivien Leigh together as they appeared in the play *The Sleeping Prince*, and the lady said she thought it was meant as a mean joke, but Dad had no idea what she was talking about and just nodded. She signed the magazine and gave it to him, and he said goodbye and thanked her.'

Tommy went home, convinced that he had met Diana Dors. It wasn't until he showed his wife the autograph that he was informed he'd actually spoken to Marilyn Monroe. Tommy was dumbfounded.

Tuesday 2 October was an authorised day off for Marilyn, and then on the 3rd – when the actress arrived at Pinewood almost two hours

late – a photograph appeared in the press that showed Marilyn and Olivier filming a kissing scene on the set of *The Sleeping Prince*. This particular scene had caused a sensation when filmed, mainly because people were intrigued as to how the two rival stars could possibly pretend to adore each other. Dozens of crew members filed silently onto Stage A to witness the historic event, though, in the end, even the most passionate of staff ended up bored, since it took all day to shoot.

The main trouble with the scene was that the two stars had gone past the point where they even wanted to pretend anymore. Marilyn held back as though embarrassed because her husband was lurking in the shadows, but this only seemed to make Olivier more insistent that they practise until it was perfect. Still Marilyn resisted, until finally – just before the end of the day – she relaxed and they managed to shoot the scene and the publicity photograph. As Olivier yelled, 'Cut!' Marilyn rushed into the arms of Miller, and the photo was sent off to the press before the star could complain about the quality of it.

Newspapers were glad of this glimpse into their working life, but the set itself remained closed to almost everyone except cast and crew. Frustrated journalists wondered aloud if Marilyn approved of such a decision, and some took their queries to her representatives. 'She is very glad of it,' publicist Alan Arnold told reporter Moore Raymond. 'She gets here at 7 a.m., works hard all day, and leaves at 7 p.m.' He added that out of the (approximately) seventy-one shooting days for *Prince*, Marilyn was only scheduled to have a handful of days off. What he failed to say, however, was that by the time of the interview in early October, she had already taken off ten unauthorised days.

Taking this into account, there were plenty of reasons not to open the set to the press, but by now, the news reports were scathing. *Picturegoer* – one of the leading film magazines in the United

Kingdom – was appalled with what was going on at Pinewood, and their columnist Derek Walker telephoned the offices of Marilyn's PR people to ask if they could please be allowed to visit. The representative was sympathetic but firm. 'We would like to help. We realise the value of your magazine . . . We're stuck with it.'

Walker believed that Olivier felt himself immune to scrutiny, but he was shocked that Marilyn could feel the same way. As far as the columnist was concerned, if there were no problems on the set of *The Sleeping Prince*, then there was really no need to keep anyone from visiting: 'One day, or perhaps two half-days, should have been set aside earlier in the film's fifteen-week shooting schedule for a mass, organised press visit to the set . . . Rumours would have been scotched before they were created. Genuine, factual stories would have been assured. Speculation would have been unnecessary and the criticism avoided.'

One person who did get past the iron curtain of Stage A was director Joshua Logan, although after the reception he received from Marilyn, he may have wished he hadn't. The two had worked well on Marilyn's latest film – *Bus Stop* – to such a degree that he labelled her a genius and seemed truly to love her. 'She has a technique for playing comedy which is unique in my experience with comediennes. She can be pathetic too, even comically so.'

Since working together, Logan had edited the movie and taken out large chunks, as well as smaller lines throughout. Marilyn had seen a rough cut of the film shortly after she arrived in London and hated the edits, claiming that some of her best scenes had gone. But that wasn't the only problem. At the beginning of production on *The Sleeping Prince*, Marilyn told Jack Cardiff that she wanted to repeat the pale make-up she had used in *Bus Stop*. The cinematographer was horrified, and wondered how it would look on camera. He needn't have worried, however, because as soon as Marilyn saw *Bus Stop*, she went off the idea completely.

Vera Day, who played Elsie Marina's friend, Betty, remembered, 'She didn't like the way she looked in that film. She thought she didn't look as nice as she could have.' Ultimately, Marilyn would refuse to attend the London premiere of the movie, and despite pleas by various officials, she also turned down a short trip to the Venice Film Festival, where *Bus Stop* was due to play. The actress pinned the blame for the aspects of the movie she didn't like on director Joshua Logan.

Logan's play, *Fanny*, was due to open in London during November 1956, and since he was in the city to talk over the details, he took the opportunity to visit Marilyn on the set of *The Sleeping Prince*. He arrived unaware that his actress was furious with him, and instead of a warm welcome, he was met with a hostile atmosphere.

Some accounts say that Marilyn slammed a door in the director's face, while others suggest that Logan begged to be let into her dressing room, without success. There does not seem to be any clear version of the event, but we do know that Logan watched a great deal of *The Sleeping Prince* in the screening room at Pinewood. He claimed the movie to be better than anything Marilyn had worked on before, and gave credit to Olivier for his direction. Afterwards the two men spoke about the experience of directing Marilyn.

Logan told Olivier to, 'Use patience,' though he did admit that the actress was incredibly hard to work with. 'She has been unhappy for so long in the sort of parts she has been given that she scarcely believes in her own talent,' he told reporter Christopher Hall. This was no slight towards Marilyn's talents, however, and he expressed his feeling that the actress was a cross between Charlie Chaplin and Greta Garbo. She had tremendous talent, he confirmed, if only she would believe in herself.

Bus Stop was released during the England trip, and received mainly positive reviews. 'Marilyn is magnificent,' screamed the

Daily Herald. 'She is terrific. Marilyn is great, the way Chaplin, Tracy, Cooper, Bette Davis are great. She can act people right out of the film into the paying queue outside.'

All of Marilyn's worries disappeared when the US reviews for *Bus Stop* trickled into Pinewood. The actress read them as she was perched in Gordon Bond's chair, having her hair done, and became so excited that she couldn't sit still. 'I nearly burned her with the curling tongs,' Gordon Bond exclaimed.

The hairdresser was of a similar age to Marilyn, and popular with all manner of actresses because of his unassuming nature and witty personality. Thanks to all the hours working on her hair, Gordon Bond was able to get close to Marilyn, bonding over a love of animals, especially Bond's canaries and dogs. The hairdresser was able to release the star's playful side, and Pinewood staff could often hear the two friends practising cockney rhyming slang in the dressing room.

Anyone questioning Marilyn's quips of 'Up the apples and pears – stairs' or 'Trouble and strife – wife' would be called 'Dearie' and met with Marilyn's trademark laugh – something that had been missing from most of the trip. As well as learning new words, Marilyn also loved to share her musical tastes with Bond, and often brought in records for them to play as he worked on her hair. Her favourite music at the time was from the new Broadway musical *My Fair Lady*, and the two would listen while chatting about cycling, tea-drinking, books, the theatre and 'English people who talk too fast over the telephone'. When asked what he thought of the actress, Bond smiled. 'Marilyn is a darling and I adore her,' he said.

The admiration was reciprocated, and Marilyn felt comfortable enough to joke about her personal life with the hairdresser. Earlier in the production, Bond recommended that the actress wear a net at night to protect her hair. Marilyn was astonished. 'Are you kidding?' she asked. 'I've been married only a month!'

Gordon Bond had to be constantly available for Marilyn on set, since she'd developed a nervous habit of pulling and running her fingers through her hair. This may have been unconscious, but it did mean that the style was often in disarray. Bond's days were long and required a great deal of commitment. Waking up at 4.30 a.m., the hairdresser would travel to Pinewood for 6.30 a.m., in the hope that Marilyn would arrive on time. When she didn't, he would busy himself with going over the hairstyles that would be required when Marilyn did appear.

Once the actress finally arrived in his chair, Bond would ensure that her hair and long hairpieces were fitted perfectly while she ate breakfast – usually consisting of orange juice, coffee, milk, eggs and sometimes ham. Bond would then spend all day on set, and get back to his Balham flat for 9 p.m. Despite the long hours, the hairstylist enjoyed his work, and felt that all young women could look like film stars, given the chance. 'I see glamour in the raw at seven o'clock every morning,' he said. 'Believe me, I know.'

Actress Vera Day was another person who wasn't scared to approach Marilyn. One day on set, the actress was sitting alone, nobody daring to go over to her – except Vera. 'There was nothing to be scared of,' she wrote. 'We talked and there was nothing blasé about her conversation.' Confident that she had now struck up something of a friendship with Marilyn, Vera brought in dozens of autograph books from local schoolchildren. People on set were terrified and told her that under no circumstances must she take them to Marilyn's trailer. Vera did anyway, and they were all signed and returned. This became such a legendary event that when studio staff found out about it, they wanted an autograph, too, and Vera acted as a go-between.

Gordon Bond and Vera Day both enjoyed working with Marilyn, but others continued to find it impossible to penetrate the entourage. Joe M. Marks – one of the assistants on *The Sleeping Prince* – remembered that as soon as Olivier cried, 'Cut!' Paula Strasberg would hurry

over and prevent Marilyn from socialising. One day when a crew member tried to converse with the actress, Marks witnessed Strasberg saying, 'Don't talk to them. You need your rest.' He described the acting coach as an 'Absolute pain. Absolute menace.' Things were made no better when Strasberg was seen dishing out pills to Marilyn between takes, and the actors had to pretend they hadn't noticed.

One day Marilyn was on set with actresses Vera Day, Gillian Owen and Daphne Anderson when she missed her mark and went off camera. Vera Day recalled: 'Laurence Olivier said in very polite tones, "Marilyn darling, I don't see you in that position," meaning camera angles etc. She said "Oh well, if you can't see me, I will go home," sweeping off the set, leaving cast and crew open-mouthed with amazement. Filming was stopped.'

As Marilyn had demonstrated at numerous press conferences, she could be exceptionally witty, with a terrific sense of humour. Her one-liners were legendary, and they occasionally appeared during the England trip. However, although she enjoyed a laugh with Gordon Bond, Marilyn often had quite a time understanding the self-deprecating British sense of humour. 'Marilyn did not get the nuances,' Allan 'Whitey' Snyder wrote. One day when she didn't understand a jokey line in the script, the actress rushed to her dressing room and wept. Thankfully, in this instance Olivier was able to explain to her how the scene should be performed, and Marilyn calmed down and returned to the set.

At the beginning of production, actor Richard Wattis described himself as being 'wildly excited' to work with Miss Monroe, and he would often enthral everyone on set with his outrageous showbiz stories. However, his sense of humour was not always appreciated: 'I tried to walk like her down the corridor one day,' he said, 'but the only attention I attracted was from two policemen – who were not impressed.'

A sad example of the British sense of humour came when pompous actor Donald Sinden found himself in a dressing room down the corridor from Marilyn's. Sinden was not a fan of the method style of acting and asked the props department to make a sarcastic sign, poking fun at the technique. Knowing what time Marilyn was due to pass, he posted it outside his room and then lay in wait, eager to hear the reaction to his 'joke'. The actress's footsteps stopped as she reached his door; then she laughed and burst into his dressing room, thinking that the man was extending the hand of friendship. After that, Marilyn would pop in to see Sinden whenever she wanted to chat.

For a woman who had found it hard to make friends on the set of *The Sleeping Prince*, she enjoyed the idea of having a safe place to be herself. Unfortunately, the friendship that had begun with a sarcastic joke seems to have been an illusion, with Sinden merely playing a role. In his 1983 autobiography, the actor wrote that while Marilyn made a stunning sex symbol, he found her to be 'one of the silliest women I have ever met'.

'All she ever seemed to be able to talk about was what she had had for lunch and things like that,' the acidic actor told reporter Roy Martin. 'Mind you, one could see why she was a star – I mean it was obvious.'

A friendship that wasn't forced or fake was the one Marilyn shared with Alan the pianist. During breaks from playing the piano at Parkside, he would often spend his time studying poet and essayist Walt Whitman. One day Marilyn came into the room as he was reading, and asked what he was doing. When Alan explained his interest in Whitman, Marilyn sat down, chose a passage from the book, and they discussed it together. The actress knew a lot about the poet, and gave Alan quite a lecture on the subject.

'You're a bit of a blue stocking, aren't you?' joked the youngster. He

was referring to the Blue Stockings Society, an eighteenth-century British organisation made up of intellectual women. Marilyn didn't get the reference, and stared down at her legs.

'Blue stockings?' she asked. 'Oh no, I couldn't possibly wear blue stockings. They're so vulgar!'

A day or so later, Alan couldn't find the Walt Whitman paper he was working on, and went into the drawing room to look for it: 'There was Marilyn propped up on cushions on the sofa with tatty robe and curlers and slippers, holding the paper. One passage had been causing me trouble and Marilyn told me how I should treat it. She wrote "This has to be read loving[ly], doesn't it?" on the paper.'

While Marilyn educated Alan on the subject of Walt Whitman, he repaid the favour by telling her all about British actress and singer Gracie Fields. One day Alan was playing a Fields record when Marilyn came into the room: 'She listened and giggled, and got the drift of what [the song] was about. She wanted to learn how to talk like her and did a pretty good job of it. She wouldn't say "damn" though because she thought it was rude. She also liked George Formby and was fascinated by the fun and the banjo ukulele playing. Marilyn laughed like a drain at the rude bits. She would sing Gracie Fields around the house which was surreal. She was very quick to pick things up and didn't do a bad job of it.'

Marilyn enjoyed Alan's company and they got along well, but there is no question that Parkside House was not always a peaceful or calm place to be. The staff were there throughout the day and into the evenings; Plod seemed to follow Marilyn's every move, and Milton H. Greene, Paula Strasberg and various members of *The Sleeping Prince* crew would pop in and out on a regular basis. Marilyn couldn't even take a walk around the garden without bumping into a policeman or being spied on by an errant photographer, hiding in the bushes.

Still infuriated that they had been banned from the set of *The Sleeping Prince* by Olivier, reporters decided that it was Arthur Miller's fault that they could not have access to Marilyn at Parkside. 'Miller doesn't exactly give orders,' a detractor once said, 'but he kind of gives the impression he'd be surprised if things didn't go his way.'

This feeling only seemed to spur on those who wanted to infiltrate Marilyn's private life, and instead of respecting her wish to be left alone, reporters thought up more and more elaborate ways to get to the star. It became commonplace for journalists to sneak through the bushes in order to gain access to Parkside House. Once inside the grounds, some would even climb trees for a better look, though several fell out before being hauled off by security.

Two photographers had what they thought was the ingenious idea of catching Marilyn unawares in her bedroom. They did not attempt to break and enter, however. Instead, they waited until there was no one watching, and then snuck into the grounds, scaled the walls of the house and ended up on the roof. Exactly how they got there is a mystery, but it likely involved the jutting porch, growing ivy and a convenient drainpipe.

Once on the roof, the plan was to have one man – armed with a camera – hang upside down towards Marilyn's bedroom, while the other clung on to his feet. It wasn't the safest of ideas, but one they were willing to try if it meant winning a revealing picture of the star. In the end, however, their efforts were in vain. A member of security happened to be passing the front of the house, spotted the men in action, and forced them down before any harm could come to them, or to Marilyn's privacy.

'Reporters were camped outside the main gate,' recalled head gardener's daughter Cary Bazalgette. 'They seemed like a pack of dogs, and I was disgusted by them.' One day when the teenager was walking by herself in the grounds, a journalist jumped out from

nowhere, and accosted her. 'Hello, little girl,' he said, but Cary kept walking.

The situation with the press was creepy, and even when they couldn't gain access to the house itself, they still came up with elaborate ideas to get Marilyn's attention. One afternoon an enterprising journalist decided to enrol the help of the children that crowded around the gate. One of the boys, G. Pearson, had spent most of his free time at the house, and was rewarded on several occasions when Marilyn waved on her way home from the studio. However, one day he and his friend had a bigger adventure when they were approached by a couple of journalists, who asked the boys if they'd like to earn 'a large silver coin'. The children nodded in agreement, and one of the journalists thrust an envelope into Pearson's hand. 'Go in and give this letter to Marilyn,' he said.

'The envelope just had on it, Miss M. Monroe,' remembered Pearson. 'We had to jump over the gates – about four to five foot high – as they were locked, and walked up to the house.'

When the boys reached the imposing white mansion, they rang the bell and stepped back, waiting for Marilyn to answer. Instead, they were greeted by the maid. Pearson pressed the envelope into her hand, and asked if she'd please pass it to Marilyn. That done, the maid closed the door and the boys stepped back, waiting for a reply. They did not have to wait long before Arthur Miller appeared and demanded to know how they got onto the property, and what the letter was about.

'I answered that we had jumped over the gates and that some man had given us the letter. He then told us to go back the way we had come; his actual wording I cannot remember, but it was loud, abrasive and in words that I had heard adults use before.'

The boys scuttled off down the drive, and a photographer was waiting as they jumped over the gate. The journalist grabbed his notebook and jotted down the boys' story, and the boys became

local celebrities when the incident was reported in a newspaper. 'I remember my mother sending a cutting to my uncle, who was stationed in Cyprus, in the army,' Pearson said.

Columnist Tom Hutchinson was able to visit Parkside officially on two separate occasions. The first interview took place early in the morning, and the actress seemed tired and dazed. She appeared calmer and more collected during the second encounter, but both interviews followed the same pattern – uninvited members of Marilyn's entourage would drift in and out of the room, contributing their own thoughts and at times even finishing her sentences. Instead of enjoying the interviews, the journalist found them to be strange; eerie even.

When Marilyn and Hutchinson were able to talk, they discussed the actress's latest read, *The Trial* by Franz Kafka, which tells the story of Josef K., a man arrested and prosecuted for a crime that is not revealed to the character or reader. Marilyn was interested in the theme of guilt in the book, and expressed her belief that all humans feel as though they have fallen in some way. The actress also seemed to be preoccupied with the subject of critics – or more importantly, the ones who criticised her own work.

As the interview drew to a close, Hutchinson got up to leave. Before he could go, however, Marilyn looked up at him and exclaimed, 'Too many people. Too many people.'

As news of the ongoing rift between Olivier and Monroe filtered out of Pinewood Studios, the residents of Englefield Green wondered how they could cheer up Marilyn. Some arrived at Parkside with gifts and flowers, while others made sure to wave as her car passed on the way to or from work. One of the latter was Margaret Gibbon, who lived on the other side of Englefield Green. A keen gardener, Margaret was often in her front garden, tending to her plants and flowers. During the summer/autumn of 1956, her attention was

drawn to a large chauffeur-driven car that seemed to come past at the same time every evening. It did not take long before she noticed that the passenger was Marilyn Monroe. Margaret waved, Marilyn returned the gesture, and a connection was formed. After that, the two greeted each other on a regular basis.

One Sunday, Margaret and her family were in the Fox and Hounds pub when she was recognised by Marilyn's bodyguard as 'the lady who waves'. The two got talking, and the man revealed – not-too-discreetly – that the actress seemed unhappy and alone. Before they knew it, Margaret and her family were at the gates of Parkside, where they were presented with an autograph and a signed photograph.

Even 'Greeners' who did not see Marilyn in person still cared about her wellbeing. Teenager Maurice Smith would often pack his fishing pole and head to a pond in Great Windsor Park. There he would sit by the water and wonder if he'd see Marilyn cycling past on her bike. Alone and with just the sound of the birds for company, Maurice found himself thinking about the actress. 'I always thought that she should be with me, beside the pond and finding peace, as I was enjoying,' he said.

Chapter Nine

A View from the (London) Bridge

By October, relations between Marilyn and Arthur were brighter, and the notebook incident seemed to have been resolved somewhat. Rehearsals for A *View from the Bridge* were going well, Arthur's free time had opened up, and he was seen frequently on the set of *The Sleeping Prince*. This seemed to cheer Marilyn, and she often rushed into his arms at the end of each scene, and together they would discuss the day's work and Arthur's forthcoming play.

'They were overtly in love,' said Vera Day, 'and could not get enough of each other.' Between scenes, the couple could be seen holding hands, or Miller would stroke Marilyn's arm in a comforting manner.

Assistant David Tringham recalled, '[Miller] was absolutely besotted by her. He was a tall, gangly fellow, and he would follow Marilyn around. Everywhere you went, there he was – eyes on stalks. He would try not to get in the way, but always wanted to see her and be in her eyeline.'

Publicist Alan Arnold wrote that the couple were so affectionate that their relationship seemed too intimate to witness. 'Yet they were quite impervious to being seen as they held each other close, hugged one another, and laughed into each other's eyes, in the presence of the unit.'

Not only was Miller besotted, but he was also anxious to boost Marilyn's confidence. As he hid in the shadows of *The Sleeping Prince* set, the playwright would sometimes ask stand-in Una Pearl to 'Tell her she's good, try to give her some confidence.'

It wasn't just in the vicinity of Pinewood that the couple were loved up. One of the staff at Parkside House walked into the drawing room and caught the couple in a passionate embrace. Others often overheard Marilyn calling Arthur by her nickname for him – Pa.

By this time, the playwright had settled into British life to such an extent that the Foreign Office demanded to know if he ever planned on going home. They had received information that his passport would expire at the end of the year, and did not want him to hide out in Britain while his political troubles raged on in the States. Miller assured immigration that he did intend to return to America, and then got back to his life in Englefield Green, which included writing a short story entitled 'The Misfits' (which would go on to become a movie, starring his wife), and taking walks around the large garden.

When Miller couldn't visit Marilyn at Pinewood, he would ring her dressing room to see how she was. On one particular day, however, the phone at Parkside was out of order and he needed to find an alternative way to contact her.

Cary Bazalgette remembered being in the family cottage in the grounds of Parkside when there was a knock at the door. When she opened it, she was shocked to discover the playwright standing outside. 'I'm terribly sorry to bother you,' he said, 'but I need to use a phone to get in touch with my wife at the studio.' The man was polite and formal, and Cary was surprised because she didn't think adults normally spoke to children in such a grown-up way. 'It was extraordinary, how nicely he spoke to me,' she said.

'Everything about him is handsome,' Marilyn said in July 1957. 'People are always asking me what it's like to be married to such a

brilliant man, and he has caused me to change. I don't even know what the word "intellectual" means, but I tell you how I'm different. Playwrights are interested in everything about life, and all about people. Since I've been married to Art, life's a lot bigger for me.'

As the premiere of A View from the Bridge grew closer, Marilyn hired Madame de Rachelle to make her a dress that would make headlines around the world. De Rachelle was described as a 'theatrical costumier, and outstanding designer', and together with her fitters, she worked on period, ballet and revue costumes, as well as gowns for stage productions and individuals. Now she was to work for Marilyn on a low-cut scarlet gown. A satin cape, long gloves and platform-soled sandals from Anello & Davide would complete the look.

Marilyn adored the dress design, but when she showed it to friend Amy Greene and The Sleeping Prince designer Beatrice 'Bumble' Dawson, they were horrified. Both women offered the advice that her outfit should be conservative and black, as it simply wasn't the proper thing to attend the British theatre in a scarlet dress with plunging neckline.

Marilyn questioned why this was so, and Beatrice told her that red would be out of the question at an event full of intellectuals. 'For intellectuals you have to wear black?' asked Marilyn. 'Who said so?' She reminded everyone that Miller was an intellectual, that his favourite colour was red, and she would wear the dress for him. The actress then spent much of Saturday 6 October at Parkside, engrossed in a fitting with the staff of Madame de Rachelle.

Marilyn wasn't the only one impressed with the gown. A short time later, head gardener's daughter Cary was visiting her stepmother at Parkside when Miller and Marilyn were out for the day. The young teenager wandered around the house, and found herself in the vicinity of Marilyn's closet. Disappointed to see that most of the

actress's clothes were black and beige, Cary's eyes then fell on the scarlet dress. It stood out from the plain clothes next to it, and the young girl fell in love, admiring the vibrant colour, and the ruffled material of the bottom half. Marilyn felt the same way. She loved the gown so much that on leaving England, it was wrapped carefully in tissue and shipped to the States so that she could wear it again during the holidays.

Supporting her husband at the premiere of A *View from the Bridge* seemed far more important to Marilyn than work on *The Sleeping Prince*. On Tuesday 9 October, she was fifty minutes late at Pinewood, and then held up production for forty-seven minutes while she had a dressing-room fitting with the staff of Madame de Rachelle. The next day Olivier's patience was stretched once more when the actress arrived over an hour late, and then sent Beatrice Dawson to London's Baker Street to collect her finished dress from Madame de Rachelle.

On the same day, Mr J. W. Irvine-Fortescue, a Scottish farmer and county councillor, took to the floor of a meeting in Kincardine. The man was an admirer of Marilyn and used the meeting to share his opinion that the star should be sponsored by the National Farmers' Union to advertise British farm products. 'The thing that always takes the trick nowadays is sex. Let us "fee" Marilyn Monroe to advertise farm products on television, saying that British beef is best.'

He was buoyed to hear that another attendee believed this to be a terrific idea, but if it was to advertise British meat products, then surely the actress should be British herself . . . Someone like Diana Dors perhaps? The discussion came to a halt, and the disappointed Mr Irvine-Fortescue resigned himself to never seeing Marilyn applaud local beef on television.

On Thursday 11 October Marilyn took an unauthorised day off in order to ready herself for the glamorous opening night of A *View*

from the Bridge. For reasons unknown, Miller told reporters that he did not know if he would attend the first night of his play, but if that was ever his intention, he had forgotten about it when the evening came. By the time the couple jumped into their car, Miller was already dressed in his evening togs, but Marilyn had yet to change into her scarlet gown.

As a good PR exercise, the Oliviers agreed to attend the performance, and the Millers dropped into Lowndes Place for food and drinks with them, Jack Cardiff, and his wife Julie. In his 1990 biography, Hugo Vickers wrote that Leigh's daughter Suzanne Holman described the visit as 'sticky'.

No further explanation was offered, although it could be linked to another story in the book, which describes a time when – during a dinner party – Marilyn disappeared into the bathroom with a glass of champagne. Vivien was said to be horrified, and took it upon herself to go and find her. Jack Cardiff later wrote that when he arrived at the house, Marilyn was upstairs, changing into her scarlet gown. When the actress emerged, Vivien gawped at Marilyn, and then at Olivier, but he looked on in 'amused tolerance'.

Publicist Jean Bray remembered that 'Marilyn was terrified of Vivien Leigh. Really frightened.' Jean believes that these feelings may have originated from the fact that Leigh was Olivier's wife and had been in the stage version of *The Sleeping Prince.* Jack Cardiff, meanwhile, believed that Marilyn felt inferior to the *Gone with the Wind* actress. No doubt this particular get-together did nothing to change Marilyn's mind.

The scene that greeted the Millers, Oliviers and Cardiffs outside the Comedy Theatre was almost identical to the one at the Lyric three months before. Crowds lined the streets, ten deep in some places, while theatregoers battled to get through, and police officers held everyone back and begged passers-by to move on. When Marilyn's car pulled up, the crowd was hysterical. Surging forward,

several women had their dresses torn, and police had to link arms in an effort to keep everyone back. Marilyn smiled with as much enthusiasm as she could muster, as a group of officers elbowed people out of the way so that the actress and her husband could make it to the door.

Miller's reaction to the jostling scene was to declare the whole thing a mess, but Marilyn was more joyful. 'I think it was a wonderful, enthusiastic welcome,' she said, 'and I'm glad they were enthusiastic.'

Inside the foyer, a crowd of ticketholders caused problems by refusing to take their seats inside the auditorium until they had seen Marilyn. The actress seemed to float on a sea of people, and agitated stewards and officers swarmed in every direction. Finally, the famous couples were able get into the auditorium but, even then, there were problems when they were shown to the wrong seats. Spectators watched while the steward shuffled them to the correct places on the third row, and Marilyn beamed and waved at the waiting photographers. By now, only a handful of the audience had made it to their seats – the rest were still crowded in the foyer, trapped in a bottleneck of their own creation.

Those people who did manage to get inside took the opportunity to speak to the Millers, and a few even succeeded in coaxing a roaring laugh from Arthur Miller and a bright smile from Marilyn. Sitting beside them, Vivien Leigh grimaced while Olivier – already annoyed that filming had been disrupted that day – looked on sourly. His dour aura was not lost on the reporters in the theatre, who sympathised with his plight.

The seats eventually filled up and, fifteen minutes later than scheduled, the lights dimmed for act one of *A View from the Bridge*. The cast, including Anthony Quayle, Mary Ure and Megs Jenkins, took to the stage, and so began the story of Eddie (Quayle) and his obsessive, over-protective love for his orphaned niece (Ure). As the

house lights went up for the interval, stewards rushed forward in an attempt to keep the audience from leaving their seats. The plan was that if the crowds were kept inside, the Millers and Oliviers could head to a private room to enjoy a drink in peace. However, the rebellious crowd pushed the officials aside and rushed to the bar, where the famous party were forced to make their way through hundreds of bodies once again.

This episode humoured Moore Raymond from the *Sunday Dispatch*, who had already decided that Marilyn was pushing her luck in terms of public relations. 'Between Sir Laurence and Arthur Miller, Marilyn is losing a lot of public goodwill,' he wrote; adding that while Olivier had kept reporters from speaking to the star at Pinewood, Miller was responsible for keeping her out of sight at Parkside. 'What does Marilyn think of this?' he pondered.

Jack Cardiff recalled Marilyn being hesitant to go back into the auditorium at the end of the interval, stalling in the same way she did every morning in her dressing room. Finally, Arthur managed to bundle her out of the room, and they made their way back to their seats. At the end of the performance, the players took their bows and were given a standing ovation, as the curtain rose and fell, over and over again. However, despite calls of 'Author!' Miller did not rise to his feet or address the audience. 'I just couldn't get out of my seat to answer the calls,' he said.

The drama critic of the *Birmingham Post* was in the theatre, and watched as the crowd cheered for far longer than most West End audiences. 'Perhaps the cheering was for Brook, Quayle, Miller, in that order but whatever the order, tonight has set off the new venture with a play that will be argued about, and nothing is better for the living theatre than close and eager debate.'

As the crowds refused to disperse outside the theatre, young author Colin Wilson and his girlfriend, Joy, drove past in a taxi. Ever since Marilyn's arrival in England, the writer had attended

numerous parties purely because the hosts promised that the star would show up. She never did, of course, and Wilson had resigned himself to the fact that they would never meet. However, on the evening of 11 October, Wilson stared out of the cab window and realised that he was looking at a crowd of people waiting for Marilyn to appear. The writer had recently been to dinner with director Peter Brook and his wife, and was acquainted with actor Anthony Quayle, so was confident that he'd be able to blag his way into the theatre. He wasn't wrong.

Striding between the two rows of policemen guarding the front door, Wilson and his girlfriend headed straight to the box office.

'Tony Quayle's dressing room,' Wilson told the assistant and, to his amusement, they were not only directed to the room but were also allowed access as well. By now, the cast and guests were in the middle of an after-show get-together, and because he knew some of the people there, it wasn't long before Wilson was introduced to Marilyn. She was so charming that the writer felt as though he were about to fall in love. His misguided efforts at flirting were thwarted when Vivien Leigh began talking to him, and Marilyn drifted over to Wilson's girlfriend, Joy. By this time, Marilyn's scarlet, low-cut gown was causing her some discomfort and, to Joy's amusement, the actress went to the dressing-room mirror, grabbed the front, and tried to heave it up an extra inch. Despite the room being full of people, Marilyn was seemingly unaware that anyone could see her.

The next morning, the reviews for A View from the Bridge came in. Miller may have fretted that British audiences would not enjoy the play, but he was pleasantly surprised. Critics found it to be strong, impressive, sympathetic, and not in any way salacious. However, it was Marilyn – and her plunging dress – who made the headlines, and newspapers around the country printed photographs taken from every angle – and particularly from a great height.

Writer Roberta Leigh – who had been so appreciative of Marilyn just a short time before – now changed her opinion. In her 15 October column, the author wrote: 'A word of advice to a very famous Mrs: On the one night that attention should be directed on your third husband, Marilyn, forget that you are a very famous Miss.'

Although people have often dismissed Arthur Miller as something of a hanger-on during the England trip, the positive response to A *View from the Bridge* confirms that this just wasn't so. Theatregoers and literary journalists alike were excited by his presence and loved his contribution to the London theatre scene. The *Stage* summed up the mood of many when it described him as, 'A man of intellect and charm, Mr Miller is a very welcome guest in this country.'

The *West London Observer* described Arthur as being well-known as Marilyn's husband, 'But much more important, he is one of America's leading intellectual dramatists – as can be realised by anyone visiting the Comedy Theatre.'

Marilyn was back on the set of *The Sleeping Prince* on Friday 12 October, just forty minutes late for her 11.30 a.m. call, causing a hold-up of only twenty minutes. Then on Saturday the 13th, John Blaikley – the gynaecologist who had treated Marilyn in September – arrived at Parkside for a follow-up consultation. He did not note exactly what treatment – if any – was administered, but Marilyn does seem to have been in good spirits, since afterwards the Millers headed out to celebrate Arthur's forty-first birthday, which was in four days' time.

The couple travelled to Horsham, an hour or so from Englefield Green. Arriving at around 3 p.m., the chauffeur parked in the Bishopric car park, and the couple headed for the row of shops nearby. Since it was now later in the afternoon, it was hoped that they could browse in peace. However, a group of girls, gathered at

the bus stop, recognised Marilyn and made enough noise to rouse the interest of staff in the E. G. Lyne butcher's shop.

By the time the couple reached XVIIth Century Galleries next door, news of their appearance had spread far, and curious crowds rushed to gather outside the shop. Marilyn was stuck, and while the shop owner took the opportunity to engage her in conversation, she wandered around the shelves and bought an antique souvenir. Meanwhile, the chauffeur sprinted over to the chemist across the road to buy some sunglasses. How dark glasses could possibly deter fans at this point was a mystery, but armed with a pair, the driver headed back to the shop. The actress slid them on, fixed her hair and then she, Miller and the chauffeur fought their way through the fans and hurried to the car. Afterwards, shop owner Mr Williams took delight in telling curious reporters that Marilyn was 'a perfect lady', and an assistant at the chemist ran home to tell his friends what had happened. 'They wouldn't believe me,' he later said.

Once the couple had left Horsham, they drove forty minutes to Lewes, where they stopped into the Shelleys Hotel. Staff member Peggy Heriot was on duty at the time: 'One afternoon I was in reception at the Shelleys Hotel and in walked Marilyn with her husband Arthur Miller. She wore no make-up but looked really beautiful; they were both very casually dressed. They asked to look around the hotel then came back to reception saying they were hungry and wondered if I could give them something to eat. I telephoned our then chef who was resting in his room, saying that Marilyn Monroe would like some food. He thought I was joking but, once convinced, came down and talked to the couple. They ate in the drawing room and when they left, they thanked the chef and me profusely and went on their way.'

The chef in question was Arthur Luke, who served soup, chicken Maryland, peach Melba and cheese. The couple's drink of choice

was Scotch on the rocks, and they signed the menu as a thank-you to the restaurant for opening just for them. At 6.45 p.m., Marilyn and Arthur were driven back to Englefield Green, and by the time the evening diners arrived at the Shelleys Hotel, Peggy Heriot and Arthur Luke wondered if it had all been a delicious dream.

As Marilyn and Arthur were meeting fans in Horsham and Lewes, the employees at Scottish knitwear factory Lyle & Scott were wondering how they too could get close to the star. After sending a special champagne-coloured sweater – named after Marilyn – to Pinewood, an imaginative member of staff decided that they should follow up with a mammoth letter, begging her to visit them. The scroll, which was over twenty feet long, was signed by nine hundred people at the Hawick factory, from the youngest apprentice to the chairman himself – Charles D. Oliver – and included the message, 'We all think you are the tops – there isn't a blonde we would rather meet.'

In-house model and receptionist Maureen Nixon was enrolled to show just how long the message was. Climbing to the fourth rung of a factory ladder, the young woman held the scroll up so that a photographer from the *Edinburgh People's Journal* could snap a pic. Then the paper was rolled up and packaged, ready to make its way to Pinewood Studios, where it was finally delivered to Marilyn's dressing room.

Despite the star's joy at receiving such a thoughtful package, she was unable to visit Scotland and the Lyle & Scott factory. However, just days before she left England, Marilyn sat down and wrote the staff a heartfelt note, and organised a signed photograph. In the letter, the actress thanked them 'for your scroll and the lovely sweater', and added, 'Perhaps I can best tell you how much I appreciate your gift by saying that I started out working in a factory myself, so the scroll with all your names on it is a very meaningful honour for me, and I will always keep it. You all make me proud of my Scotch blood.'

Employees at Lyle & Scott told journalists that the large photograph would be framed and hung with pride in their factory, but it promptly disappeared. In 1996, I. Jackson – the Lyle & Scott promotions manager for the previous forty-eight years – could not recall such an item in the factory, and predicted that it may have ended up in the home of a fan.

By now, the power struggle between Arthur Miller, Paula Strasberg and Milton H. Greene was gaining momentum, and they could barely stand the sight of each other. There were problems from all angles: Miller still questioned Paula's teaching techniques, had grown envious of Milton H. Greene's friendship with Marilyn, and now suspected that the photographer was mismanaging Marilyn Monroe Productions; Paula still hated Miller after the notebook incident, and only tolerated Milton because he was part of the Monroe partnership; and Milton couldn't stand Paula and felt she brought nothing to Marilyn's career, and he despaired that Miller was inserting himself into business affairs that shouldn't concern him.

The problem was that, like it or not, Marilyn had involved Arthur in her business life, even before they were married. In May of that year, while making *Bus Stop*, the actress had told her future husband that she had had several fights with Greene about both the company's finances and drama coach, Paula Strasberg.

At the time, Arthur assured Marilyn that he had absolutely nothing against Milton; did not particularly know him; and believed that there was no reason why there should ever be any conflict between them. However, he did give advice on the problems she was having, and expressed his belief that Milton was trying to work out what kind of role Arthur should play in their future life. While he tried to convince Marilyn and himself that he did not resent Milton at all, the playwright did use almost two pages to write about the problems

he saw within the business relationship. Now, Milton was at an even bigger disadvantage – that of being branded a traitor by Marilyn because he enjoyed the company of Olivier and sympathised with his struggles.

'I adored Milton H. Greene, and we were very close,' said Jerry Juroe. 'For Marilyn, you were always on one side or the other. There was no pleasing both.'

Shortly before the England trip, reporter Milton Shulman asked Marilyn about her relationship with Greene. She was firm in her response. 'I would listen to his advice about a film script, but I wouldn't necessarily take it. I make up my own mind about everything.' Shulman came away from the meeting with no doubt that the boss of the partnership was Marilyn.

It is understandable that the actress was upset by Greene's closeness to Olivier. After all, he had been brought over as part of her own entourage, and she expected him to be on 'her side'. The two shared a close business and personal relationship, and during her first year in New York, Milton, his wife Amy and their son Joshua had been not only her friends, but also – at times – her housemates.

'In New York, I learned to make friends,' Marilyn said in March 1956. 'I never had any friends, only conquests. I didn't have the time to find real friends. I was always being looked at, [and] had no chance to look.' Now it seemed as though Milton was being drawn away by 'the enemy' and, despite no evidence, Marilyn even suspected that her business partner was buying antiques with company money and shipping them back to the States.

The tension on set was relieved somewhat in the second half of October, when Paula Strasberg headed back to the States for a short holiday. Marilyn seemed happier, and many people – including make-up artist Allan 'Whitey' Snyder – noticed that the actress was working much better without her. In addition to that, other actors and members of the crew were able to get closer to the actress, and she let

her barriers down long enough to enjoy conversations with the technicians, which covered everything from their work to their families.

During a downtime on set, one of the crew members told Marilyn that his daughter was learning to play the piano, and she wanted to duet with him. The actress thought this was a marvellous idea, and the two spoke about it in some detail. However, before the end of the conversation, Colin Clark pushed his way between them in an effort to share something that he felt was particularly pressing. Still eager to continue the piano conversation, Marilyn pretended not to see Clark, and then dismissed him with a swift one-liner. 'Marilyn was never rude,' recalled Alan the pianist, 'but she had a wonderful way of putting people down.'

As the date for the Royal Command Performance grew ever closer, designers around London wondered if Marilyn would grace them with the task of making her gown. Over the last few months, many had designed dresses with the actress in mind, and some had even shown them in their collections. Pierre Balmain had recently been to Paris, where one of his gowns – made from coral-and-gold lamé – was 'just crying out for Marilyn Monroe to fill it'. Meanwhile, during the London fashion shows, designer Digby Martin had premiered a 'wiggle-waggle' dress for women who wanted to be just like Marilyn.

This fascination within the fashion industry enabled one hoaxer to wind up five famous dressmakers by telephoning their offices, pretending to be Marilyn. The phone calls would all start the same way. A gentle, American voice would announce that, 'This is Mrs Miller speaking. Lady Olivier advised me to call . . .' and then she would make an appointment to look at dresses suitable to meet the Queen. The intentions behind the bookings were unclear, but the hoaxer did cause ripples of excitement in the fitting rooms of the designers involved.

Some were more sceptical than others. When the hoaxer called the Savile Row premises of Hardy Amies – one of the Queen's dressmakers – the staff suspected it was a joke. Usually, Vivien Leigh arranged for her secretary to call before referring friends or associates, but that had not happened this time. Wary to book in the mysterious caller, a representative for Hardy Amies called Pinewood Studios and was put through to Arthur Miller. 'He confirmed that his wife hadn't called us,' Amies told a reporter from the *Daily Sketch*. 'It must have been most embarrassing for Mrs Miller.'

The staff of Norman Hartnell (the designer who had worked on the Queen's coronation dress) were less suspicious. When the hoaxer picked up the phone and dialled Mayfair 0992, she gave such a good impersonation of Marilyn that nobody felt the need to doubt her. Once again, the impostor said that the dress was for the Royal Command Performance, and she then made an appointment for 3 p.m. on 16 October. Hartnell was hosting a small fashion show that day, and 'Marilyn' declared that she would love to come along to see it for herself.

Most of the staff were sure it was Mrs Miller who had telephoned, but doorman William Carolan was sceptical. He made a bet with milliner Clare Taft that the actress would not show up, but Taft was determined that they would see the star sometime that afternoon. Bet made, Carolan then stood at the imposing door of 26 Bruton Street, with its marbled lampposts and royal warrant, and welcomed guests arriving for the fashion show upstairs. The one person he didn't greet, however, was Marilyn Monroe. Staff discreetly stared out of the windows in an effort to see if the actress's car would arrive, but at 5.15 p.m. they gave up, and Clare Taft paid the winnings to Carolan.

Norman Hartnell assured reporters that 'Marilyn' had caused them no inconvenience by not showing up, but enjoyed wondering what kind of outfit he would design if the real Marilyn ever dropped by.

The phoney never did come forward to claim her place as an impersonator, but she does seem to have inspired enterprising agents and PR executives, who used the tale to help their clients.

On 31 October 1956 – just days after young singer Tommy Steele charted with his single 'Rock with the Caveman' – an article appeared in the *Daily Sketch*, which said that 'Marilyn' had personally telephoned Steele to offer him hundreds of pounds to sing at a party. The story went that the nineteen-year-old believed the woman to be Mrs Miller, until she inundated him with further calls and was revealed to be fake. The anecdote made good press but, sixty-five years later, Steele denied ever hearing of this particular rumour and said that the incident did not happen.

Marilyn took an interest in all things related to the Queen but, in reality, she had no intention of using one of Her Majesty's dressmakers for the gown. Organisers of the Royal Command Performance (or 'The Queen's Show' as Marilyn nicknamed it) asked all female artistes to dress in a suitable manner to meet royalty – for example, they should not wear gowns that were so low-cut that they showed too much cleavage. This revelation gave columnist Donald Zec a great idea for a column, and he proceeded to interview a variety of actresses on the subject of what they would wear for the performance.

Most of the women assured Zec that they would be covered up. Mary Ure – the actress currently appearing in Miller's A *View from the Bridge* – made clear that everyone should respect the feelings of the royal family. 'There are better ways of displaying sex-appeal than cleavage,' she said. Marilyn, however, refused to give anything away. 'This is strictly confidential – between my dress and me,' she told Zec.

Marilyn may have given a light-hearted reply to the journalist, but plans for the gown had actually taken up much of her spare time in the weeks leading up to the event. She had grilled publicist

Jeanne La Chard on what to wear, but it can be safely assumed that what Marilyn chose was not what La Chard suggested. Nor was it anything like the kind of gown recommended by the organisers of the Royal Command Performance. Instead, Marilyn went back to the fitting rooms of Madame de Rachelle, where the actress shared her thoughts and even a rough sketch of an idea. The costumiers were intrigued, though the design would go through some extreme fine-tuning before the gown was finally ready to be fitted.

Marilyn's mind may have been firmly on what she should wear to meet the Queen, but staff at the BBC were more concerned with obtaining an interview with the actress and her husband. On Friday 19 October, producer Stephen W. Bonarjee wrote to the Millers and asked if they'd be interested in taking part in a discussion for the *At Home and Abroad* programme. There had been many influential people on the show in the past, including British Prime Minister Sir Anthony Eden, Indian Prime Minister Jawaharlal Nehru, the Archbishop of Canterbury and actor Charlie Chaplin. Bonarjee hoped that these names – and the chance to talk about serious issues – would entice the couple to say yes.

Several days later, Gordon Mosley, the BBC Head of Overseas Talks and Features, was also interested in speaking to the Millers. This time it would be a high-brow chat about themes presented in Miller's plays, and would be between the playwright, Marilyn and philosopher Bertrand Russell. Mosley hoped that a taping could take place after an organised dinner in November, though he was open to further suggestions. This letter, and the one from Bonarjee, arrived at Parkside House soon after, but by this time Marilyn and Arthur were so tired of inquisitive journalists that they didn't reply to either of them.

Around this time, the coronation scene was filmed. Shot in a reproduction of Westminster Abbey, the scene dramatised the 1911

coronation of George V and came as a welcome relief to everyone, since it involved no dialogue and very little action. In the scene, Elsie Marina is invited to the abbey as the Queen's lady-in-waiting, and sits with Northbrook while the royal party sit on the other side of a large, wooden archway. Marilyn's job in the scene was to read the order of service, stare at the Prince through the arch, whisper to Northbrook, and become emotional while watching the ceremony.

Because Olivier had only a small part in this scene, he was able to work almost exclusively as a director, and Marilyn not only accepted his advice but seemed to relish it. The only annoyance came when the actress insisted on having a record player, which blasted nothing but 'Londonderry Air' for the entire day, but even so, the day was deemed a magnificent success.

Meanwhile, journalist Marcus Milne found an ingenious way of gate-crashing Pinewood Studios – by hitching a ride with a bus full of extras. During his time on Stage A, he tried to uncover some set-related scandal, but the unit was suspicious of newcomers and all Milne managed to discover was what everyone knew already – that Marilyn was often late, and Olivier had to shoot scenes in small bursts because the actress frequently forgot her lines.

As Milne waited impatiently for Marilyn to arrive, one of the third assistant directors realised that he was standing out from the crowd of extras. He approached the reporter, only to be told that he was awaiting the stage manager. Sometime later, the assistant returned. 'It has occurred to me,' he said, 'that there isn't any stage manager.' Milne was then asked to leave but, as he sauntered back up the corridor, Marilyn came rushing in the other direction. Head down, so as not to attract attention, the actress bumped into Milne, squealed 'Oooh!' and then headed off to the set. The journalist went home and playfully wrote up the encounter as a one-word, exclusive interview.

* * *

Marilyn spent Saturday 20 October at Parkside, where fitters from Madame de Rachelle arrived to go over her gown for the Royal Command Performance. She was back on set on Monday the 22nd but it proved to be a stressful day for everyone. First of all, Marilyn was almost ninety minutes late, and then the day's filming was held up by a further two hours and fifty-five minutes – the longest delay of the entire production. This revelation was carefully noted by the assistant in charge of keeping tabs on Marilyn's timekeeping but, in this instance, it was unfair to place the blame on her shoulders.

Almost as soon as the actress walked onto set, the beads on her dress began popping off for no apparent reason. This problem was fixed, just in time for Marilyn to announce that her hair didn't look right. Hairdresser Gordon Bond was hauled in to cure the problem and then, just as everyone was ready to continue, an electrical fault plunged the set into darkness.

Still, once the electricity had been restored, the unit got to work, and it wasn't all bad. The scene scheduled for that day was where Elsie Marina sings 'I Found a Dream' during her attempt to seduce the Prince, and it caused quite a sensation around the set. With hints of a British accent, one technician was overheard saying that Marilyn was 'like an English Deanna Durbin', and onlookers agreed that she sounded beautiful. In just five takes, the scene was finished, and then everyone went home, feeling as though the problems that day had all been worth it.

The next day – 23 October – everything came crashing down. Marilyn phoned in sick, and no amount of phone calls could persuade the actress to come into the studio. Rumours abounded that she was either suffering from exhaustion from the day before, or was punishing Olivier over the daily rushes, his treatment of Paula Strasberg, or both. Either way, the cast and crew had to content themselves with the few remaining scenes that Marilyn was not involved in.

On the same day, biographer and journalist Maurice Zolotow sent a telegram to Arthur Miller. In the note, he congratulated Miller on the success of *A View from the Bridge*, and then listed nine rumours he wished to discuss for an article he was writing. Most of the questions were related to Marilyn Monroe Productions; particularly whether or not Miller was taking a more active role; if he and Milton H. Greene had a difference of opinion on what should be going on within the company; and if Arthur and Marilyn were going to buy out Milton's share in the company.

When Arthur Miller responded on 24 October (while Marilyn was still off sick), he was casual and to the point. In the telegram, he denied having any kind of connection to the company, other than being married to the president. He only took a normal interest in her affairs, he explained, and any rumours of in-fighting within the company were space fillers for newspapers.

Around the same time, Zolotow phoned Milton H. Greene in London, and asked similar questions. Had Arthur Miller been appointed as an officer of MMP? Did the men have a difference of opinion? Would Greene sell his shares, and did he believe that Miller wanted him out of the company?

Some of the questions Greene refused to answer, but he did reveal that he was now living alone after his wife and baby son had returned to the States, and that MMP had future plans for creating projects for films and television. Amusingly, when asked if there was any friction between himself and Miller, the photographer replied that they were good friends. It was something of an exaggerated claim, but undoubtedly better than expressing the truth.

Wednesday 24 October was Dame Sybil Thorndike's birthday, and a story was placed in the *London Letter* newspaper column, which stated that the veteran actress had shot the ballroom scene that day. The piece gave details of how Marilyn and Olivier greeted their

co-star, wished her a happy day, and then put their troubles aside in order to act as joint hosts of a birthday tea party. Of course, no celebration would be complete without an elaborate cake, which was apparently presented to Dame Sybil during the course of the afternoon.

There was only one problem with this story – Marilyn was still off sick, and Dame Sybil wasn't involved in the ballroom scene at all. It appears that the fluffy tale was something of a PR exercise; a way of showing that the feuding stars were nothing of the kind. When planting the story, however, nobody had guessed that one of the main stars of the article would be nowhere near Pinewood Studios on the day of the 'joint party'. Instead, Marilyn spent the day at Parkside, accepting deliveries of the gown and shoes for the Royal Command Performance, and having them fitted with the help of Madame de Rachelle and Beatrice Dawson.

On Thursday 25 October, everyone ploughed into the studio to shoot the ballroom scene mentioned in the 'tea party' article. This was to be one of the most elaborate parts of *The Sleeping Prince*, and Roger Furse and Carmen Dillon's spectacular set design consisted of a massive dance floor with a gold staircase sweeping up to the landing above. Peppermint marble pillars lined the ballroom, while large, gold lights were displayed on the walls. Although the lights weren't real, Jack Cardiff used yellow filters on the camera to give the illusion that they were switched on. Plants, flowers and statues on plinths covered various areas, and huge chandeliers dangled above the dance floor. Garlands were woven up the banister and across the landing, where deep pink chairs and small tables played host to party guests.

The story depicted in the scene shows Elsie Marina (Marilyn), and Nicolas (Jeremy Spenser) perched on the grand staircase, discussing what demands the latter would like to make on his

father (Olivier). During their conversation, dozens of party guests struggle to get around them, including Lady Sunningdale (Maxine Audley), who insists they move over so that she can squeeze past. The Prince then appears, and he and Elsie dance while she tells him of Nicolas's demands.

The ballroom scene had already been pushed back because of Marilyn's absence during the days before, and now Olivier was on edge, waiting to see if his leading lady would show up at all. With such an extensive set and hundreds of extras in costume dress, putting together the scene was a logistical nightmare that Olivier did not wish to repeat, so the prospect of sending everyone home without having filmed anything was nerve-wracking.

At 9.30 a.m., the company received word that Marilyn had arrived in the studio. She was thirty minutes late, but that was better than not being there at all. The extras were dressed and rehearsed, the main stars were prepared, and the crew were eager to get going, but even after her hair and make-up had been done, Marilyn didn't appear on set.

Hairdresser Gordon Bond popped his head around the door, and was met with the sight of cast and crew clock-watching and fidgeting in their elaborate costumes. 'She's ready,' he said, 'but she's stalling. It's nerves again.' Some of the extras tut-tutted, while others took the opportunity to try and sit on Marilyn's canvas chair and discussed how they could possibly get close enough to touch her. One of the assistants decided to check the insurance status of the dancers, while stand-in Una Pearl sat on the stairs with Jeremy Spenser. A cry rang out that there was tea at the back of the room for anyone who needed it, while Olivier had his make-up retouched, stared at his watch, and prayed for a miracle.

After waiting and wondering if Marilyn would arrive on set, finally there was a flurry of activity, and the star wandered into view, wearing dark glasses and flanked by studio police. The security

pushed the extras out of the way, and shouted at them to stay back. One of the coppers demanded that the extras grab a cuppa while they waited, but nobody was interested in a drink. Instead, the dancers tried to shuffle forward, but the officers made it impossible to see, let alone talk to, Marilyn.

Unfortunately for Olivier, this robust behaviour was witnessed by none other than Derek Hill from *Picturegoer* – the very magazine that had been furious for being banned from the set. Hill had been able to get onto Stage A after interviewing cinematographer Jack Cardiff, who took Hill along as his guest. Now, the journalist kept an eye on the policemen, and made notes for a future article.

'She's too condescending,' exclaimed one extra within earshot of Hill. 'You'd think it was a blinking coronation the way they behave.'

One person who has vivid memories of being on the ballroom set is David Tringham. He was called in to help when third assistant director Colin Clark found it hard to cope with organising the extras. According to Tringham, Clark was 'running around like a headless chicken, and didn't have a clue. He was getting nowhere – he only ever wanted to be in the aura of Marilyn. He was always trying to get Marilyn's attention.'

Tringham remembered the actress's arrival that day: 'Marilyn waddled down from make-up to the set and I thought she looked like a jelly that hadn't set properly . . . She was very remote. She was protected – she was an icon. Her entourage buzzed around and Milton would be snapping all day long. He could never take a bad picture on that set.'

Olivier and Marilyn sat on the stairs, conversed for a moment, and then grabbed their scripts and climbed to the top. The two actors descended, going over their lines as they did so, and once at the bottom, they held hands and practised the dance routine. Things seemed to be going well, until Marilyn was told that she would wear a sash over her costume. She refused, claiming that

it would make her look like a beauty queen. In the end, the star was persuaded to wear it, but only if she could control where it sat against her chest.

It was finally time to run through the scene, and the entire set sprang into action. There were couples twirling on the dance floor, groups scattered around the upper balcony, and party-goers ambling up and down the stairs. One of the extras was professional dancer Edna Adam, who was there with her partner Billy Bourne. Edna acknowledged that the scene was hard work due to the amount of dancing involved – at least twenty-five full-costume rehearsals for one sequence alone – but enjoyed the overall experience. 'Miss Monroe and Sir Laurence are really marvellous to all of us and have unlimited patience,' she said.

Another couple, Frank and Winifred Alexander, ran a dance school and were excited to be involved with the ballroom scene. They had rehearsed for two weeks with their fellow dancers, and when they eventually met Marilyn, they found her to be pleasant and nothing like the temperamental actress they had read about in the press. 'In fact, she goes out of her way to be helpful,' Winifred said.

Despite the security team's intentions to keep Marilyn away from everyone, she did manage to impress several dancers during the two-day shoot. Maurice Jay was employed to help William Chappell arrange the dance sequence, while dance champion Bob Burgess was called upon to teach Marilyn the routine. 'She picked it up very quickly,' he said. 'First she asked me which foot to start off with. Then she adopted the American bunny-hug style of hold – left hand rather round the back of the man's neck.' However, once Burgess had sorted out this slight problem, Marilyn picked up the steps perfectly, and the dance between herself and Olivier was one of the most beautiful in *The Sleeping Prince*.

Someone who wasn't so impressed was Derek Hill from *Picturegoer*. Before he was thrown out of Stage A by Roger 'Plod'

Hunt, he grew bored with the mundane rehearsal and shoot of the ballroom scene: 'Envious of my experience? You needn't be. Despite all the paraphernalia of protection for Monroe, all the secrecy, this turned out to be just an ordinary set visit. Only one thing WAS extraordinary: the way extras were treated when Marilyn came into view. If I were an extra and been treated like that – I'd have stayed away from *The Sleeping Prince* set . . . AND WILLINGLY.'

Someone else who wasn't enthralled by the experience of working with Marilyn was David Tringham: 'She was always late. The extras, dancers, choreographer were all there, and always in wardrobe. They just had to be patient, have tea and wait. Marilyn was completely self-centred and no help to everyone else. Making films isn't fun, but can have moments. But she wasn't aware. She would come, do the scene, then they'd say it was great, even if it wasn't.'

Marilyn wasn't the only one being fawned over by her entourage. Olivier had his own band of buddies who were willing to tell him that everything was wonderful, even when it wasn't. What's more, it seemed to irritate Olivier that Marilyn wasn't one of those people. Tringham remembered: 'It was frosty between Marilyn and Olivier. He couldn't handle it that she didn't defer to him. She had a knack of putting him down. Olivier lived in a parallel world that didn't exist, and was surrounded by cronies, telling him how great he was.'

'The stress caused by Marilyn made Olivier's life hell,' said publicist Jerry Juroe. 'But Larry needed to work. He was in a difficult position, because he was always treated like a god on film sets, but on this one, he was there thanks to Marilyn. Olivier wasn't accustomed to being there for the grace of God. He just couldn't accept the fact that Marilyn was the producer.' In spite of this, Juroe never saw Olivier lose his temper on set. 'He was able to hide it because he was the world's greatest actor. He was very close to his team.'

The almost twenty-year age difference between Olivier and his leading lady was not lost on the cast and crew of *The Sleeping Prince*. David Tringham recalled: 'There was just no chemistry. It was a fatal flaw – they thought that putting Olivier (the so-called greatest actor) together with the greatest pin-up would be a hit, but Marilyn looked as though she was talking to her father!'

It wasn't just Olivier's appearance that was deemed fatherly. He had taken to telling Marilyn off when she kept people waiting on set. One day during a particularly stressful scene, the actress was marched onto the set to apologise to Dame Sybil Thorndike. Much to the chagrin of Olivier, the veteran actress wouldn't hear of it. Telling Marilyn that she mustn't concern herself with something so trivial, Sybil then accused Olivier of being too stern with his co-star, and told him that Marilyn was under a lot of strain, and he was not helping with his bullying tactics. To Dame Sybil, Olivier was always going to be the little boy who carried her train in *Henry VIII* and, as a result, she was one of the only people on set who was not intimidated by his power.

Marilyn was thrilled that Dame Sybil continued to be an ally, and beamed after hearing her words. She was even happier when the veteran actress described Marilyn as being the only one out of the whole company who knew how to act in front of a camera. Olivier was less than impressed, particularly when Dame Sybil told him that with Marilyn on screen, nobody would be watching him.

One day, while shooting a scene in which the Queen and the showgirl have to descend a large staircase in the embassy, Olivier asked for more than a dozen retakes. This meant that the two women were forever marching up to the top of the stairs, and Marilyn became concerned that the older lady would exhaust herself. Dame Sybil was astonished. As far as she was concerned, the person who needed protecting was her younger, fragile co-star. '[Marilyn] is quite enchanting,' Thorndike said in September 1956.

'There is something absolutely delightful about her. She is not at all actressy.'

'People wanted to help [Marilyn] all the time,' remembered Elaine Schreyeck, 'but everyone grew antagonistic about her lateness. One day Olivier made her apologise to the whole unit, and she did. It was sad and I wanted to jolly her along. I would have loved to get to know her better, but Paula didn't give us the opportunity.'

When Marilyn couldn't remember her lines on one particular day, Dame Sybil sat down and helped her to go through them. This kindness wasn't forgotten, and Marilyn always held the actress in high regard. However, while Dame Sybil adored the actress, there was still trouble ahead, such as the day Marilyn had a monstrous falling out with the wardrobe department. The story made it into the newspapers and, years later, assistant Joe M. Marks confirmed the confrontation: 'The lady tried to fire the wardrobe because they accidentally came into her dressing room and she was almost stark naked; not an uncommon sight in a dressing room at the end of a hard day's filming with her. The wardrobe man would go into Marilyn's dressing room at the end of the day to collect dresses. One day she was naked, except for her shoes. She screamed, "How dare you?!" and either attempted to, or had him fired. We all liked him very much, for he knew his job well . . . He would not have made a pass at her in a million years.'

Damage done, the assistants refused to go anywhere near Marilyn's dressing room, especially if it was time to call her onto the set. Nobody else was willing to take on the job so, in the end, Laurence Olivier and Jack Cardiff would take it in turns, though neither of them relished having to do it. 'Her spikiness and spite were frightening,' Olivier wrote.

Even though the set of *The Sleeping Prince* remained closed, throughout the shoot stories continued to be leaked. It was Jerry

Juroe's job to shrug off any rumours of discord and deny all hints of trouble, but the stories and comments from an unnamed source were too factual to be ignored. Specific incidents and dates appeared in the newspapers, and it was clear for a long time that there was a spy on set. For much of the shoot, nobody had a clue who it was, but then it was discovered that Alan Arnold, one of the Arthur P. Jacobs staff, was writing a series of articles about the shoot.

Everyone was furious, but none more so than Marilyn and Laurence Olivier. The latter instructed his team to fire the man immediately. 'It was an extreme no-no to ever sell your story of life on a film set,' said Jerry Juroe, who recalled Marilyn being extremely upset by the betrayal. 'It was all part of the everyday angst she felt. Everything was a problem for Marilyn.'

The scandal was made worse when it was revealed that Alan Arnold had noticed *Picturegoer*'s Derek Hill on the ballroom set, and made him promise not to write anything about what he saw, presumably partially because he was planning his own tell-all. 'It was like the Inquisition,' Hill later said.

Despite the scandal, Arnold's story appeared in the *Sunday Dispatch* newspaper. In the articles, he gave a great deal of behind-the-scenes scandal, including the fact that everyone admired Olivier for his patience, especially when Marilyn continued to fluff or forget her lines. According to the ex-publicist, the actress pushed Olivier's patience to the limit when it took twenty-nine takes to do one particular scene.

Arnold even went so far as to quote cinematographer Jack Cardiff's thoughts on Marilyn. 'Half-way through the picture she began asking herself whether [Olivier] was really the genius she had at first imagined,' Cardiff was quoted as saying. 'Well, he is. Larry's knowledge and experience of acting and filmmaking are gigantic compared to Marilyn's.' The cinematographer apparently said that he believed Marilyn would one day see what a genius Olivier was,

and that she would grow to trust him again. 'But that will be when it is too late,' he said.

Since Marilyn had grown to trust and value the friendship of Jack Cardiff, it can only be imagined how upset she was to hear him quoted in this way. The notoriously private Olivier was furious that his business was being splattered all over the British press, and Jean Osborne, chairman of the Association of Cinematograph, Television and Allied Technicians Publicity Section, gave a scathing statement to the newspaper, rebuffing the first article.

In the comment, Osborne said that her department deplored the breach of professional etiquette shown by Alan Arnold, a member of the association. 'While appreciating that your newspaper had no hand in sponsoring these articles, we would like to make clear our disapproval of the unethical action of the writer.' Neither the newspaper nor Alan Arnold were concerned, and two follow-up articles appeared in the weeks ahead, while Arnold scuttled off to New York.

Another person who was incensed about the scandal, was columnist Tom Hutchinson, who complained in *Picturegoer* that his magazine and others like it had been prevented from giving the story of what went on during the making of *The Sleeping Prince*. 'Then the bombshell burst. It was revealed that Arnold had sold his series.' Hutchinson acknowledged that Arnold was wrong to tell his tale, but also blamed Olivier's closed-set rule. 'Would it have happened at all if there hadn't been this fatuous secrecy surrounding the film-making? I say not. It's high time that "The Sleeping Knight" – and I mean Sir Laurence – woke up to that fact.'

As all of this was going on, Olivier was buoyed to discover that Paula Strasberg could not come back to England because of a clause in British employment laws, and was ecstatic at the prospect of being able to finish the film without the coach on set. That was

until Marilyn received a call from Paula, telling her that she was being refused entry to the country. Suspicious that Olivier was deliberately keeping Paula away, the actress insisted she be brought back immediately. The director balked at the request, until Marilyn once again made his on-set life unbearable and he was coerced into making sure the coach returned.

Olivier would come to regret his decision. First of all, the moment Strasberg arrived at Pinewood, the barriers between director and star, and star and other personnel, seemed impermeable once more. Then almost a year later, Olivier was shocked to find Paula's air ticket on a list of *The Sleeping Prince* expenses. He scrubbed it off, stating that the second trip was entirely her own affair, and, while he was at it, the director also refused to pay expenses related to hairdresser Sydney Guilaroff, assistant and friend Hedda Rosten, and lawyer Irving Stein. As far as Olivier and agent Cecil Tennant were concerned, these people were all under contract to Marilyn Monroe Productions, and that was the end of the matter.

Chapter Ten

When Marilyn Met the Queen

On Friday 26 October, the stars due to attend the Royal Command Performance were invited to a party at the Odeon Theatre, Marble Arch. In keeping with her decision to turn down almost every invitation offered, Marilyn was not there, but the acerbic actress Joan Crawford was.

Crawford had been vocally hostile towards the younger actress for some years, and had been particularly scathing in 1953 when she criticised a low-cut gown that Marilyn had worn to an awards ceremony. Crawford claimed – rather dramatically – that she had never been so embarrassed by Marilyn's look. 'The make-up of the true star is founded on talent,' she said. 'Miss Monroe is giving a grotesque interpretation of the artistry and sincerity that is, and has always been, behind the making of movies.'

Instead of aiming barbs at Crawford for the attack, Marilyn expressed that she was deeply hurt by the comments, and this spurred her fans to inundate Crawford with hate mail. The bitter actress denied that her words were ever intended to be made public, but her opinion remained the same. Now, Crawford was in England to make *The Story of Esther Costello*, accompanied by her husband, Pepsi chief executive Alfred Steele. When they arrived in London

on 24 July, a reporter from the *Daily Express* asked Steele the same question he had asked Arthur Miller ten days before: what is it like to be married to a great celebrity? Steele told the reporter that he had first and foremost married a lady, and it wasn't until later that he'd discovered she was also a movie star.

'I bet Mr Miller couldn't top that!' squawked Crawford.

Now, at the Cinematograph Trade Benevolent Fund party, the older actress provoked trouble again, this time by speaking about Marilyn's refusal to attend public functions.

'Marilyn Monroe should be here on an occasion such as this,' she complained, and then bizarrely denied that the two had ever been in a feud. Crawford did, however, claim that she had once turned down the job of teaching Marilyn how to dress properly, as she found it impossible to help her.

As soon as the Marble Arch party was over, a reporter phoned publicist Jerry Juroe and asked what Marilyn thought of Crawford's comments. Juroe refused to wake Marilyn up to ask such an inane question, stressing that she was exhausted after working on the two-day ballroom scene. 'She finished work at 7 and was in bed by 9 . . . She's finding it exhausting,' he said.

The next day – Saturday 27 October – Dame Margot Fonteyn gave a party for Princess Margaret after a Bolshoi Ballet performance of *Romeo and Juliet* at Covent Garden. The Princess had just returned from a tour of Africa, and was happy to accept Fonteyn's invitation to share her theatre box and then attend the after-party. Fonteyn wondered if Marilyn would like to go too, but, though flattered, the actress declined and left it to a spokesperson to let the famous ballerina know.

'Miss Monroe,' he said, 'will be taking things easy over the weekend, to be ready for Monday night's Royal Command Film Performance.' This decision did not please certain quarters of the British press, who were growing ever more frustrated with Marilyn's

elusive behaviour. At least one reporter phoned Parkside to see what the problem was, but was given the standard reply that the actress was resting and planned a quiet weekend.

But it wasn't just social events that Marilyn was afraid of. Announcing that she would be too busy learning her lines for *The Sleeping Prince*, Marilyn refused to attend the Royal Command Performance rehearsals on the morning of Sunday 28 October, and sent publicist Jerry Juroe instead. The stars (and Jerry) all gathered in the circle lounge at the Empire Theatre, where they were given a lecture by committee official Theo Cowan on what to do when meeting royalty. 'Relax,' he said. 'Speak to her Majesty only when spoken to.'

After the talk, the stars all took their places and practised meeting the Queen. Jerry Juroe had to pretend to be Marilyn, and stood next to actor Victor Mature. 'Nobody knew who the hell I was,' recalls Jerry, 'but it was my fifteen minutes of fame!' Afterwards, he headed to Parkside to take Marilyn through what was expected of her. There he found the actress excited but nervous: 'The Queen was a very special woman, and inside Marilyn was still a little girl from California. She was a nervous wreck to meet her, and you can't put Marilyn down for that.'

On Monday 29 October – as the looming Suez Canal crisis dominated the headlines – Marilyn was to meet the Queen. When the day dawned, the actress was once again absent from the set of *The Sleeping Prince*, and while it is impossible to say if she had prior permission to have the day off, those keeping tabs on her timekeeping wrote down her absence as 'Not available'. It is doubtful that the movie even crossed Marilyn's mind that day, as her full attention was on readying herself for the evening ahead. These preparations included hours of hairstyling with Gordon Bond, and then her make-up was applied. Lastly, it was time to slip into a gown that would make headlines around the country.

Officials may have instructed the female attendees to dress conservatively, but the dress Marilyn chose to wear when meeting Queen Elizabeth II was like nothing they had in mind. Made of gold lamé, the gown was so low-cut that the tops of Marilyn's breasts were on full display. Tight to the body, with spaghetti straps and a fold of material meeting at the chest and heading down towards the floor, the dress came complete with a matching cape and bag.

Several staff were on hand to help Marilyn get into the gown, before she slipped on long gloves and platform sandals, similar to those worn at the premiere of *A View from the Bridge*. A quick spritz of perfume, and Marilyn grabbed her handbag and descended the stairs. The driver was waiting outside, and the smiling actress crunched her way over the gravel drive and climbed into the car, accompanied by Arthur Miller and Milton H. Greene. For Jerry Juroe, Marilyn's departure from Parkside House meant that he could breathe again. For the past few weeks, his major concern had been to ensure that Marilyn arrived at the theatre before Her Majesty, and although it would be a little tight, the actress accepted and achieved the challenge.

As the chauffeur pulled up outside London's Empire Theatre, it was as though the entire population of Britain was gathered outside. It was a cold October evening and a biting wind blew its way around Leicester Square, but this didn't stop fans from queuing for hours just for a glimpse of Marilyn, the Queen and an abundance of other famous folk. Dressed in winter coats, hats and gloves, the crowds screamed and pushed forward, while policemen tried to hold them back. As Marilyn exited the car, a photographer swooped in and took a picture, looking down the front of her dress. He moved aside, and then the fans' excitement reached fever pitch.

'Marilyn! Marilyn!' they chanted, and the smiling actress turned and waved to everyone who greeted her. By this time, she was having trouble keeping her cape on her shoulders, and she and Arthur spent

some time adjusting it, before fighting their way through the crowds and into the theatre.

Inside the foyer, the place was alive with guests, staff, photographers and, as the film was to be *The Battle of the River Plate*, active seamen. As Marilyn wandered past, holding her wrap around her chest, most of the crowd turned and stared. She smiled broadly, then threw back her cape to reveal her spectacular dress. Flashlights popped, and then she and Arthur Miller ascended the steps and reached the space where the celebrities were lining up to meet the Queen. The rest of the audience, meanwhile, made their way into the auditorium, where they took their seats to the sound of musician Nelson Elms on the organ and the orchestra of the Royal Marines School of Music. Soon they would watch the Queen greeting the famous attendees via the cinema screen.

In the upstairs lounge, an excited but nervous Marilyn had removed her cape and was sandwiched between actors Victor Mature and Anthony Quayle (Miller was not being presented to the Queen). Quayle was one of the stars of *The Battle of the River Plate*, and the rest of the line-up read like a Who's Who of cinema royalty. Stars included Brigitte Bardot, Peter Finch, Norman Wisdom, Anita Ekberg, Vera-Ellen, Sylvia Syms, John Gregson, Mary Ure and Marilyn's arch-enemy, Joan Crawford. In addition, there was also a generous smattering of industry professionals, as well as Royal Navy-related guests who had been involved – or were related to a participant – in the real Battle of the River Plate.

As Marilyn waited with fellow celebrities in the long, buzzing lounge, the Queen arrived in Leicester Square with her sister, Princess Margaret. Also in the party were Lord and Countess Mountbatten, though the Duke of Edinburgh was absent, having already left for a four-month official trip on the Royal Yacht *Britannia*.

Her Majesty, wearing a beautiful black, full-skirted gown and a diamond-and-emerald tiara, was greeted outside by Charles Penley,

the Empire's general manager, and then slipped into the foyer, where she was met by Reginald Bromhead, president and chairman of the Cinematograph Trade Benevolent Fund. That done, the Queen made her way upstairs, where she not only met the famous attendees, but also many journalists. Some of the pressmen crouched on the floor, others hustled for a better view, but all followed Her Majesty as she greeted her guests.

The line was long, and Marilyn was more than halfway down. At times the actress stared ahead, nervously waiting her turn, but as the Queen moved closer, Marilyn could be seen peeping out and then excitedly chattering to actor Victor Mature.

As the Queen shook hands with the stars, Reginald Bromhead discreetly glanced at his notes to make sure he named each celebrity correctly. And then it was Marilyn's turn.

As the Queen gave her a brief look up and down, the actress took Her Majesty's hand and then descended into a well-practised curtsy. The two then chatted for several minutes, and covered subjects including being neighbours and the Queen's beloved Windsor. 'We love it,' Marilyn said. 'As we have a permit my husband and I go for bicycle rides in the Great Park.'

The Queen finally moved on, and then Marilyn repeated the process with Princess Margaret, who was wearing a rose-and-gold brocade gown. The women chatted about cycling, life in England and the making of *The Sleeping Prince*.

'It's going on very well,' Marilyn told the Princess. 'And it will be with regret that we have to leave in about a fortnight's time.'

Princess Margaret then greeted actor Anthony Quayle, but this was not the last of her conversation with Marilyn. Hearing them talk about *A View from the Bridge*, the actress interrupted the conversation and asked the royal to go and see the play. 'The Princess laughed and said she might,' Marilyn said afterwards and, sure enough, Princess Margaret did attend a performance a short time later.

Once she had made her way up the line, the Queen was greeted by six-year-old Nicholas Douglas Morris, who presented her with flowers and gave a little bow. Only when Her Majesty had spoken to every person in the line was it time to take her seat with the audience and celebrities in the theatre. The lights dimmed, a cartoon production called *The History of the Cinema* was shown and then it was time for the main feature, *The Battle of the River Plate*.

In addition to watching the film, the attending celebrities were required to line up onstage and take a bow, one by one. As before, Victor Mature stood on one side of Marilyn, and Anthony Quayle on the other. However, because the actress had not been to the rehearsals, she had no idea what she should do next, and as the group stood behind the closed curtain, waiting for their names to be called, Marilyn panicked. In his 1990 autobiography, Quayle wrote that the actress asked him over and over what she should do when her name was called, but despite explaining several times, Marilyn was too anxious to remember.

As the line shuffled forward, she turned to actor Victor Mature, and asked him what she should do. 'Fall on your ass baby,' he replied, and then slipped through the curtain. Marilyn was introduced several seconds later and, despite her nerves, she stepped forward, turned right, then left, and the crowd went crazy.

As Marilyn exited the theatre, she was buzzing with excitement. Before she could get into her waiting car, several reporters stepped forward and asked what she thought of the royal guests.

'The Queen is very warm-hearted,' Marilyn said. 'She radiates sweetness. She asked how I liked living in Windsor, and I said, "What?!" and she said that as I lived in Englefield Green, near to Windsor, we were neighbours. So, I told her that Arthur and I went on bicycle rides in the park.'

Another journalist asked if it was difficult to perfect her curtsy. 'Not a bit,' Marilyn said, laughing, and then she demonstrated for him.

The previously nervous woman who had begged off the prior rehearsal was brimming with confidence as she slid into her car and headed back to Parkside. In contrast, outwardly confident actor Victor Mature said that he was so nervous he couldn't remember a thing the Queen said to him; Brigitte Bardot admitted she was worried about her curtsy; and acidic Joan Crawford claimed that she had never been so scared in her life.

As the years have passed, some wonder if the Queen knew who Marilyn was, but judging by the 'neighbours' remark, there is no doubt that she not only knew, but also had knowledge of the star's whereabouts. Further proof comes in the form of the 1954 premiere of *Beau Brummell*, a movie starring Marilyn's *Gentlemen Prefer Blondes* co-star, Jane Russell.

The Queen, the Duke of Edinburgh and Princess Margaret were all in attendance, and Her Majesty took time to speak to Russell. The actress revealed that she was going to make *Gentlemen Marry Brunettes*, based on a book by Anita Loos, the author of *Gentlemen Prefer Blondes*. During the conversation, Princess Margaret told Russell how much she enjoyed *Blondes*, while the Duke of Edinburgh jokingly wondered if brunette Russell was getting even with Marilyn, since the latter had been the blonde in the earlier movie.

In 1961, an article appeared in the *People* that gave a glimpse of the Queen's thoughts on Marilyn, through the eyes of an unnamed 'friend'. The article said that after the Royal Command Performance in 1956, the Queen became fascinated with Marilyn and watched every one of her movies. She apparently told the friend, 'I thought Miss Monroe was a very sweet person. But I felt sorry for her, because she was so nervous that she had licked all her lipstick off.' Footage of the event seems to back this up, since Marilyn can be seen licking her lips as she waited for the royal guests to reach her.

The Queen may have enjoyed meeting the actress, but at least one woman seemed unimpressed. When singer Jane Morgan was

asked what she thought of Marilyn's attire, she was reported as saying that she found it offensive. 'Miss Monroe must have a terrible inferiority complex to dress the way she does,' she said.

The next day – Tuesday 30 October – Marilyn was due at the studio at 10.30 a.m., but did not make it in until 12.35. Despite Brigitte Bardot later saying that she and Marilyn had exchanged friendly chat in a theatre bathroom, Marilyn complained to hairdresser Gordon Bond that the French actress had tried to upstage her during the Royal Command Performance.

'Marilyn was heard to call Brigitte "that silly little girl", and "who did she think she was?"' remembered Vera Day. Bardot had claimed many column inches in that day's newspapers (although Marilyn had won the bulk, including many covers), but if Marilyn had looked closer at the *Daily Mirror*, she may have had another Bardot-related complaint.

ITV announced that their 8.30 p.m. edition of the *Close Up* programme was dedicated to clips of Marilyn's films, but only because they had been unable to put together a show on director John Huston. Producer Macdonald Martin told the newspaper that he was delighted with the Marilyn programme, but was moving on to his next project – an exclusive interview with Brigitte Bardot.

On Thursday 1 November, Marilyn was over two hours late arriving at Pinewood Studios, and there were forty-five minutes of delays on set. However, the actress must have felt that the day was productive enough because she sent a telegram to Terence Rattigan in New York, sending her best wishes, and telling him that the film was just about done.

The next day, Olivier received word that Marilyn could not make it onto the set. The film was so close to completion that cast and crew were staggered to find their leading lady indisposed again, especially since there was little else that could be shot without Marilyn's presence.

While the cast and crew of *The Sleeping Prince* groaned at Pinewood, members of the Englefield Green cricket club were ecstatic because Marilyn and Arthur had made a donation towards the construction of their new pavilion. The couple had cycled over to the club several times during the summer months, and enjoyed their visits so much that they felt it only fitting to donate to the cause. Now, though, the cricket season was over, the nights were drawing in, and it was dark both when Marilyn left for work and when she returned. It would be another two weeks before the end of the England trip, and the Millers were now counting down the days.

They weren't the only ones.

On Monday 5 November – Bonfire Night – Marilyn returned to the set of *The Sleeping Prince* an hour later than expected, and then kept everyone waiting for two hours, twenty minutes. By now, nobody was surprised, and even when Marilyn did appear on set, most people got on with their work and paid her scant attention.

An example of the lack of attention came during one of the last scenes to be shot, which showed the line-up where Elsie Marina meets the Prince for the first time. In a nod to the broken-strap incident at the Plaza Hotel press conference, it was planned that Elsie Marina should curtsy, and at the same time her strap would pop loose. However, no number of rehearsals could get the break to happen at the right time and, in the end, a nail was hammered into the floor, and elastic attached to the nail at one end, and Marilyn's costume at the other. That done, a technician hid behind the scenes and released the elastic at just the right time. When the strap did eventually break, Marilyn laughed and exclaimed, 'Is there a man on the set?' The joke was a light-hearted moment in an otherwise stressful day, but then the actress became concerned that her breast could be seen on camera. A tired Olivier summoned various members of the crew to ask their opinions, but the men told

the director that, while shooting the scene, they hadn't even been looking at Marilyn.

Jean Kent played the part of actress Maisie Springfield in the line-up scene. Her part was small, as was her memory of her co-star. 'My knowledge of Marilyn was limited to a few lines in one brief scene,' she said, 'and she was rather more concerned that the bust line of her dress should be in the right place than anything else.'

Marilyn was late but worked with few hold-ups on 6 and 7 November, but then called in sick on Thursday 8 November – the same day Laurence Olivier hoped they'd be able to wrap up Marilyn's work on the movie. As the cast and crew waited to see what would happen next, Olivier wondered if there was enough film in the can to call time on the production. Marilyn was not expected on the set any more, so the director decided to spend the remaining production time studying the rushes and working with editor Jack Harris. Together they would cobble together something that resembled a completed movie, and then Olivier would decide what to do with it. Marilyn, meanwhile, holed up with Arthur at Parkside House and disappeared from public view.

Olivier believed he had not been able to get the best performance out of Marilyn, but eager to put the whole experience behind him, the actor/director decided that he would be willing to let the whole thing go if the Millers were satisfied with the movie. By Wednesday 14 November, the couple had watched the film in a Pinewood screening room, and Olivier told Marilyn that he would be happy to reshoot certain scenes if she felt they were needed. However, the actress would have to promise that she would behave; that she would be punctual and look to him as director, instead of Paula Strasberg.

The actress agreed and, on 15 November, reported to Pinewood at 6.45 a.m. – her actual call time. Marilyn was made up and then walked down to the soundstage, where Olivier had set up small

pieces of scenery all around the room. The idea was that they would shoot a scene using one background, move on to the next one, and keep going until they reached the end.

That was easier said than done.

In the space of a week, Marilyn seemed to have forgotten all of her lines, and she kept everyone waiting for two hours, twenty minutes. Olivier despaired until suddenly something clicked, and the actress sprung into life and completed the scenes. Not only that, but Paula Strasberg seemed to blend into the background, making Olivier's life a whole lot easier.

The reshoots were done over two days, during which time they managed to complete not only the shots but also post-synchronising – adding sound to the already filmed scenes. Olivier and soundman John Mitchell had been loth to do this process because they both felt that Marilyn wouldn't be able to handle it, and Mitchell had gone to great lengths to get the sound perfect during shooting – even installing a tiny body microphone when a boom was impractical because of shadows.

Despite this, no matter how much care had gone into the sound process, there were still portions of the film that needed to be clearer. Olivier and Mitchell didn't hold out much hope, but Marilyn surprised everyone by completing the process in a few hours. When John Mitchell congratulated her, the actress shrugged. 'It's the only thing I can do properly,' she said.

When everything was finally completed, Marilyn presented gifts to the entire unit. There were jewellery boxes for the ladies, and gifts including bottles of alcohol and wallets for the men. Colin Clark later claimed to see cast and crew collect the gifts from a long table and then throw them into the bin. However, if true, it certainly wasn't the case with everyone. Continuity supervisor Elaine Schreyeck collected her jewellery box, and has kept it for over sixty years. 'Marilyn was very generous,' she recalled.

Stand-in Una Pearl received a velvet-lined box, along with a job reference: 'Una is a lovely girl, extremely talented. I value her as a friend. She will go far in the profession.' When asked what she thought of Marilyn, the stand-in replied, 'She was very nervy. But I wouldn't say she was temperamental.' Una added that she had learned a lot about acting from the star, and hoped to one day be the UK's version of Marilyn Monroe.

A photograph was taken that showed Marilyn in the company of all of *The Sleeping Prince* crew. From the lowest assistant right up to the mighty Olivier, the team posed with Marilyn in the centre. They were the picture of happiness – principally because the whole saga was now over. Production assistant Norma Garment recalled being surprised to be included in such a photograph, as she had not been asked to take part in one in the past. Still, she was thrilled, and kept the photograph with her for over sixty years.

Actress Vera Day was another person who cherished her Marilyn memories. Forty years later, she wrote, 'I found her to be charming and beautiful. Difficult yes. But there was only one Marilyn, and she jolly well deserved to be difficult . . . She was sensationally beautiful. I know she irritated nearly everyone, but she was surrounded by a lot of "po-faced actors" who gave her a hard time. She was dreadfully insecure, goodness knows why, because she had everything going for her.'

One 'po-faced actor' was Esmond Knight, who played Colonel Hoffman. He later gave his rather cruel view of Marilyn to biographer Hugo Vickers: 'Marilyn – stupid woman that she was – she was an absolute cretin – she couldn't remember the simplest line.'

On the opposite end of the spectrum was Dame Sybil Thorndike, who had the optimistic view that anyone who found Marilyn difficult must be difficult themselves. While she admitted that Marilyn would never arrive on time, Sybil made no secret of her love and admiration for her younger co-star. 'She had no leading

lady frills at all,' she wrote. 'She was as nice to the small boy who brought her coffee as she was to the stars.'

In addition to presenting gifts, Marilyn gave a heartfelt apology to her colleagues. As the unit was herded onto the set, the actress stood in front of them, smiled and said sorry for being 'beastly. I hope you will forgive me as it wasn't altogether my fault. I have been ill.' There was then an informal party, where Marilyn socialised with the other cast and crew members in a way she had rarely done before. Soundman John Mitchell was surprised that Marilyn knew his name, and recalled her being genuinely sad when it was time for her to leave.

Some of the crew spoke to reporters afterwards, and all agreed that the actress's apology was necessary, since the hold-ups and lateness had caused a considerable amount of stress and anger. However, while Marilyn could never say that she made many friends on the set of *The Sleeping Prince*, in her defence, she wasn't the first nor the last star to keep to herself. 'You want to talk to the stars like normal people,' said David Tringham. 'But you can't – you have to hold your distance and not be too familiar.'

Now that the production was finally finished, reporters were determined to find out exactly what went on. At least one sought out Jerry Juroe in the hope of discovering some scandal. All he found out, however, was that Juroe had no wish to spill any gossip. Laughing off the idea of a feud, the publicist offered the explanation that there had been several discussions between Olivier and Marilyn, but nothing that couldn't be handled.

'There are bound to be scenes here and there which he sees one way and she another. Miss Monroe is tremendously self-critical. And Sir Laurence . . . well, you know what an exacting director he is.' This, according to Juroe, was why some scenes had required fifteen takes. He then reminded the reporter that it had been an exhausting movie for Marilyn, with her required on set for most of the shoot.

Newspapers were never going to believe that the production of *The Sleeping Prince* was anything but difficult, and Juroe didn't entirely believe his statement, either. Talking about the movie over sixty years later, the publicist said, 'Something was always a problem. There was always a problem, even when there wasn't.'

As the finishing touches to *The Sleeping Prince* were being put together at Pinewood, Armand Georges was wandering around Englefield Green with a large box in his arms. Mr Georges had been an actor, but was forced into retirement due to bad health. However, his passion had never died, and now he spent his time writing about the theatre, campaigning for fellow actors, and making a model of a Victorian travelling theatre out of matchsticks, silver paper and cardboard.

Armand's passion had led to a variety of newspaper articles and a TV spot on a BBC show called *Friends to Tea*. There, he showed his model, which came complete with working doors and a mini brazier. Many wondered what he would do with it next, but Armand already knew. When the retired actor heard that Marilyn was interested in acting on stage, he wrote to ask if she and Arthur would care to accept the model as a gift.

'I thought they would like to see what the original theatres were like,' Armand said, and he was proved correct. He received an enthusiastic letter from the Millers, telling the model-maker that they would be delighted to receive the theatre, and would eventually donate it to a museum in New York.

And so it was that on a chilly November day, Armand found himself searching the Surrey lanes before finally stumbling across the white gates of Parkside House. An enthusiastic Arthur Miller accepted the model, apologised that Marilyn was at Pinewood, but promised that his wife would find it just as wonderful as he did.

* * *

On Friday 16 November – as Marilyn completed her last day of reshoots – a British branch of Marilyn Monroe Productions was registered in London, with a nominal capital of £100 and a primary goal of producing films. Journalists were keen to find out if these projects would involve Marilyn, but they were unable to extract a comment from the actress. However, they did manage to obtain an official statement from Milton H. Greene's camp: 'Miss Monroe intends to make more films in this country in view of the happy relations at Pinewood. The films will not necessarily star Miss Monroe.'

From the beginning of their association, Marilyn and Milton had dreamed that their company could branch out into making all kinds of media. 'We shall not restrict ourselves to films in which Miss Monroe appears,' Milton had said. 'We plan to finance other films, enter TV production and, under our corporation set-up, to engage in any branch of the entertainment business.' However, Greene later told biographer Fred Lawrence Guiles that while he had casually discussed the British plans with Marilyn, he had never mentioned them to Arthur.

When the playwright found out, he screamed at Greene down the phone and said that the company had been registered behind Marilyn's back. According to Greene, one of the first movies planned to be produced by the company was a Jack Cardiff-directed version of D. H. Lawrence's *Sons and Lovers*. However, the reaction from Parkside ensured that these plans would be blocked.

That evening, when journalists were filing their stories about the creation of the company, and Marilyn and Arthur Miller were fuming at Milton, the London premiere of *War and Peace* took place. The movie starred Audrey Hepburn, and was the only premiere (aside from the Royal Command Performance) that the Millers had agreed to attend.

This decision likely hinged on the fact that *The Sleeping Prince* cinematographer, Jack Cardiff, had also worked on *War and Peace*,

and the couple wanted to show their support. However, with the exhaustion of the last two days of retakes, and with the perceived cloud of betrayal hanging in the air, the Millers snubbed the event. Organisers couldn't believe that the couple hadn't shown up, and the premiere was even delayed by fifteen minutes in the hope that they would attend. In the end, however, the cinema personnel had to admit defeat. The audience crowded into the auditorium, and the film was shown without the presence of Marilyn and Arthur.

On Sunday 18 November, Marilyn and Arthur attended their last public event: a discussion at the Royal Court Theatre on the subject of the British theatre. The evening was entitled *Cause without Rebel* and was held in aid of *Encore* magazine, a quarterly review for students of the theatre. The speakers on stage were writers Wolf Mankowitz, Arthur Miller, Benn Levy, Colin Wilson and John Whiting, while overseeing the discussion and asking the questions, was Kenneth Tynan – the man whose dinner party Marilyn had previously snubbed.

Mankowitz had met Marilyn briefly at Pinewood, when he had been lucky enough to get past the closed-set barrier. However, he found the production on an impromptu hiatus, which he said was caused, 'Because the relationship between Olivier and Marilyn was very, very bad. He couldn't stand her at all and found her acting – her way of setting about acting – and Mrs Strasberg's presence, absolutely unbearable.'

By the time Marilyn and Arthur arrived at Sloane Square, the theatre was full. Many of the attendees were there to hear the literary greats speak, but a fair few were only interested in seeing Marilyn. She waited until the lights had dimmed and then crept to her seat on the fourth row of the stalls, but reporters followed her into the auditorium, and began snapping pictures and asking questions. Marilyn was in no mood to talk. After all, this was Arthur Miller's

night, and she was steadfast in her belief that she was there only to support her husband.

Wearing a black dress suit with a fur-trimmed jacket, the actress declined photographers' requests to look into the cameras, and instead stared directly ahead. Still, the flashbulbs continued, even when the speakers had arrived onstage. The discussion began, but nobody could hear a word because of the commotion on the fourth row. Boos erupted from those who had come specifically to see the conversation, and in the end an organiser stepped forward and threw his arms in the air.

'This is a debate; not a circus,' he shouted.

The photographers stopped snapping and were escorted out of the building.

Wolf Mankowitz later remembered that Miller was so preoccupied by his wife that he could not concentrate on the discussion. According to Mankowitz, there had been gossip backstage that Marilyn could be pregnant, and that it had caused 'a great kerfuffle'. He did not appreciate the actress's presence: 'It kind of, sort of destroyed the whole point of the occasion – the audience was much more interested in trying to see her than they were interested in what we were saying about the British theatre.'

In actual fact, it was Wolf's interaction with writer Colin Wilson that caused the most distraction. Since the overnight success and subsequent fame caused by the publication of his book, *The Outsider*, Wilson had found himself on the receiving end of vicious comments and petty jealousy from several fellow writers and critics. Describing Mankowitz as 'That bastard', Wilson still smarted from the encounter, forty years later. 'He was very, very anti-me. I think [he was] jealous of this silly overnight success.'

Perhaps the problem stemmed from the fact that Wilson was not originally supposed to take part in the debate, but the organiser asked him at the last moment. Wilson agreed, but from the beginning of

the discussion, Mankowitz took an instant dislike to the twenty-five-year-old writer. Wearing cords, polo-neck jumper and jacket, Wilson was somewhat surprised by the reaction. 'He decided to go for me and got several sort of cheap laughs by making various jokes.' The young author was pleased that he was able to fire some shots in return, but the other writers could barely get a word in.

At one point, Wilson declared that he agreed with a statement Mankowitz had given about intellectuals and the theatre. Mankowitz snapped, 'I'm sorry. I withdraw what I said.' As if that wasn't bad enough, Wilson then knocked a glass of water all over himself, before disclosing his wish that everyone in England should one day speak with the same dialect. Mankowitz snapped that this notion was inexperienced nonsense.

'I said it just perpetuated class division,' Wilson remembered. 'I'd be glad of the day when everyone more or less spoke with the same kind of accent.'

When Wilson revealed that he considered Shakespeare to be 'a second-rate mind who produced a lot of quotations suitable for printing on calendars', Mankowitz sneered and said that the calendars would undoubtedly be better than Wilson's book, *The Outsider*.

Marilyn surveyed the argument from the safety of the fourth row, her gloved hands knitted together. With only one full day left of the England trip, she could be forgiven for wondering why she had chosen to attend the evening at all. At least one other spectator felt this way, and shouted that the event was supposed to be about the theatre, not an attack on Wilson. Mankowitz sniffed and shouted back, 'Why not? An attack on Wilson can be our contribution to the theatre.' After that, Colin Wilson fell silent, and Arthur Miller was finally able to speak his mind.

With Marilyn smiling from the stalls, the playwright disclosed that he preferred to work in England than New York – something

his wife probably disagreed with – because a play could still go on in London even at 60 per cent capacity. According to Miller, even a few empty seats could close a play in New York.

'The atmosphere of hysteria is worse in the States,' he said. 'The critics have the power to close a play by bad notices . . . In England, the critics have less power – or at least, less concentration of power.'

At the end of the discussion, applause rang out throughout the audience, and Marilyn took to her feet. Turning to those around her, the actress was heard to say how exhausted she was, before retiring backstage for refreshments with the other participants. Wolf Mankowitz refused to stay, and when a reporter from the *Evening Standard* asked why, he barked, 'I have no more time to argue with Wilson. I'm already two hours late for a dinner party.'

Despite the freezing November temperatures, all around the theatre, fans, photographers and reporters gathered to catch one last glimpse of Marilyn. This was to be her final night out in London, and they didn't want to miss it. The result of this commotion was that after the refreshments, the Millers and Colin Wilson could not leave via the stage door or the main one. Eventually the three of them were ushered out of a fire door – but not before fans and the press had got there first. Marilyn signed several autographs, as Miller told reporters that as soon as they could get to their car, he and his wife would head straight back to Parkside.

As the crowds closed in, Marilyn grabbed Colin Wilson's hand, and led him through the throng. He was shocked that she held his hand instead of Miller's, and took it as a sign that there was some kind of attraction between them. What seems likelier is that Marilyn merely felt compassion for the younger, less-experienced celebrity (especially after his treatment on stage), and her move was one of care, not magnetism.

In all, the experience at the Royal Court Theatre was not a happy one for Colin Wilson. The discussion was later published in

a theatrical magazine, and the article featured all of Wilson's pauses and hesitations. The result – according to Wilson – was that he was 'made to look completely bloody illiterate'.

In his autobiography, *Timebends*, Miller wrote that Marilyn was rather quiet on the way home from London. He wondered if it was because she had attended the event as a human being, rather than an actress, and thought that if they could only carve out a normal existence in the States, they may be able to have a great life together.

Parkside House was leased until 27 November, with the intention that Marilyn and Arthur would use the extra time to see sights around the United Kingdom, and maybe even dash over to Paris for several days. However, in the end, the actress was just too exhausted and wanted to go home. So it was that on Tuesday 20 November, 1956, the couple did some last-minute packing and readied themselves for the trip back to New York. Marilyn would say an official goodbye to Laurence Olivier and Vivien Leigh at London Airport but, for now, the Parkside staff bid their boss farewell.

'We lined up to say goodbye,' remembered a constable from the Surrey Constabulary. 'We shook hands with Mr Miller, and Marilyn gave us all a kiss on the cheek.' The policeman would meet many famous people in the next thirty years, 'but none had the aura of Marilyn. She was a one-off woman.'

Cary Bazalgette, daughter of Deryck, the Parkside gardener, rushed home from school that day and, still wearing her muddy hockey clothes, stood and watched as Marilyn kissed the staff goodbye. As a fourteen-year-old girl, Cary was fascinated by the actress's hair, tied up in a little bun at the back of her head. As Marilyn made her way down the line, everyone was astounded that she kissed all of the staff; they just weren't used to that kind of farewell from other famous visitors.

Housekeeper Dolly Stiles had brought her daughter to work occasionally, and Marilyn jokingly told the child that she'd love to take her back to America, and then presented her with a signed photograph. Another person who apparently received an invitation to New York was Roger 'Plod' Hunt, the bodyguard whom Marilyn happily ran away from on several occasions. Whether the actress was serious about the invitation is not known, but Hunt turned her down anyway and later revealed that he found working for the Millers to be rather dull. It is not known if a US invitation was extended to Marilyn's chauffeur, but he too was presented with several photographs and a thank-you letter for driving her safely, even in the fog.

Something that Marilyn definitely couldn't take back to the States was the baby fish that belonged in the fish tank at Parkside House. Born just as the actress arrived in London, Marilyn had taken a shine to the little creature, and housekeeper Dolly Stiles told reporters that her boss would feed the fish herself, talk to it, and even cover the tank with a cloth at night. Stiles revealed that as she was leaving Parkside, Marilyn blew her adopted pet a kiss, and exclaimed, 'I wish I could take you with me. Be a good little fish.'

For Alan the pianist, the farewell would be bittersweet. The two had shared some of the brighter moments during Marilyn's trip, and on saying goodbye, she presented the young lad with a pen and pencil set, as well as a card. He wished the actress well, and continued to hold a good thought for her sixty-five years later. However, while many of the people who worked with Marilyn believe that the experience opened doors for them, for Alan, the aftermath wasn't always positive.

'Working for Marilyn caused so much spite for my home life, with people asking "why him?" So, my family clammed up about it. I went to see *The Prince and the Showgirl* but nothing else – we just didn't talk about it; it was a non-subject.'

Charles Moore might have been eager to greet Marilyn and Arthur when they arrived at his home in July, but it is not clear if he was at Parkside to bid them farewell. By now, he was sick of the takeover of his home, and had been furious when he was informed of a number of damages. One of his concerns was the breakage of two chair legs, which were repaired without his prior knowledge or consent. Also, there was the matter of a huge telephone bill that the Millers had managed to rack up. The charges had been passed to Olivier by estate agent Sybil Tufnell, and caused so much controversy that they were still being argued over well into 1957.

Shortly before 6 p.m., Marilyn had completed her packing and goodbyes, and, dressed in a black woollen dress and a mink coat, she and Arthur jumped into their car for the last time. As the chauffeur headed down the drive and turned left onto Wick Lane, the car passed the local pub, the Sun Inn, where four months previously landlady Mrs Bacon had written her invitation to Marilyn. Still smarting from the lack of response, she didn't care about the actress's departure. When a reporter asked if the Sun Inn would host a goodbye party for Marilyn and Arthur, Bacon was quick to dismiss the idea. 'We only saw Mr and Mrs Miller once,' she said, 'and the local people couldn't care less.'

Someone else who couldn't care less was Laurence Olivier. He and Vivien Leigh were not enthused about bidding Marilyn farewell but, for the sake of good relations, they agreed to publicists' requests and headed to London Airport. Chain-smoking in the VIP section of the departure terminal, Olivier appeared glum, and could be forgiven for wondering if he'd be left to entertain the reporters himself.

One reporter from the *Daily Sketch* had previously asked the actress's press agents (sarcastically renamed as her 'praise agents') if there would be time for a press conference before the plane took off. Marilyn's rep had prepared the reporter for disappointment. 'If she

doesn't get there in time, there won't be one,' he said. 'She'd love to meet everyone before she goes. But you know how it is with packing and everything.'

Thankfully, the traffic from Englefield Green to London Airport was relatively steady, and at 6.13 p.m. Marilyn strolled into the room, two minutes early. Considering the riots when the actress arrived in July, her departure was quiet and without incident. It had been a long four months, and the hostile ring of privacy that surrounded Marilyn had not gone unnoticed.

And so it was that there was just a handful of reporters and photographers in attendance, and the only autograph hunters were some airport cleaners who happened to be passing. Still, one reporter was sad to see Marilyn leave. 'She added a couple of cherries on top of the murky cocktail of our current affairs,' said Cassandra from the *Daily Mirror*.

The reporters who were present thought Marilyn looked delightful in her high-necked suit, but only narrowed eyes greeted Arthur's attire. Describing him as wearing 'customary baggy sports coat and trousers creased like an elephant's legs', a reporter from the *Daily Sketch* joked that the playwright looked as though he didn't have 'a fiver to his name'. But everyone was happy to see the Millers, though Paula Strasberg's appearance was a little less welcome. Dressed in her usual black attire with an added veil, at least one reporter thought she looked more like a nun than a dramatic coach, but at least she stayed in the background and let Marilyn speak for herself.

When asked what she enjoyed most about being in England, Marilyn ignored the making of *The Sleeping Prince*, and instead concentrated on her social life. 'The biggest thrills for me were meeting your Queen, and my husband's new play,' she said. She believed the British people were her most enthusiastic fans, and appreciated just how warm the public had been to her during the

stay in England. 'But I did have the feeling that you British were in the midst of a crisis here,' she said, referring no doubt to the country's involvement in the Suez Crisis.

When asked what her favourite English food was, Marilyn said that she had particularly enjoyed one dish, though the name eluded her. 'Darling, what was that stuff Dickens wrote about?' she asked her husband. After several guesses, it was found that she meant whitebait – tiny fried fish, eaten whole. Referring to Marilyn's mention of Charles Dickens, one reporter from the *Daily Sketch* snipped that, 'She tossed the writer's name off as if she read books every day.'

Marilyn was then asked about the future. 'I have nothing lined up for me right now except being a wife. We are going home to New York, where I want to be a wife, where I will be Mrs Miller.' The actress added that she and Arthur planned to build a new house, and that she wanted to learn how to cook.

Describing Olivier as the greatest actor she had ever worked with, Marilyn denied that there had been fights on the set of *The Sleeping Prince*. 'No rows, just the kind of agreements and disagreements one always gets. I have no idea how the stories of rows got about.' She then added that in spite of any difficulties, the two actors had enjoyed working together, and she was eager to return to Britain, sometime in the future. Olivier puffed on his cigarette and nodded in agreement, but Arthur and Vivien Leigh remained quiet.

Once the press conference was over, the Millers headed onto the tarmac, but not before Marilyn had paid £252 in excess fees for her twenty-four trunks and suitcases. Among the belongings she would be taking home was the *Daily Sketch* bicycle, a host of sweaters, the model theatre and an Oxford classical dictionary – a gift for Miller.

Photographer Horace Ward was at London Airport to take photos of Marilyn: 'I remember a crowded press conference in the old tin-hut terminal with dreadful drab green curtains they had up as a

backcloth, which everyone moaned about. There were hardly any fans around; it was mostly airport staff and a few police, and after the press briefing the couple went to the customs hall then on to the tarmac, where I walked alongside her to the plane.'

In the excitement of the moment, Marilyn realised she had left her handbag somewhere in the airport. There was a mad dash to find it, and then as the plane sat on the runway, Olivier and Vivien Leigh leaned in to give Marilyn a quick peck on the cheek, and she reciprocated. 'I hope to see you again soon,' Olivier fibbed, and then after several cries of 'Goodbye!' the Millers finally boarded the plane, and the doors closed.

In *The Sleeping Prince*, the story ends with a sad farewell between Elsie Marina and the Prince. It is a bittersweet moment for the characters; one where they realise that they cannot stay together, due to prior commitments. Elsie Marina begs her prince to send a signed photo, they wish each other a melancholy 'Au revoir', and then the Prince disappears out of the door. Elsie gathers her belongings together, throws on an old raincoat, and then she leaves the embassy – walking in the opposite direction to the Prince. The departure was a sad affair for both characters, and was in complete contrast to the goodbyes shared by Marilyn and Larry.

Once his co-star was safely out of earshot, Olivier was asked again about his experience of working on *The Sleeping Prince*. He resisted the temptation to announce how relieved he was that the experience was over, and instead offered the unlikely opinion that he would do it all again; that Marilyn was wonderful, and the completed film was delightful. According to the actor, the only problem was his co-star's nerves, but otherwise she was quite well. Years later he would tell an interviewer that, 'I've never been so glad when anything was over.'

The aircraft taxied down the runway and then, at 7 p.m., took off into the skies, heading to Shannon Airport, Ireland. The London

Airport farewell may have been a quiet one, but the people of Shannon were as excited as the Brits had been back in July. They crowded around the couple to such an extent that Miller became agitated and demanded to know why there was no decent security to protect his wife. Things calmed down when the couple made it to the restaurant, where they were served refreshments, before boarding the plane that would take them back to the United States.

An hour before touchdown at Idlewild, New York, over one hundred reporters, photographers and TV presenters set up their cameras and microphones in the hope of speaking to Marilyn about her London experience. They were left disappointed when the plane landed, however, and the Millers headed through the airport with nothing more than a wave. As the journalists seethed, one of Marilyn's press representatives was given the job of explaining that the couple were both exhausted and did not wish to be interviewed. According to the rep, all Marilyn wanted to do for the next two months was to rest, but this did nothing to thwart the reporters' frustration.

The British press corps would sympathise with their American counterparts, since they too were left wondering what they had experienced over the past four months. Marilyn's arrival in London had been such a positive affair but, now, the shine had dulled. Thomas Wiseman at the *Evening Express* tried to sum up the feelings of many. He explained that while the British public were ready to champion Marilyn's newfound intellectual image, 'they were not so ready to condone the long distances (not to mention private detectives) that she put between herself and her public; seductiveness is not enhanced by standoffishness.'

Chapter Eleven

The Prince and the Showgirl

On the day Marilyn left England, newspapers announced that Warner Brothers disliked the title *The Sleeping Prince* (mainly because it didn't make reference to Marilyn's role), and wanted to change it to *The Prince and the Showgirl* for American audiences. Olivier had discovered this information earlier in November and was displeased, stating that the title made the film sound like a Betty Grable movie or some kind of Edwardian musical.

He proposed keeping *The Sleeping Prince* as the title in the United Kingdom, but Warner Brothers told him that they were taking a poll to find a suitable alternative. Along with *The Prince and the Showgirl*, they proposed A *Night in Love*, *The Royal Bed* and *The Purple Pillow*. Olivier had written to Terence Rattigan on 13 November, eager for him to come up with something nicer, but in the end the title was a non-negotiable matter and *The Sleeping Prince* became *The Prince and the Showgirl* around the world.

In late January 1957, Laurence Olivier headed to New York to show the film to Jack Warner. He had no intention of seeing Marilyn, but he was reluctantly persuaded by Milton H. Greene and Warner Brothers into posing for some publicity photos. The day of the shoot dawned and, as Olivier headed into the studio, he couldn't

believe the change in his leading lady. No longer the nervous, temperamental woman he had encountered in London, now the actress was prepared, eager and happy to pose for the photographs.

For Olivier, this confirmed a theory that had been put to him by a friend – that of Marilyn being more of a model than an actress. A lunch was prepared, music played, and the co-stars posed together – Marilyn wearing a sequined gown, and Olivier in a long, polka-dot robe and cravat. But despite seeming to enjoy the process, Marilyn was eager for it to be finished. 'She only stuck around for a few rolls,' said publicist Jerry Juroe. She then threw her arms into the air, announced that the shoot was over, and walked out of the door. This was the last time Olivier and Marilyn would ever be in the same room together.

The lavish US premiere for *The Prince and the Showgirl* took place on Thursday 13 June, 1957, at New York's Radio City Music Hall, with an after-show champagne supper-dance at the Waldorf Hotel. Marilyn was accompanied to the event by her husband, and the two posed with Jack Warner; the actress beaming, while even Arthur Miller managed a smile or two. Olivier was not in attendance. Instead, he went to the European premiere, held in London on 25 June, in aid of the Actors' Orphanage and the Variety Artistes' Fund for Under-Privileged Children.

It was hoped that Marilyn would fly over to England for the premiere, but nobody really expected her to show. Sure enough, just days before the film's debut, Marilyn sent word to Warner Brothers that she had a bad case of sunburn, brought on by sitting in her garden for too long. This would prevent an eleven-hour transatlantic flight, since she apparently could sit down 'only with difficulty'. What's more likely is that Marilyn was in the early stages of pregnancy and didn't want to risk the trip. Sadly, she was to lose the baby later that summer.

The reviews for *The Prince and the Showgirl* were mixed, and most leaned towards Marilyn as the star of the show. Penelope Houston from *Sight and Sound* magazine decided that 'Marilyn Monroe's honey and cream performance, her look of wide-eyed calculation and air of being a lost but resourceful innocent in an over-sophisticated world, are apt and endearing. This is a gentle performance, ably directed, and faltering only when the plot manoeuvres give the actress no alternative but to repeat effects.' Houston concluded that the film was essentially the same as the stage production: 'Lemonade in a champagne bottle.'

Screenland called *The Prince and the Showgirl*, 'A wonderful comedy that's a complete joy to watch, and it will be a long time before the salvoes of huzzahs and bravos die down for the delightful Marilyn.' *Photoplay* declared that, 'Both Olivier and Sybil Thorndike, as the absent-minded old dowager Queen, perform expertly. But sweet-faced, happily un-corseted Marilyn dominates.'

One of the franker reviews came from a reporter in the *Leicester Chronicle*, who asked, 'What has happened to Sir Laurence Olivier?' and told readers that his performance in *The Prince and the Showgirl* was undistinguished. The writer wondered if he was worried about being upstaged by Marilyn: 'Sir Laurence comes over as stodgy, negative and entirely uninspired. Marilyn is radiant, amusing – and pretty as a picture.' He felt that Dame Sybil Thorndike gave the most memorable performance, but quite bluntly wondered if the disappointing performances from Wattis and Spenser came as a result of something going wrong with Olivier's direction.

Picturegoer thought the storyline of *The Prince and the Showgirl* was threadbare and wafer thin, but did applaud the performances. 'Olivier has gilded it with stylish production and Monroe has added the performance of her life . . . Olivier has worked such wonders with Monroe that one's apt to overlook his own performance: an immaculate combination of pomp and poignancy.'

Marilyn rarely spoke about her trip to England, but did mention the movie in a 1957 interview with columnist Hal Boyle. 'I co-produced this with Olivier,' she said. 'I bought the property and brought it to him. He had played the prince on the stage, and I thought he was the only man for the role. In all fairness, he should probably be called the producer. I'm the owner.'

Forgetting any problems they'd had during the England trip, for a time the marriage between Marilyn and Arthur seemed to work. 'He's the boss of this household,' she said in 1957. 'I don't think the marriage versus career thing ever would come up with us. But if it ever did, our life together comes first . . . I'm mad about the man.'

One man she wasn't so mad about any more was Milton H. Greene. After he had tried to act as peacekeeper while in England, Marilyn could not forgive what she considered his treachery of being friends with Laurence Olivier and 'taking his side'. She also believed that Greene had mismanaged her company, a feeling that was encouraged by Miller. The former best friend found himself out of Marilyn's affections and out of the company in 1957.

'I don't want to do anything to hurt Marilyn's career,' Greene said, 'but I did devote about a year and a half exclusively to her and practically gave up any other work or photography.'

The fallout caused complications for Laurence Olivier, whose only concern was the success of *The Prince and the Showgirl*. Milton wanted to be credited as executive producer on the movie, but Marilyn balked and told Olivier's team that under no circumstances must Greene be acknowledged. The director had no wish to be involved, and instructed the duo to keep him out of their squabbles. In the end, he provided two copies of the film – one with and one without Milton as executive producer – and told the warring partners to seek arbitrary advice from Jack Warner.

'I do not aspire to being a director right off the bat,' Milton had said in 1956. 'That I shall leave to others. But production – yes. I am learning more and more about the executive end of the business every day.'

Marilyn did indeed complain to Jack Warner but, in the end, Milton received his credit. The bond between himself and the actress, however, could not be repaired. He left Marilyn Monroe Productions without claiming anything but his initial investment, and this act of selflessness caused Marilyn's feelings to soften. The two business partners cried when they parted, though never worked together again.

Taking a break from movie-making, Marilyn spent time going to acting classes with the Strasbergs, supporting her husband during his political problems, and making plans for their homes in New York and Connecticut. For the first time in her life, she felt secure: 'I never felt before that I had roots . . . that I had a home life,' she said.

During 1957, Marilyn spoke about the projects she would like to work on, but ended up taking off that year – and much of 1958. It was as though stepping away from the camera had enabled her to turn a corner emotionally, and she expressed her happiness at her 'normal' life to journalist Bob Thomas: 'I enjoy being a wife. I like to go in the kitchen and thumb through the cook book to find something that looks interesting. I'm pretty good, too. I've baked bread and made noodles . . .'

But her happiness was short-lived. As well as a 1957 miscarriage, she suffered another lost child shortly after the making of *Some Like it Hot* in 1958. An experimental operation in 1959 proved fruitless, and she seemed to give up her quest to become a mother.

After Milton H. Greene was forced out of MMP, the company faltered, though Marilyn never completely gave up on the idea of being a producer. 'My Marilyn Monroe Productions company is all

set to start things going in a big way,' she said in 1958. 'All the legal troubles have been solved. Now it's a matter of finding a good movie, or play, or television story.' However, despite all good intentions and dreams, the company never made any films after *The Prince and the Showgirl*. The British branch of MMP lay dormant, and was eventually dissolved under the name of Jermyn Productions Ltd in 1981.

Meanwhile, Arthur Miller's career was stalling. There were a few short stories and a movie script for *The Misfits* but, apart from that, the playwright produced little during his marriage to Marilyn. Friends pondered if the actress was the cause of Miller's lack of work, though at least one surmised that his career had been deteriorating long before she came along.

In her defence, Marilyn was immensely proud of Arthur Miller as a playwright, dreamed of acting in one of his plays, and had a real desire for him to keep writing. 'I'm a demon about his work,' she said, 'and I insist that he put in regular hours. Art's work will always be the centre of our lives. But I'll keep on working, too. I'm not retired – not yet.'

A moment of joy came in May 1959, when Marilyn was presented with a David di Donatello – the Italian equivalent of an Academy Award – for her performance in *The Prince and the Showgirl*. During chaotic scenes at the Italian Cultural Institute in New York, Marilyn told reporters that the award meant 'something very special to me. I hope I'll be able to deserve it in the future.'

Under great emotional and physical strain, the making of her last completed movie – *The Misfits* – was not an enjoyable experience for anyone involved. The screenplay had been written by Arthur Miller, but there were times when Marilyn's role of Roslyn felt too raw and seemed to cross the line from fiction to fact. Filming in the desert was exhausting, and Marilyn's prescription-drug problems worsened. She received hospital treatment, but still remained fragile.

'I can't think of anything more wonderful than doing one of Arthur's works,' the actress had said in 1958, but by the time *The Misfits* was completed towards the end of 1960, their marriage was over. The marriage between Laurence Olivier and Vivien Leigh fared no better. They also announced their separation in 1960, though, in reality, the couple had called time on their relationship long before.

On the subject of Miller, Marilyn told columnist Hedda Hopper that, 'He is a wonderful man and a great writer, but it didn't work out that we should be husband and wife.' When Hopper suggested that Miller may have had a guilt complex related to his first wife, Marilyn dismissed it. 'He's too intelligent for that . . . I don't think that's fair to him really.'

After her divorce from Miller, Marilyn's life seemed to unravel. In 1961, she was hospitalised after suffering a breakdown, and then in the early summer of 1962, she was fired from her last film, *Something's Got to Give*. Columnist David Lewin – to whom Marilyn had spoken many times during her career – caught up with her outside a delicatessen in Los Angeles. He found her to be happy, philosophical and optimistic about the future.

'An actor isn't a system,' she told Lewin. 'I just have me and I carry my ability wherever I go. I can work anywhere there is a part to play and I'd like to come back to England.' Marilyn was upbeat about what some – Olivier included – saw as her lateness problem, and explained that all she was trying to do was take her time and make an effort. 'I take care to be a human being. That is important – not being a movie star.'

They spoke about her new home – a small, Spanish-style bungalow in Brentwood, California, which was the complete opposite of the grand Parkside House. Marilyn told Lewin that she was learning about trees and fruit, and looking forward to seeing them thrive in her garden. She also wished to develop as a human

being. 'What I need now,' she said, 'are foundations. Some roots that grow down and can't be yanked up.'

Conversation over, Marilyn climbed into a chauffeur-driven white convertible, told Lewin that he must come and visit her when she'd settled into her new house, and then waved him goodbye. It was the last time he would see her. Despite her upbeat outlook, the woman who had won the hearts of the Englefield Green residents, Terence Rattigan's party guests and even some of the most hardened of British journalists, was in deep emotional pain. The frailties and anxieties that had haunted her in the dark corridors of Parkside House returned once again, only this time Arthur Miller was not there to count her pills or telephone for help.

As he had in England, make-up artist Allan 'Whitey' Snyder worried about Marilyn's drug intake, and pleaded with her to be careful. The actress brushed him off. 'She just laughed and said she knew what she was doing,' he told investigators.

Marilyn Monroe died the night of 4 August 1962, in the bedroom of her new Brentwood home. After an initial investigation, her passing was ruled as a probable suicide.

In Hawick, Scotland, the staff at Lyle & Scott remembered the letter they wrote to Marilyn, and wept over the fact that they had been unable to meet her. In a little homestead beside Kinfauns Castle, Alexander Penney read the news of Marilyn's death, and wished that she had been able to overcome her demons. Later his young son, Fraser, expressed an interest in the star, and Penney reflected on her passing. 'If only she had stayed away from drugs,' he said with sadness in his voice. In Perth, a couple bought a copy of the *Daily Mirror* revealing the news of Marilyn's passing, and then used the newspaper as underlay for their new carpet. It would stay there for almost sixty years.

Back in England, fourteen-year-old Michael Knight was holidaying with his parents in the seaside town of Scarborough. His father sent him to buy a newspaper, which had the news of Marilyn's passing emblazoned on the front. 'I was aware of her importance,' Michael said, 'and I was shocked, as I thought famous people couldn't die.'

Another visitor to Scarborough was Marilyn fan Maureen Moore, who had spent the afternoon with her fiancé Eric, discussing their forthcoming wedding. As the couple strolled along the promenade, Maureen caught sight of a billboard outside a newsagent. She was blindsided by the news of Marilyn's passing. 'I cried and said I wanted to go home. We had travelled on Eric's motor scooter, so I was able to cry my heart out all the way home. It was like a light had suddenly gone out.'

In London, a young actress called Patricia Marlowe found the news all too much, and took a fatal overdose of pills. The Bishop of Bath and Wells – the Right Rev. E. B. Henderson – described the suicides of Marilyn and Patricia as a form of protest.

Ray Johnson, the young soldier who had waved at Marilyn outside the Savoy Hotel, heard the news on television: 'It was a Sunday afternoon. The newsreader was Michael Aspel, and the announcement was brutally frank: "Marilyn Monroe is dead!"' Ray walked around in a daze for the next week, memories of his brief glimpse of the actress engrained in his mind.

Writer Colin Wilson heard the news and thought back to his brief encounters with Marilyn. He had been in Los Angeles just a year before and wondered whether to contact her, but, in the end, had decided against it. Now he felt nothing but sorrow, and a sense that he should have reached out.

In the Daily Mirror office, reporter Donald Zec wrote a loving tribute to the woman he knew as one of his closest Hollywood friends. He described how Marilyn lit up the room with her laughter, 'and she saddened the place with her sighs and tears'. Zec had witnessed

the actress on film sets, and recognised that there were times when she could be infuriating and stubborn, but, overall, the Marilyn he knew was someone who shone 'diamond bright', and he knew that the world had lost some of its warmth now that she had gone.

Andrew McKenzie was one of those reporters who had been staggered by Marilyn's wit during the Savoy press conference, and now his mind wandered back to the night of the Royal Command Performance. 'When I talked to her afterwards,' he wrote, 'I was impressed once more by her friendliness and great charm.'

Daily Express columnist David Lewin looked back on his friendly relationship with Marilyn, and decided that the actress was 'a superb performer and a fine comedienne, the best in the business'. But he was under no illusion about her problems, and entitled his article, 'The girl who took on too much'.

Anna Freud sat at her desk and wrote a letter to the actress's final psychiatrist, Dr Ralph Greenson. Anna was saddened by Marilyn's death, but she came to believe that whatever her problems may have been, they were too great to have been resolved by analysis.

Dame Edith Sitwell was devastated by the news. 'Marilyn Monroe was lonely,' she told *Daily Mirror* columnist Marjorie Proops. 'She had a strange ghost-like quality. She wasn't nearly as sexy as men liked to imagine. She was a sad, sad lovely girl.'

Still smarting from his experience of working with her, Sir Laurence Olivier refused to be drawn into an in-depth discussion about Marilyn's passing. He did, however, offer up the theory that she was 'the complete victim of ballyhoo and sensation. She was exploited beyond anyone's means.' He also admitted that, 'She could be incredibly sweet and very witty, but her work frightened her.'

Twenty-five years after the making of *The Prince and the Showgirl* Olivier would watch the movie again and find that, quite unexpectedly, his feelings had mellowed. He accepted that while his performance had been good, Marilyn was 'the best of all'.

Dame Sybil Thorndike appeared on the BBC's *Panorama* programme on 6 August, and described how Marilyn was 'married to the camera'. She felt that her former co-star was beautiful and as innocent as a child. 'She may have had a lot of experiences,' she said, 'but they were foisted on her by the outside world.' The programme then showed a moving tribute to Marilyn's work, after which presenter Richard Dimbleby reflected on how everyone would feel so much older now that the actress had gone.

In New York, Lee and Paula Strasberg were shocked and saddened by Marilyn's death. They had believed the star was making great plans for the future, and found it hard to believe that she was gone. They were both invited to the private funeral, and Lee wrote and delivered a heartfelt eulogy. 'For us, Marilyn was a devoted and loyal friend, a colleague constantly reaching for perfection . . . It is difficult to accept the fact that her zest for life has been ended by this dreadful accident.'

Milton and Amy Greene were in France when they heard the news of Marilyn's death. Several weeks before, Amy had dreamed that her former friend was in trouble, and it disturbed her. Milton picked up the phone and spoke to Marilyn for several hours, asked if she'd like him to visit, and then made plans to go to Los Angeles in August. Now she was gone, and the photographer was deeply sorry that he hadn't insisted on seeing her when he had chance. Milton was adamant that Marilyn's death was the result of forgetting how many pills she had taken.

Arthur Miller had remarried, and his wife – photographer Inge Morath – was pregnant with their first child. Six years ago, he had been in England with Marilyn, spending a rainy bank holiday together before the first official day of shooting. Now his former love had gone, and Miller was disturbed. He told director Joshua Logan that the actress had always lived close to death, though Miller believed that her death was an accident.

Sitting in the garden of the Roxbury home he had shared with Marilyn, the playwright was philosophical when reporter John Gold came to visit. 'If she was simple, it would have been easy to help her,' he said. 'One must have humility and respect for the mysteries of life. She could have made it with a little luck. She needed a blessing.' To reporter Robin Stafford he said, 'It was a tremendous shock to me. But I still maintain it was not deliberate.'

In the garage, just feet away from where Miller spoke, Marilyn's beloved bicycle still hung on the wall.

Arthur chose not to attend her funeral. 'She is not really there anymore . . . It would not be appropriate to mourn her in that way.' As he did during the England trip, the playwright explored his feelings about the marriage by writing them down, only this time his words were turned into a play, *After the Fall*. Miller had been working on the piece for quite some time, but its release, less than eighteen months after Marilyn's death, was greeted with concern and negativity from critics. In spite of his insistence that the work was not a literal observation of Marilyn, Arthur Miller's reputation never fully recovered.

Britain had been enjoying a warm bank holiday weekend, but the news of Marilyn's death muted the summer mood. In Englefield Green, Margaret Gibbon tended to her plants, and looked out on to the empty road where Marilyn's car had once passed. A young paperboy headed out of the newsagent where the actress had once parked her bike, his delivery bag full of newspapers reporting her death.

In Wick Lane, customers stood at the bar of the Sun Inn, and thought back to when the landlady, Mrs Bacon, had written her invitation to Mr and Mrs Miller. The gates of Parkside House where, exactly six years before, Marilyn had laughed and signed photos for the local schoolchildren, were still. The students who

once rushed up the drive to serenade the star from beneath her bedroom window had long since graduated and moved away. The front door, where Marilyn had posed with Laurence Olivier, was now closed.

Round the back of the house, a gate still gave access into Windsor Great Park, but there were no photographers poised to snap pictures. Small boys fished in the pond, but none hoped that the actress might join them.

Marilyn, whom Britain had loved so much, would not visit again.

'It seemed to be raining the whole time. Or maybe it was me.'

— Marilyn Monroe, after the London trip.

Sources

Author's Note: The British Library's Laurence Olivier files were accessed in June 2004, before they were catalogued. I have therefore included the box and file numbers that were attributed to the material at that time.

In 1995, third assistant director Colin Clark published The Prince, the Showgirl and Me. *Written as a diary, the book detailed his experiences during the making of* The Sleeping Prince. *Five years later, his* My Week with Marilyn *was published. This book was a fairy tale of sorts, detailing a period when Marilyn allegedly spent a considerable amount of time with the young assistant. The book caused raised eyebrows when it was released, and many wondered how true to life it was. Members of the cast and crew were surprised, since they had been unaware of any kind of friendship, on – or off – the set of* The Sleeping Prince. *I have discovered that when compared to official records, letters, notes and newspaper reports, there are discrepancies with the relaying of dates and events, including many of Marilyn's absences from the set, in both of Clark's books. In that regard, I have stuck to official records during the writing of this book, so inevitably my dates often differ to those of Clark.*

Epigraph

'I am dying to walk bareheaded in the rain' – 'She's here!', *Sunday Dispatch*, 15 July 1956.

Chapter One – Ballyhoo, Tibbs and Spivs

'We don't think there will be screaming fans' and 'Possibly they don't care' – 'Marilyn Monroe's agents seek safety from crowds' by William Hickey, *Daily Express*, 13 July 1956.

'Why won't you say anything' – 'Leaving New York' by Christopher Dobson, *Daily Express*, 14 July 1956.

'Come on honey' – 'Police ready to greet her here today', *Daily Herald*, 14 July 1956.

'Never have I seen' – 'Marilyn leaves in a stampede' by Richard Greenough, *Daily Mail*, 14 July 1956.

'We both need some privacy' – 'Police ready to greet her here today', *Daily Herald*, 14 July 1956.

Twenty-seven pieces of luggage was reported in various articles, including 'Marilyn leaves in a stampede' by Richard Greenough, *Daily Mail*, 14 July 1956.

'I realized that just as I had once fought to get into the movies'— Marilyn Monroe with Ben Hecht, *My Story* (New York: Taylor Trade Publishing, 2007), p. 174.

'She told me that she wanted' – 'The man who made Marilyn Inc' by Guy Austin, *Picturegoer*, 30 June 1956.

'I never tried to be independent' – 'The symbol of success: To producer Marilyn Monroe it is a bed of her own' by Hal Boyle, *Lowell Sun*, 10 June 1957.

'All any of us have' – 'I'll never be the same' by Elsa Maxwell, *Modern Screen*, July 1956.

'I'm willing to go back to work' – 'Future plans told by Marilyn Monroe' by Bob Thomas, *Herald Press*, 10 November 1955.

'I cannot think of anyone better' and 'Yes, I certainly think she could' – 'Marilyn Monroe to Team with Sir Laurence Olivier', *Belfast News-Letter*, 10 February 1956.

'The most charming boss' – 'The Real Marilyn' by Fred Billany, *Newcastle Sunday Sun*, 15 July 1956.

'She is an expert comedienne' – 'I'll never be the same' by Elsa Maxwell, *Modern Screen*, July 1956.

'She is very sweet' – 'Marilyn "Sweet and Charming"', *West Hartlepool Northern Daily Mail*, 11 February 1956.

'We think we'll get started' – 'The things she said to me' by Earl Wilson, *Photoplay*, May 1956.

Rosamund Greenwood's letter to Terence Rattigan – 16 January 1956, Terence Rattigan files 74371 (c) 819c, British Library, London.

'a dear little boy, very forceful' and 'He and Carol Reed' – 'Life's such FUN at 80 – There is so much left to do says Sybil Thorndike' by Elizabeth Frank, *Daily Herald*, 16 July 1962.

'I adored Miss Monroe's performances' – 'My film with Marilyn Monroe – by Dame Sybil' by Cecil Wilson, *Daily Mail*, 6 July 1956.

'She's very nice' – 'Eaton Hall Cadet will join Marilyn Monroe to take part in her newest film', *Cheshire Observer*, 21 July 1956.

'Oh dear' – letter from Vera Day to author, 25 March 1996.

'match her hair' and 'I think she has the most wonderful' –
'Design for Marilyn' by Jean Bartlett, *Leicester Evening Mail*,
7 May 1956.

'Marilyn's face was much more' – 'Marilyn's dresses marked top
secret' by Anna Landau, *Aberdeen Evening Express*, 9 July 1956.

'The Premier Costumers since 1790' – advert in *Kinematograph
Weekly*, 5 September 1957.

Other information regarding L. & H. Nathan was found
in 'Cinemagic' by Miranda Gudenian, *Evergreen*,
5 December 2018.

'You could hardly expect Marilyn' – 'Uncle Edgar comes before
cousin Marilyn' by Thomas Wiseman, *Aberdeen Evening
Express*, 1 May 1956.

Memos regarding the writing of *The Sleeping Prince* script –
Terence Rattigan files 74371 (c) 819c, British Library, London.

'treat seduction too lightly' – 'Sir Laurence wins', *Daily Express*,
11 July 1956.

'Hummingbird. She is a petite' – 'Would you dare to start again?'
by Anne Sharpley, *Londonderry Sentinel*, 26 February 1955.

'We take the same trouble' – 'Mrs Sybil Tufnell', *Birmingham Post
and Gazette*, 12 January 1959.

'everyone at Tibbs Farm' – 'You're OK for springs, Marilyn' by
Donald Zec, *Daily Mirror*, 14 May 1956.

'When we decided to let the house' – *Evening Standard*,
28 May 1956.

'I really don't know what to do' – 'Bring Marilyn', *Sunday
Dispatch*, 1 July 1956.

'But then, they're not' – 'Mr Green is so Retiring' by
Edward Goring, *Daily Mail*, 9 July 1956.

'I may be 80' – 'Waiting', *Daily Sketch*, 9 July 1956.

'I'm furious' – 'Flies into Row' by Robert Cunningham, *Daily Mail*, 14 July 1956.

'been fooled like hell' – 'Marilyn's Landlady is hopping mad' by Noel Whitcomb, *Daily Mirror*, 14 July 1956.

'I don't like people making a fool' – Matt White and Owen Summers, *Daily Sketch*, 14 July 1956.

Lookalike and wiggle contests – adverts appeared in *Peterborough Advertiser*, 1 June 1956; *Dundee Courier*, 7 September 1955; *Fifeshire Advertiser*, 31 March 1956.

'Caused scenes which had to be seen' – 'Wiggle', *Airdrie and Coatbridge Advertiser*, 31 March 1956.

Marilyn lookalike contest at Peterborough Town Hall – 'Dancing', *Peterborough Citizen & Advertiser*, 1 June 1956.

'Prize for the girl' – 'M.A.R.Co Social Club Tomorrow – Saturday', *Grantham Journal*, 6 July 1956.

'If Miss Monroe chooses' – 'Miss Vivien Leigh wishes to meet Marilyn Monroe', *Belfast News-Letter*, 11 February 1956.

'I detected a slight influence' – 'Marilyn Monroe tones are not suitable for folk-songs!' *Courier and Advertiser*, 5 March 1955.

'The ultimate triumph of alliteration' – 'The Literific: Fun in Debate at "Queens"', *Belfast News-Letter*, 21 October 1954.

'Ill-mannered and boorish behaviour' – 'University Notes: The "Literific"', *Belfast News-Letter*, 29 October 1954.

'Much easier for most' – 'Peer Backs Films Against TV', *Courier and Advertiser*, 22 January 1954.

'A collection of spivs . . .' – 'Are We Really Like This?' by Herbert Wilson, *Aberdeen Evening Express*, 13 February 1954.

Chapter Two – A Peroxide Hydrogen Bomb

'I told her that she should handle herself' – 'I say Marilyn was scared of Olivier . . .' by Allan 'Whitey' Snyder, *Daily Mail*, 8 May 1957.

'Her blonde hair was bright' – 'Meeting a myth at the airport', *Observer*, 15 July 1956.

'I envy you' – 'He's My Man – I Adore Him' by Donald Zec, *Daily Mirror*, 16 July 1956.

'It was hysterical' – author interview with Jerry Juroe, 21 July 2020.

'The girl with the wiggle' and 'Well, of course, it's not' – 'Enter the love birds', *Sunday Mail*, 15 July 1956.

'I want to see the way she walks!' – 'Counter Attraction' by Kenneth Pearson, publication and date unknown.

'are the loveliest in the world' – 'M!! – That means Marvellous Marilyn!' by Harry Procter, *Daily Mirror*, 15 July 1956.

'She says she's here' – 'Meeting a myth at the airport', *Observer*, 15 July 1956.

'What do you think' – 'Counter Attraction' by Kenneth Pearson, publication and date unknown.

'She certainly seems to be well accustomed' – 'It was fantastic pandemonium, but Marilyn keeps smiling', *Aberdeen Evening Express*, 14 July 1956.

'She speaks as though' – 'Counter Attraction' by Kenneth Pearson, publication and date unknown.

'She's like a drug' – 'M!! – That means Marvellous Marilyn!' by Harry Procter, *Daily Mirror*, 15 July 1956.

'[Marilyn] burst through' – 'Meeting a myth at the airport', *Observer*, 15 July 1956.

'It fits' and 'He's my man' – 'He's My Man – I Adore Him' by
Donald Zec, *Daily Mirror*, 16 July 1956.

'I'm here' and 'a gaunt, balding figure' – 'Lend me a bike says
Marilyn' by Roderick Mann, *Sunday Express*, 15 July 1956.

'I am going to buy a bicycle' – 'Marilyn – and the wiggle – are
here', *Sunday Dispatch*, 15 July 1956.

'I'll lend you mine' – 'Lend me a bike says Marilyn' by Roderick
Mann, *Sunday Express*, 15 July 1956.

'Oh dear no', 'because I've heard' and 'I like very informal clothes'
– 'Keep calm is the Monroe doctrine' by Ian Forbes, *Newcastle
Sunday Sun*, 15 July 1956.

'That would be very nice' – 'Marilyn – and the wiggle – are here',
Sunday Dispatch, 15 July 1956.

'Who is Marilyn Monroe?', 'My stepmother came home' and
subsequent quotes – author interview with Cary Bazalgette,
17 April 2021.

'I live very modestly' – 'I've not begun to earn much – yet . . .' by
Logan Gourlay, *Sunday Express*, 8 November 1953.

'She made her own bed' – 'Marilyn in the house' by Helen
Bolstad, *Photoplay*, September 1955.

'a warm, open person' – quote from Nigel Hammett in 'Miss
Monroe and my Aunt Florrie' by Heather Driscoll-Woodford,
BBC Surrey, 29 October 2009.

Details of the friendship between Marilyn and Geltner – undated
letter from Marianne Geltner, Julien's Auctions website, lot 16,
sold 17 November 2016.

'Take him in the shrubbery' – letter to the author from retired
member of the Surrey Constabulary, 17 July 1997.

Further information on Marilyn's arrival came from: 'Marilyn Monroe on Flight to London', *Londonderry Sentinel*, 14 July 1956; 'Marilyn Hopes to go Cycling', *Sunday Post*, 15 July 1956; and 'Marilyn Here – 100 Camera Eyes Waiting', *Lancashire Evening Post*, 14 July 1956; 'Marilyn's Honeymoon Secret is Out' by Denis Pitts, *Daily Herald*, 13 July 1956.

'Everyone would be delighted' – 'Marilyn to call at local?' by Peter Woods, *Daily Mirror*, 21 July 1956.

Egham telephone exchange – Pamela Burns to author, 12 September 2020.

'All the girls at the exchange' – 'Sacked because of my 40-33-44' by John Sandiford, *Daily Mirror*, 27 August 1956.

'It's not my idea' – 'Marilyn in the "Window Look"!' by Donald Zec, *Daily Mirror*, 16 July 1956.

'O-ch! Isn't she wonderful!' – 'This is honeymoon with Marilyn!', *Daily Herald*, 16 July 1956.

'I am so sorry we were detained' – 'Marilyn kept them laughing', *Newcastle Journal*, 16 July 1956.

'Naturally I want to improve' – 'Marilyn Monroe's ambition', *Birmingham Post*, 16 July 1956.

'the most unique person' – 'Marilyn in the "Window Look"!' by Donald Zec, *Daily Mirror*, 16 July 1956.

'It's an absolute necessity' – 'All for a quiet life, says Marilyn', *Daily Express*, 16 July 1956.

'She slapped down' and 'From what I've seen' – 'This is honeymoon with Marilyn!', *Daily Herald*, 16 July 1956.

'You use Chanel No. 5?' – 'Marilyn kept them laughing', *Newcastle Journal*, 16 July 1956.

'We assured him we wouldn't' and 'Oh, it's lovely' – 'Now, Mrs M mind our bike!', *Daily Sketch*, 16 July 1956.

'You can hardly move' – 'They've met! And I was there' by Eve Perrick, *Daily Express*, 23 July 1956.

'I'd love to – but I can't' – 'GI gatecrashes on Marilyn', *Daily Sketch*, 16 July 1956.

'I had just come home' – author interview with Ray Johnson, 11 April 2021.

'Her off-the-cuff quips' – 'Marilyn kept them laughing', *Newcastle Journal*, 16 July 1956.

'obviously come to England' – 'Marilyn and Dr Johnson', *Leicester Evening Mail*, 16 July 1956.

'He was not prepared' – 'Cinemagic' by Miranda Gudenian, *Evergreen*, 5 December 2018.

'What specific Beethoven symphonies' and 'A symbol?' – 'But Mr Miller ducks the No. 4 Press talk' by Richard Kilian, *Daily Express*, 17 July 1956.

'How do you define the American' – 'Marilyn says, "I'm dumbest, but not stupid"', unknown newspaper, 17 July 1956.

Chapter Three – The Sleeping Showgirl

'Went wild, and threatened' – letter to the author from Allan R. Pemberton, 26 April 1996.

'The Lord's my shepherd' – written by Francis Rous, *c.* 1650.

Arthur Miller wrote about the students in Arthur Miller, *Timebends: A Life* (London: Bloomsbury, 2012), pp. 414–15.

'We'll burst into the place' – '60 students "invade" Marilyn at 1 am' by Vincent Mulchrone, *Daily Mail*, 17 July 1956.

'I got soaking wet' – letter to the author from Allan R. Pemberton, 26 April 1996.

'those who participated' – letter to the author from Donald W. J. Foot, 18 February 1996.

'*The Times* did not trust its readers' – 'The Wiggle and the Aged Peer', *Daily Mirror*, 17 July 1956.

'the new Battle of Britain' and 'The increased competition' – 'Britain in mortal peril, says Premier', *Sunday Post*, 15 July 1956.

'Since then she has been' – 'Euripides and Miss Monroe', *Western Mail*, 24 July 1956.

'like a bunch of uncouth adolescents' – 'That Little-Girl Appeal' by Winifred Carr, *Daily Telegraph*, 19 July 1956.

'looked as though she had slept' – 'Marilyn so Dowdy', *News Chronicle*, 23 July 1956.

'I believe I manage' – 'Marilyn is dowdy, fashion expert says', *Los Angeles Times*, 24 July 1956.

'Take courage Jean!' – 'The girl who called Marilyn dowdy' by Bruce Rothwell, *News Chronicle*, 1 August 1956.

'Why all this fuss' – 'Letters to the editor', *Western Mail*, 2 August 1956.

Noël Coward's thoughts on Vivien Leigh's pregnancy were covered in Hugo Vickers, *Vivien Leigh* (London: Pan Books, 1990); Barry Day (ed.), *The Letters of Noël Coward* (London: Methuen Drama, 2008); and Graham Payn and Sheridan Morley (eds), *The Noël Coward Diaries* (London: Papermac, 1983).

'Between acts, everyone talks' – 'Marilyn in the house' by Helen Bolstad, *Photoplay*, September 1955.

Miller's views on *South Sea Bubble* – letter to Kermit
 Bloomgarden, 20 September 1956, Kermit Bloomgarden Papers,
 box 52, folder 25, Wisconsin Historical Society.

'Honestly, I don't know' – 'Midnight with the Millers', *Daily
 Express*, 18 July 1956.

'Marilyn was sitting on the sofa' – author interview with Alan the
 pianist, 3 December 2009.

'Officially, I was called a press officer' – letter to the author from
 Jeanne La Chard, 13 June 2007.

Olivier/Logan correspondence – letter from Laurence Olivier to
 Joshua Logan, 9 June 1956, and Logan's reply, 20 June 1956,
 Logan Box 31, Folder 13, Joshua Logan Papers, Manuscript
 Division, Library of Congress, Washington, DC.

'I got intelligence and taste' – 'Will Mr Miller rewrite the Monroe
 story?' by Milton Shulman, *Evening Standard*, 13 July 1956.

'pouted, crossed her legs' – 'Marilyn was Oh, So shy!' by
 Peter Woods, *Daily Mirror*, 19 July 1956.

'Don't be stupid' and subsequent quotes – author interview with
 Jean Bray, 16 February 2021.

'There were quite a few people' – letter to the author from Brenda
 Porter, 6 May 1996.

Information about the Stratford 'visit' – various newspapers,
 including 'Midland Diary', *Birmingham Post*, 19 July 1956.

'I suppose if we'd stopped' – 'Let-down', *Daily Express*,
 21 July 1956.

'I saw her' – 'Exit Belinda' by Lorna Thomson, *Daily Sketch*,
 21 July 1956.

'like someone slumming' – 'Marilyn: Talking about myself' by
 W. J. Weatherby, *Observer Review*, 2 May 1976.

'It was very stimulating' – 'Marilyn says she'll still be her old sweet self' by Dick Kleiner, *Lima News*, 1 April 1956.

'To espouse the Method' – 'Paganism in the West End' by Charles Marowitz, *Theatre World*, April 1958.

'If I didn't believe' – 'The woman and the legend' by Dorothy Manning, *Photoplay*, October 1956.

John Mitchell's description of rehearsals – John Mitchell, *Flickering Shadows: A lifetime in film* (Malvern Wells: Harold Martin & Redman, 1997), pp. 111–12.

'stand over there' – author interview with Alan the pianist, 3 December 2009.

Chapter Four – Thank You for the Moon

'I would love to see her' – 'O'Casey to meet Marilyn', *Stage*, 26 July 1956.

'She is a delightful girl' – 'Tea party', *Daily Mail*, 16 July 1956.

'Of course I'd be delighted to play' – 'The Very Private Life of MM' by William Barbour, *Modern Screen*, October 1955.

'If anybody deserves credit she does' – 'The real Marilyn' by Fred Billany, *Newcastle Sunday Sun*, 15 July 1956.

'You see what a nice' – 'They've met! And I was there' by Eve Perrick, *Daily Express*, 23 July 1956.

'[Marilyn] knows the world' – quoted in Roger G. Taylor, *Marilyn in Art* (London: Elm Tree Books, 1984), no page number.

'He's the greatest in the world' and 'I doff my hat' – 'Eyes that won the Oscar' by Jack Cardiff, *People*, 24 August 1958.

Brian Smith enters a fancy-dress competition – 'Thousands flock to Minster's Flower Show', *East Kent Times*, 27 July 1956.

Fred Greenway enters a fancy-dress competition – 'Young Fred won as Marilyn', *Western Mail*, 6 August 1956.

'the Monroe walk to a series' and 'it's not as simple' – 'I'll teach the Marilyn wiggle by post, he says', unknown newspaper, 23 July 1956.

'All that stuff about how I wiggle' – 'Marilyn says she'll still be her old sweet self' by Dick Kleiner, *Lima News*, 1 April 1956.

'Bless you both' – 'Invitation to Marilyn', *Arbroath Guide*, 21 July 1956, and 'Letter from Marilyn Monroe', *Arbroath Herald*, 24 August 1956.

Invitation to open a Skegness club – 'Benny Hill to open club', *Skegness Standard*, 26 September 1956.

'I do not think she can possibly cope' – 'No approach to Marilyn Monroe says officials', *Morecambe Guardian and Heysham Observer*, 20 July 1956.

'Dear Marilyn Monroe' – 'Fish Supper with the Teddy Boys', *Evening News*, 21 July 1956.

Details of the Rattigan party – Terence Rattigan files 74371 (c) 819c, British Library, London.

'Some lunatic immediately leapt' – letter to the author from PC Packham, 1 June 2004.

Details on Little Court – 'Prince's Temporary Home', *Dundee Evening Telegraph*, 31 October 1929; 'The Prince of Wales at Little Court', *Truth*, 6 November 1929; and 'Writer's ex-home For Sale', *Reading Evening Post*, 16 August 1969.

'It's wonderful' – 'Marilyn's high-society debut' by Radie Harris, *Daily Express*, 26 July 1956.

'Marilyn wore an Edwardian dress' – letter to the author from Sir John Gielgud, 10 March 1992.

'It was such a friendly party' – 'Marilyn's high-society debut' by
Radie Harris, *Daily Express*, 26 July 1956.

'discussing the destinies of the human race' – 'Foreign affairs gave
off-for-holidays look', *Coventry Evening Telegraph*, 27 July 1956.

'that beast' – Jack Cardiff, *Magic Hour: The Life of a Cameraman*
(London: Faber and Faber, 1997), p. 209.

'I am here as Marilyn's friend' – 'Marilyn – "A bit stuck-up
but charming"' by Alan Arnold, *Sunday Dispatch*,
18 November 1956.

'You may be the Marilyn' – photograph of the figure competition
taken in Hastings; the events were also covered in the *Sunday
Mirror* throughout summer 1956.

Letter from John Morris – dated 7 August 1956, supplied by the
BBC Written Archives Centre, 6 April 1992.

'I am familiar with *Lysistrata*' – 'Marilyn Too Busy for Radio Part',
Belfast News-Letter, 11 August 1956, and 'Marilyn Sorry, But
Too Busy', *Northern Daily Mail*, 11 August 1956.

'I am delighted that the BBC' – 'Marilyn has to say No to the
Third' by Cyril Aynsley, *Daily Express*, 11 August 1956.

'A lady rushed past' – author interview with Elaine Schreyeck,
25 September 2020.

The story of the confiscated camera – 'Sir Cork Tip' by Tanfield,
Daily Mail, 8 August 1956.

'The camera is always suspect' – 'Last straw', *News Chronicle*,
9 August 1956.

THE SLEEPING PRINCE – NO VISITORS' – 'Marilyn
starts that film – at 5 am' by John Lambert, *Daily Express*,
8 August 1956.

'She looked so glamorous' – 'London Letter', *Western Mail*, 8 August 1956.

'It's not really me that's late' – 'Marilyn Monroe' by Bill Foster, *Sunday Graphic*, 29 March 1959.

'This lack of confidence shows up' – 'The two faces of Marilyn Monroe' by Maxine Block, *Screenland Plus TV-Land*, January 1959.

Chapter Five – The Lesson I Want to Learn

'I am not saying this because I haven't won' – 'Bathing Beauties' allegations of favouritism and rigged contests', *Morecambe Guardian and Heysham Observer*, 10 August 1956.

'Marilyn – I'm certain it was' – 'I won't be catty about Marilyn' by Vera Day, *Picturegoer*, 12 January 1957.

'You, perhaps as well as anyone' – 'I am going to adopt a baby' by Louella Parsons, *Modern Screen*, July 1960.

'I'm beginning to feel like a piece' – 'How Marilyn Monroe sees herself' by Sid Ross, *Parade*, 12 October 1952.

'a complete pain' and 'I really liked' – author interview with Jean Bray, 16 February 2021.

'Arthur sometimes reminds me' – 'Marilyn Monroe's marriage' by Robert J. Levin, *Redbook*, February 1958.

'He is one of the few contemporary' – 'The men who interest me . . . by Mrs Joe DiMaggio', *Pageant*, April 1954.

'I am in love with the man' – 'I am going to adopt a baby' by Louella Parsons, *Modern Screen*, July 1960.

'I have never been so happy' – 'Goodbye to all this?' by Christopher Dobson, *Daily Express*, 27 June 1956.

Lee Strasberg's memories of the unnamed director –
Lee Strasberg, Strasberg Estate, *The Lee Strasberg Notes*, ed.
Lola Cohen (Abingdon: Routledge, 2010), pp. 88–9.

'We had to put them in at the dead of night' – *Daily Sketch*,
15 September 1956.

'I remember Marilyn as being' – author interview with
Norma Garment, 10 September 2020.

'as Marilyn walked to the set' – author interview with
David Tringham, 25 September 2020.

'I never heard of any arguments' – author interview with
Norma Garment, 10 September 2020.

'Lots of people are a bit disappointed', 'It's a wonderful picture'
and 'Absolutely no friction' – 'It's your fault Olivier' by
Derek Walker, *Picturegoer*, 13 October 1956.

'[It] perhaps entailed a little more skill' and subsequent quotes –
letter to the author from Dennis Edwards, 20 May 1993.

'There were breakdowns' – author interview with Jerry Juroe,
21 July 2020.

Snyder's embarrassment – 'I say Marilyn was scared of Olivier . . .'
by Allan 'Whitey' Snyder, *Daily Mail*, 8 May 1957.

'We all wondered why' – letter to the author from Joe M. Marks,
24 May 1996.

'As the producer, you shouldn't want' – author interview with
Elaine Schreyeck, 25 September 2020.

'Marilyn got wind of this' – author interview with Alan the pianist,
3 December 2009.

'When a director says' – 'Marilyn Incorporated' by Logan Gourlay,
Sunday Express, 30 October 1955.

'She simply vacillates, oscillates' – 'I say Marilyn was scared of Olivier . . .' by Allan 'Whitey' Snyder, *Daily Mail*, 8 May 1957.

'Hello! Good to see' – letters to the author from Joe M. Marks dated 24 May 1996, 1 June 1996 and 3 June 1996; also, author interview, summer 2005.

'next day you go to see the "rushes"' – 'Is this Marilyn's secret?' by Jympson Harman, *Liverpool Echo*, 30 November 1956.

'Some of my earlier fears' – 'The best is yet to come' by Marilyn Monroe, *Preview Annual*, 1957.

'I think my husband has the solution' – 'I am going to adopt a baby' by Louella Parsons, *Modern Screen*, July 1960.

'I saw in Miss Monroe' – 'The man who made Marilyn Inc.' by Guy Austin, *Picturegoer*, 30 June 1956.

'a walking disaster' – Fred Lawrence Guiles, *Norma Jean: The Life of Marilyn Monroe* (Nashville: Turner, 2020), p. 364.

'I would sit next to the camera' – author interview with Elaine Schreyeck, 25 September 2020.

'She just got in the way' – author interview with David Tringham, 25 September 2020.

'Paula was always looking' – author interview with Jerry Juroe, 21 July 2020.

'I'm afraid we didn't talk much' – letter to the author from Daphne Anderson, 22 May 1996.

'Tomorrow is always full' – 'Life's such FUN at 80 – There is so much left to do says Sybil Thorndike' by Elizabeth Frank, *Daily Herald*, 16 July 1962.

'Do forgive my horrid face' – Jonathan Croall, *Sybil Thorndike: A Star of Life* (London: Haus Publishing, 2008), p. 414.

'That *is* Marilyn' – Elizabeth Sprigge, *Sybil Thorndike Casson* (London: Victor Gollancz, 1971), p. 289.

'Apart from closing theatres' – 'Sybil Thorndike looks back' by Eric Johns, *Theatre World*, June 1954.

'I consider Miss Monroe to be one' – 'Dame Sybil on Marilyn', *Coventry Evening Telegraph*, 1 March 1958.

'She detected an inherent sadness' – letter to the author from John Casson, 13 June 1996.

'[She is] a very talented actress' – 'As Others See Them' by Joan Camden, *Shields Evening News*, 6 December 1958.

'I loved Sybil Thorndike' – 'Marilyn Monroe talks as she seldom has' by David Lewin, *Daily Express*, 6 May 1959.

Chapter Six – The Impossibility of Love

'If Sir Laurence wants all the British publicity' and 'The way things are going' – 'Don't fence her in, Larry' by Tom Hutchinson, *Picturegoer*, 11 August 1956.

'I was standing in the front garden' – Tricia Jones to author, 12 September 2020.

Memories of Marilyn's bike-riding – Staines, Egham and Englefield Green Appreciation Group, including contributions from Marion Rees, Kellie Hawkins and Wendy Tant.

'Bicycles are not permitted in this park' – undated letter to the author from Mrs Joyce Jackson.

'Marilyn would often mislay them' and memories of Marilyn's lateness because of a bike ride – letters to the author from Joe M. Marks dated 24 May 1996, 1 June 1996 and 3 June 1996; also, author interview, summer 2005.

'Obviously, of course, once the director' and 'lucky little swine' – letter to the author from Norman Wisdom, dated 5 March 1992.

Shooting schedule for *The Sleeping Prince* – Laurence Olivier files Box 104, 10/8, British Library, London.

'We would all arrive' – author interview with Elaine Schreyeck, 25 September 2020.

'I've a tremendous admiration' – 'Jack Cardiff's Vistavision venture' by Derek Hill, *American Cinematographer*, December 1956.

'I was part of Marilyn's team' – author interview with Jerry Juroe, 21 July 2020.

'Oh, you're on their side!' – author interview with Elaine Schreyeck, 25 September 2020.

'She had the courage to challenge the big movie moguls' – 'Marilyn Confesses To Elsa Maxwell: I'll Never Be The Same' by Elsa Maxwell, *Modern Screen*, July 1956.

'Acting for me is agony' – 'Marilyn and Miller . . . bound to come unstuck!' by David Lewin, *Daily Express*, 12 November 1960.

'Don't you worry about that' – 'That Girl on that bike', *Daily Express*, 13 August 1956.

The Strasbergs trip to Notley – Susan Strasberg, *Marilyn and Me: Sisters Rivals Friends* (London: Doubleday, 1992), p. 95.

'We are bitterly disappointed' – 'Vivien seeks peace' by Anthony Carthew, *Daily Herald*, 16 August 1956.

'We are terribly upset' – 'Vivien Leigh loses her baby' by David Lewin, *Daily Express*, 14 August 1956.

Noël Coward's reaction to Leigh's pregnancy – diary entry, 14 August 1956, Graham Payn and Sheridan Morley (eds), *The Noël Coward Diaries* (London: Papermac, 1983).

'It is a terrible thing' – 'Vivien Leigh loses her unborn baby', *Coventry Evening Telegraph*, 14 August 1956.

'It is difficult enough' – 'Vivien Leigh loses her baby' by David Lewin, *Daily Express*, 14 August 1956.

'What a terrible picture!' and 'The less you put out about this' – 'Tensions between Marilyn and Olivier' by Alan Arnold, *Sunday Dispatch*, 11 November 1956.

'Do I look all right?' – 'The day I became Marilyn' by Sarah Wise, *Mail on Sunday*, *You* magazine, 24 November 2002.

Codeword 'Tom' – Jack Cardiff, *Magic Hour: The Life of a Cameraman* (London: Faber and Faber, 1997), p. 204.

Marilyn's red hands – 'Eyes that won the Oscar' by Jack Cardiff, *People*, 24 August 1958.

'We have tried to blame ourselves' – 'Did Vivien work too hard for too long?' by David Lewin, *Daily Express*, 15 August 1956.

'dour Mr Miller' and 'I hope he has a nice' – 'Now David seeks a dragon' by Kenneth Bailey, *People*, 19 August 1956.

'I feel most deeply honoured' – 'Selznick award for Sir Laurence', *Northern Whig and Belfast Post*, 21 August 1956.

'In *The Sleeping Prince*' – 'What the stars eat at their own canteen' by Brigid Delaney, *Shepherd's Bush Gazette*, 14 December 1956.

Details of the gown with replaceable front – 'Cinemagic' by Miranda Gudenian, *Evergreen*, 5 December 2018.

Information about the caviar scene – 'Marilyn was too lovesick to work' by Alan Arnold, *Sunday Dispatch*, 4 November 1956.

'Arthur's a marvellous person' – 'Marilyn Monroe' by Louella Parsons, *Modern Screen*, September 1956.

Louis Untermeyer's observations of Marilyn – letter to his friends John and Harriett Weaver, 11 July 1956, Special Collections, University of Delaware Library, Newark, Delaware.

'Arthur says' – 'The two faces of Marilyn Monroe' by Maxine Block, *Screenland Plus TV-Land*, January 1959.

'getting involved in things' – Albert Maysles to Donald Spoto, quoted in Donald Spoto, *Marilyn Monroe: The Biography* (London: Chatto & Windus, 1993), p. 411.

'trying to immunize herself' – Fred Lawrence Guiles, *Norma Jean: The Life of Marilyn Monroe* (Nashville: Turner, 2020), p. 365.

The Strasbergs' recollection of the notebook incident – Fred Lawrence Guiles, *Norma Jean: The Life of Marilyn Monroe* (Nashville: Turner, 2020), pp. 369–70; Susan Strasberg, *Marilyn and Me: Sisters Rivals Friends* (London: Doubleday, 1992), pp. 96–7.

'He said he agreed with Larry' – Berniece Baker Miracle and Mona Rae Miracle, *My Sister Marilyn* (London: Weidenfeld & Nicolson, 1994), p. 175.

After the Fall notebook incident – the play was first performed in 1964; the incident can be found in the 1985 Penguin edition of the play, p. 108.

'I was not of any use' – Fred Lawrence Guiles, *Norma Jean: The Life of Marilyn Monroe* (Nashville: Turner, 2020), p. 370.

'It was the ultimate betrayal' – author interview with Jerry Juroe, 21 July 2020.

Information on Marilyn's overdose – author interview with Jerry Juroe, 21 July 2020; I believe that the incident took place during the early hours of 22 August, since Juroe insists that the episode was close to the beginning of production, that Marilyn was off work for several days and that this was her first absence. Official records show that the first time Marilyn was absent was 22–24 August. These dates also tie in with the Strasbergs' memories.

'Marilyn was certainly ill' – author interview with Alan the pianist, 3 December 2009.

'I disappointed him' – W. J. Weatherby, *Conversations with Marilyn* (London: Robson Books, 1976), p. 187.

Marilyn's Parkside House notes – Stanley Buchthal and Bernard Comment, *Fragments: Poems, intimate notes, letters by Marilyn Monroe* (London: HarperCollins, 2010). pp. 105–21.

'My sleep depends' – 'A good, long look at myself' by Alan Levy, *Redbook*, August 1962.

Chapter Seven – Ambitions of Royalty

'The choice has not yet been made' – 'Marilyn and the Queen', *Northern Whig*, 23 August 1956.

'But for goodness' sake' – 'Marilyn was too lovesick to work' by Alan Arnold, *Sunday Dispatch*, 4 November 1956.

'settling in to English cooking' – 'Marilyn is told to take a rest' by David Lewin, *Daily Express*, 25 August 1956.

Marilyn's trip to Anthony Quayle's home – Anthony Quayle, *A Time to Speak* (London: Barrie & Jenkins, 1990), p. 338.

'We were not satisfied' – 'Marilyn Eats Out', *Daily Mirror*, 25 August 1956.

Servants speaking to the press – author interview with Dolly Stiles, 18 May 2004; Miller wrote about the problem with the servants in Arthur Miller, *Timebends: A Life* (London: Bloomsbury, 2012), pp. 427–8.

'They certainly are happy' – 'Marilyn and mate staying in seclusion', *New York News*, 13 August 1956.

'Hugely enjoying life' – 'Marilyn was too lovesick to work' by Alan Arnold, *Sunday Dispatch*, 4 November 1956.

David Lewin's thoughts about Miller's trip to the US – 'Arthur Miller cited for contempt' by Henry Lowrie, *Daily Express*, 26 July 1956.

'I'll be back in just ten days' – *News Chronicle*, 27 August 1956.

'My conscience will not permit me' – 'Arthur Miller still refuses to disclose names', *Belfast News-Letter*, 28 August 1956.

'and saw a woman immensely sad' – 'Marilyn was too lovesick to work' by Alan Arnold, *Sunday Dispatch*, 4 November 1956.

'the boss-woman with the greatest' – 'Boss-woman' by Roberta Leigh, *Daily Herald*, 27 August 1956.

BBC radio request – letter from Michael Gill to Marilyn, 27 August 1956, supplied by the BBC Written Archives Centre, 6 April 1992.

'I don't want to do anything' – 'Vivien Leigh goes house-hunting' by David Lewin, *Daily Express*, 29 August 1956.

'One day I wasn't there' and 'was beyond all reason' – author interview with Alan the pianist, 3 December 2009.

'Miss Monroe started to come apart' – letter to the author from Jeanne La Chard, 13 June 2007.

'I'm not allowed to say' – 'Marilyn ill – doctors put her to bed' by Tony Burton, *Daily Mirror*, 4 September 1956.

'an arduous task' – Lord Drogheda, *Memoirs* (London: Weidenfeld & Nicolson, 1978), p. 262.

'Consultation and examination' – receipt from Mr J. B. Blaikley, 31 October 1956.

'absolute rubbish' – 'Marilyn is not expecting baby – Mr Miller', *Aberdeen Evening Express*, 5 September 1956.

'Marilyn Monroe is not having a baby' – 'Marilyn is not having a baby', *Daily Herald*, 6 September 1956.

'2 stories linked' – 'The Caucasian Chalk Circle', *Theatre World*, October 1956.

'The truth is she was very interested' – 'The Two Worlds of Arthur Miller' by Thomas Wiseman, *Aberdeen Evening Express*, 9 October 1956.

'Undoubtedly the most interesting event' – from an advert in *Theatre World*, October 1956.

'One of the most ambitious club' – 'New play at the Comedy', *Stage*, 13 September 1956.

'something just like this venture' – 'Theatre venture exciting', *Birmingham Daily Post*, 10 September 1956.

'As a playwright I loathe' – 'Marilyn supports theatre showing 3 banned plays' by William Hickey, *Daily Express*, 10 September 1956.

'I hope to be there' – 'Marilyn Monroe in beat-the-censor club', *Belfast News-Letter*, 10 September 1956.

'extremely risky' – 'Theatre venture exciting', *Birmingham Daily Post*, 10 September 1956.

'Marilyn has been screened already' – 'Marilyn Monroe in beat-the-censor club', *Belfast News-Letter*, 10 September 1956.

'I found Miss Monroe' and 'I advised her' – 'He meets Marilyn Monroe', *Marylebone Mercury*, 14 September 1956.

'strictly dumb blonde role' and 'I mean she's only heard' – 'Marilyn does a leg stint – in aid of literature', *Daily Sketch*, 10 September 1956.

Olivier's thoughts on the negative press – telegram to Radie Harris, 19 September 1956, Laurence Olivier files Box 103 10/2, British Library, London.

Details of Anna Freud's consulting rooms and techniques – Bryony Davies at the Freud Museum, www.freud.org.uk.

'He's the one I believe in' – 'Marilyn Monroe on middle age' by Logan Gourley, *Sunday Express*, date unknown, 1960.

'I'm not taking a full course' – 'Marilyn Incorporated' by Logan Gourlay, *Sunday Express*, 30 October 1955.

'Wrapped in a towel' – email to the author from Albert Maysles, 20 September 2005.

Details of Marilyn's charity portrait – 'Terence Rattigan buys a nude for £40 – the artist: Marilyn' by William Hickey, *Daily Express*, 14 November 1956.

'Taking the Mickey' – 'Nine-year-old shows court her "Marilyn Monroe Wiggle"', *Daily Express*, 13 September 1956.

'It is time we put a bit of life' – 'Let Marilyn keep death off the roads', *Birmingham Gazette*, 15 September 1956.

'rather than dominating' – 'The Stars in their places', *Birmingham Gazette*, 15 September 1956.

'I guess there are several reasons' – 'The truth about Me – by Marilyn Monroe, as told to Liza Wilson', *American Weekly*, 23 November 1952.

'I have never been very good' – 'Marilyn Monroe: A good, long look at myself' by Alan Levy, *Redbook*, August 1962.

'So is mine' and the story of the party – Dominic Shellard, *Kenneth Tynan: A Life* (New Haven: Yale University Press, 2003), p. 179.

'It's pretty horrible' – 'Marriage and Marilyn' by Terence Feely, *Sunday Graphic*, 22 July 1956.

'When Marilyn was faced' – 'I won't be catty about Marilyn' by Vera Day, *Picturegoer*, 12 January 1957.

'Unusually jolly' – 'Miller at work' by William Hickey, *Daily Express*, 20 September 1956.

Miller's views on British theatregoers – letter to Kermit Bloomgarden, 20 September 1956, Kermit Bloomgarden Papers, box 52, folder 25, Wisconsin Historical Society.

'And the other fifteen months?' and 'Why would I act' – 'The Two Worlds of Arthur Miller' by Thomas Wiseman, *Aberdeen Evening Express*, 9 October 1956.

Cardiff's suggestion of a disguise – Jack Cardiff, *Magic Hour: The Life of a Cameraman* (London: Faber and Faber, 1997), p. 201; also 'Eyes that won the Oscar' by Jack Cardiff, *People*, 24 August 1958.

Memories of trips to Salisbury and London – author interviews with Alan the pianist, 3 December 2009 and 10 June 2020.

Offer of a part in *Maiden Voyage* – Arthur Miller's letter to Kermit Bloomgarden, 20 September 1956, and Bloomgarden's reply, 1 October 1956, Kermit Bloomgarden Papers, box 52, folder 25, Wisconsin Historical Society; Marilyn's preference of the part of Hera is cited on the Marilyn Monroe Collection website: themarilynmonroecollection.com.

'It didn't bother me' – 'Never happier in my life, says Marilyn' by Bob Thomas, *Bennington Evening Banner*, 14 November 1955.

'Anywhere, anytime' – 'Marilyn may be a "brother" to you . . .', *Sunday Graphic*, 29 September 1956.

'So sorry, but I only have' – 'Marilyn's "no" to part she wanted', *Aberdeen Evening Express*, 18 October 1956.

Hedda Rosten's time in London – Arthur Miller, *Timebends: A Life* (London: Bloomsbury, 2012), pp. 425–6.

'Bust-up' – 'Not so happy', *Daily Mail*, 19 September 1956.

'I don't know where these reports' – 'Marilyn: No feud', *Daily Mail*, 26 September 1956.

'Getting on well' – 'Monroe-Olivier rift denied', *Western Mail*, 26 September 1956.

Details of the carpenters' strike – 'Sir Tom speaks up – Marilyn works on', *Daily Express*, 29 September 1956.

Chapter Eight – The Kindness of Strangers

'When I first started delivering' – email to the author from Ross Matthews, 15 September 2020.

'She came to her bedroom window' – email to the author from Bryan Godfree, 6 May 2004.

'Marilyn used to come and talk' – John Slamaker on behalf of his wife, Patricia (née Brunning) to the author, 11 September 2020.

'I was quite young at the time' – email to the author from Marion Rees, 14 September 2020.

'Naturally I looked' – letter to the author from Anne Wallage, 26 July 1996.

'My dad leaned down' – email to the author from Tony Hand, 1 June 2011.

'She is very glad of it' – 'Marilyn's life is very private' by Moore Raymond, *Sunday Dispatch*, 14 October 1956.

'We would like to help' and 'One day, or perhaps two' – 'It's your fault Olivier' by Derek Walker, *Picturegoer*, 13 October 1956.

'She has a technique for playing comedy' – 'Chance of a dream role for Marilyn' by John Gold, *Evening News*, 27 August 1956.

'She didn't like the way she looked' – 'Marilyn weeping, thinks of Frank and Coca-Cola' by Thomas Wiseman, *Aberdeen Evening Express*, 5 December 1956.

'Use patience' and 'She has been unhappy' – 'Chaplin plus Garbo, equals Marilyn' by Christopher Hall, *Daily Express*, 10 October 1956.

'Marilyn is magnificent' – 'This girl can act' by Emery Pearce, *Daily Herald*, 19 October 1956.

'I nearly burned her' and 'English people who talk too fast' – *Daily Mail*, 17 September 1956.

'Are you kidding?' – 'Marilyn's Secrets' by Vera Day, *Weekend Reveille*, 13 December 1956.

'I see glamour in the raw' – 'Mm . . . so this is Mr Bond's job!' by Betty Curtis, *Norwood News*, 23 November 1956.

'There was nothing to be scared of' – 'I won't be catty about Marilyn' by Vera Day, *Picturegoer*, 12 January 1957.

'Don't talk to them' and 'Absolute pain' – author interview with Joe M. Marks, 2005.

'Laurence Olivier said in very polite tones' – letter to the author from Vera Day, 25 March 1996.

'Marilyn did not get the nuances' – 'I say Marilyn was scared of Olivier . . .' by Allan 'Whitey' Snyder, *Daily Mail*, 8 May 1957.

'wildly excited' – 'London Letter', *Western Mail*, 8 August 1956.

'I tried to walk like her down the corridor' – 'Express From London', *Aberdeen Evening Express*, 20 October 1956.

'one of the silliest women' – Donald Sinden, *A Touch of the Memoirs* (London: Futura McDonald & Co., 1983), pp. 288–9.

'All she ever seemed to be able' – 'A touch of the suave Sinden' by Roy Martin, *Reading Evening Post*, 18 March 1982.

'You're a bit of a blue stocking' and conversations re Walt Whitman and Gracie Fields – author interviews with Alan the pianist, 3 December 2009 and 10 June 2020.

'Miller doesn't exactly give' – 'What marriage is doing to Marilyn' by Terence Feely, *Sunday Graphic*, undated, *c.* July 1956.

'Reporters were camped outside' – author interview with Cary Bazalgette, 17 April 2021.

G. Pearson's memories of going to Parkside – letter to the author from G. Pearson, 7 July 1996.

'Too many people. Too many people' and other memories of Hutchinson's interview with Marilyn – Tom Hutchinson, *Marilyn Monroe* (Leicester: Galley Press, 1982), pp. 6, 69 and 78.

'The lady who waves' – letter to the author from Margaret Gibbon, 24 May 2004, and email to the author from Susan Elliott, 20 April 2011.

'I always thought that she should be with me' – letter to the author from Maurice Smith, 24 June 1996.

Chapter Nine – A View from the (London) Bridge

'They were overtly in love' – letter to the author from Vera Day, 25 March 1996.

'[Miller] was absolutely besotted by her' – author interview with David Tringham, 25 September 2020.

'Yet they were quite impervious' – 'Tension between Marilyn and Olivier' by Alan Arnold, *Sunday Dispatch*, 11 November 1956.

'Tell her she's good' – 'The day I became Marilyn' by Sarah Wise, *Mail on Sunday, You* magazine, 24 November 2002.

'I'm terribly sorry' – author interview with Cary Bazalgette, 17 April 2021.

'Everything about him is handsome' – 'TV Parts, Family, Marilyn's Dreams' by Margaret McManus, *Syracuse Post Standard*, 7 July 1957.

'For intellectuals you have to wear' – 'Marilyn Monroe's marriage' by Robert J. Levin, *Redbook*, February 1958.

'The thing that always takes the trick' – 'Marilyn would take a trick', *Aberdeen Evening Express*, 11 October 1956.

'Sticky' and comment re Marilyn going to the bathroom with champagne – Hugo Vickers, *Vivien Leigh* (London: Pan Books, 1990), pp. 259–60.

'amused tolerance' – Jack Cardiff, *Magic Hour: The Life of a Cameraman* (London: Faber and Faber, 1997), p. 206.

'Marilyn was terrified of Vivien Leigh' – author interview with Jean Bray, 16 February 2021.

'I think it was a wonderful' – 'The crowds battle Marilyn' by Philip Tibenham, *Daily Mirror*, 12 October 1956.

'Between Sir Laurence and Arthur Miller' – 'Marilyn's life is very private' by Moore Raymond, *Sunday Dispatch*, 14 October 1956.

'I just couldn't get out' – 'The crowds battle Marilyn' by Philip Tibenham, *Daily Mirror*, 12 October 1956.

'Perhaps the cheering was for Brook' – 'A *View from the Bridge* at the Comedy Theatre', *Birmingham Post*, 12 October 1956.

'Tony Quayle's dressing room' – Colin Wilson to author, 23 April 1996.

'A word of advice to a very famous Mrs' – 'What do you Miss when you're a Mrs?' by Roberta Leigh, *Daily Herald*, 15 October 1956.

'A man of intellect and charm' – 'Limelight', *Stage*, 11 October 1956.

'But much more important' – 'First of a season of "banned" plays', *West London Observer*, 19 October 1956.

John Blaikley's consultation – recorded on a receipt dated 31 October 1956.

'a perfect lady' and 'they wouldn't believe me' – 'Marilyn beats a retreat', *West Sussex County Times*, 19 October 1956; this story was also discussed with members of the Memories of Horsham Facebook page.

'One afternoon I was in reception' – undated letter to the author from Peggy Heriot; another source is 'Marilyn Monroe and husband look in on Lewes', *Sussex Agricultural Express*, 19 October 1956.

Invitation from Hawick knitwear company – 'Fan letter 20ft long', *Belfast Telegraph*, 15 October 1956; and 'Dear Marilyn – from 900 fans', *Edinburgh People's Journal*, 20 October 1956.

'We all think you are the tops' – 'Present to Marilyn from 900 workers' by Sheila, *Advertiser*, 1 November 1956.

'for your scroll and the lovely sweater' – 'Something to talk about' by Look-out Man, *Advertiser*, 6 December 1956.

'Scotch blood' – a reference to Marilyn's ancestors coming from Scotland.

The mystery of the photo – mentioned in a letter to the author from promotions manager I. Jackson, dated 28 March 1996, and the model was named in a letter to the author dated 9 May 1996.

The letter from Miller to Marilyn during the making of *Bus Stop* – dated 25 May 1956.

'I adored Milton' – author interview with Jerry Juroe, 21 July 2020.

'I would listen to his advice' – 'Will Mr Miller rewrite the Monroe story?' by Milton Shulman, *Evening Standard*, 13 July 1956.

'In New York, I learned' – 'I've nothing against women – but I prefer men says Marilyn' by Thomas Wiseman, *Evening Standard*, 3 March 1956.

'Marilyn was never rude' – author interview with Alan the pianist, 10 June 2020.

'just crying out' – 'A dress that cries out for Marilyn' by Serena Sinclair, *Daily Herald*, 31 July 1956.

'wiggle-waggle' – 'Elegance and restraint in autumn fashions', *Belfast News-Letter*, 24 July 1956.

'This is Mrs Miller speaking' and 'He confirmed that his wife' – 'But Marilyn was a Hoax', *Daily Sketch*, 20 October 1956.

Information on the 'Fake Marilyn' – 'Marilyn Misses', *Daily Mail*, 17 October 1956; and 'Hoaxer', *Daily Sketch*, 31 October 1956.

Tommy Steele's denial of the incident – via an email to the author from Steele's agent, dated 7 July 2020.

'There are better ways of displaying' and 'This is strictly confidential' – 'The night of the big cover-up', *Daily Mail*, 10 October 1956.

Letter from Stephen W. Bonarjee – dated 19 October 1956, supplied by the BBC Written Archives Centre, 6 April 1992.

Letters from Gordon Mosley – dated 22 October and 29 October, supplied by the BBC Written Archives Centre, 6 April 1992.

'It has occurred to me' – 'Kicked out for Marilyn' by Marcus Milne, *Sunday Graphic*, 21 October 1956.

'Like an English Deanna Durbin' – 'Marilyn is off sick again – the day's work gets daily more tense' by David Lewin, *Daily Express*, 24 October 1956.

Telegrams and memos between Maurice Zolotow and Arthur Miller, and Zolotow and Milton Greene – Maurice Zolotow archive, Harry Ransom Humanities Research Center, University of Texas at Austin.

'She's ready, but she's stalling' – 'Tension between Marilyn and Olivier' by Alan Arnold, *Sunday Dispatch*, 11 November 1956.

'She's too condescending' – 'I broke the Monroe barrier' by Derek Hill, *Picturegoer*, 15 December 1956.

'running around like a headless chicken' and subsequent quotes relating to the ballroom scene – author interview with David Tringham, 25 September 2020.

'Miss Monroe and Sir Laurence are really' – 'Patient Marilyn', *Evening News*, 31 October 1956.

'In fact, she goes out of her way' – 'Local dancers in Marilyn Monroe film', *Reading Standard*, 9 November 1956.

'She picked it up very quickly' – 'Marilyn waltz', *Daily Sketch*, 26 November 1956.

'Envious of my experience?' – 'I broke the Monroe barrier' by Derek Hill, *Picturegoer*, 15 December 1956.

'She was always late' – author interview with David Tringham, 25 September 2020.

'The stress caused by Marilyn' – author interview with Jerry Juroe, 21 July 2020.

'There was just no chemistry' – author interview with David Tringham, 25 September 2020.

'[Marilyn] is quite enchanting' – 'Express from London', *Aberdeen Evening Express*, 29 September 1956.

'People wanted to help' – author interview with Elaine Schreyeck, 25 September 2020.

'The lady tried to fire' – letters to the author from Joe M. Marks, 24 May 1996 and 1 June 1996; also author interview, summer 2005.

'Her spikiness and spite' – Laurence Olivier, *Laurence Olivier on Acting* (Kent: Hodder & Stoughton, 1987).

'It was an extreme no-no' – author interview with Jerry Juroe, 21 July 2020.

'It was like the Inquisition' – 'You have been cheated' by Tom Hutchinson, *Picturegoer*, 15 December 1956.

'Half-way through the picture' – 'Marilyn – "A bit stuck-up but charming"' by Alan Arnold, *Sunday Dispatch*, 18 November 1956.

'While appreciating that your newspaper' – 'Tension between Marilyn and Olivier' by Alan Arnold, *Sunday Dispatch*, 11 November 1956.

'Then the bombshell burst' – 'You have been cheated' by Tom Hutchinson, *Picturegoer*, 15 December 1956.

Details of the unwanted MMP expenses for Paula Strasberg *et al.* – letter from Hugh Perceval to Cecil Tennant, 23 August 1957; letter from Cecil Tennant to Arthur Young and Co., 4 September 1957; both found in the Laurence Olivier files Box 103 10/3, British Library, London.

Chapter Ten – When Marilyn Met the Queen

'The make-up of the true star' – 'Why Women Love Marilyn Monroe' by Elsie Lee, *Screenland Plus TV-Land*, July 1954.

'I bet Mr Miller couldn't top that!' – 'Queen Joan Crawford back after 23 years', *Daily Express*, 25 July 1956.

'Marilyn Monroe should be here' and 'She finished work at 7' – 'Where's Marilyn, asks Joan' by Matt White, *Daily Sketch*, 27 October 1956.

'Miss Monroe will be taking' – *Evening Standard*, 23 October 1956.

'Relax. Speak to her Majesty' – 'Stars get the curtsy jitters' by Donald Zec, *Daily Mirror*, 29 October 1956.

'Nobody knew who the hell I was' – author interview with Jerry Juroe, 21 July 2020.

Royal Command Performance – footage on YouTube including a news report from British Pathé, https://www.youtube.com/watch?v=ZQ3z4q7a2sg.

'We love it' and 'It's going on very well' – 'Princess tells Marilyn "we are neighbours"', *Hartlepool Northern Daily Mail*, 30 October 1956.

'The Princess laughed' – 'Monroe plimsoll line takes a dip' by Diana Narracott, *Daily Herald*, 30 October 1956.

'Fall on your ass baby' – Anthony Quayle, *A Time to Speak* (London: Barrie & Jenkins, 1990), p. 338.

'The Queen is very warm-hearted' – 'Monroe plimsoll line takes a dip' by Diana Narracott, *Daily Herald*, 30 October 1956.

'Not a bit' – 'We're neighbours, said the Queen', *Western Mail*, 30 October 1956.

'I thought Miss Monroe' – 'Love and babies at Buckingham Palace', *People*, 22 October 1961.

'Miss Monroe must have a terrible' – 'American column', *Daily Express*, 1 November 1956.

Further Royal Command Performance information – 'The industry's most glittering night of the year', *Kinematograph Weekly*, 1 November 1956.

'Marilyn was heard to call Brigitte' – letter from Vera Day, 25 March 1996.

Details of the *Close Up* programme – 'Vera sings that song again' by Clifford Davis, *Daily Mirror*, 30 October 1956.

Marilyn's 1 November telegram to Terence Rattigan – Terence Rattigan files 74371 (c) 819c, British Library, London.

'Is there a man on the set?' – letter from Vera Day, 10 March 1996.

'My knowledge of Marilyn was limited' – letter from Jean Kent, 12 May 1996.

'It's the only thing I can do' – John Mitchell, *Flickering Shadows: A Lifetime in Film* (Malvern Wells: Harold Martin & Redman, 1997), p. 115.

'Marilyn was very generous' – author interview with Elaine Schreyeck, 25 September 2020.

'Una is a lovely girl' – 'She's the girl Marilyn left behind', *Daily Herald*, 22 November 1956.

'I found her to be charming' – letters from Vera Day, 25 March 1996 and 26 April 1996.

'Marilyn – stupid woman' – Hugo Vickers, *Vivien Leigh* (London: Pan Books, 1990), p. 259.

'She had no leading lady frills' – Elizabeth Sprigge, *Sybil Thorndike Casson* (London: Victor Gollancz, 1971), p. 289.

'Beastly. I hope you will forgive me' – 'Marilyn says: I'm so sorry' by Vincent Mulchron, *Daily Mail*, 17 November 1956.

'You want to talk to the stars' – author interview with David Tringham, 25 September 2020.

'There are bound to be scenes here' – 'Believe it or not, that film is finished', unknown newspaper, 16 November 1956.

'Something was always a problem' – author interview with Jerry Juroe, 25 September 2020.

'I thought they would like to see' – 'Post man's diary', *Hammersmith and Shepherd's Bush Gazette and Post*, 5 October 1956; an updated story appeared in the same paper on 16 November 1956.

'Miss Monroe intends to make' – 'Miss Monroe forms a new company', *Daily Telegraph*, 17 November 1956.

'We shall not restrict ourselves to films' – 'Monroe means (big) business' by Guy Austin, *Picturegoer*, 7 July 1956.

Milton Greene's thoughts on the British branch of MMP – Fred Lawrence Guiles, *Norma Jean: The Life of Marilyn Monroe* (Nashville: Turner, 2020), p. 373.

Details of the *War and Peace* premiere – 'On staying happily married to Mr Ferrer' by William Hickey, *Daily Express*, 17 November 1956.

'Because the relationship between Olivier' – author interview with Wolf Mankowitz, 28 April 1996.

'This is a debate; not a circus' – 'Marilyn was so brave but, oh so exhausted' by Edward Goring, *Daily Mail*, 19 November 1956.

'a great kerfuffle' and 'It kind of' – author interview with Wolf Mankowitz, 28 April 1996.

'That bastard', 'He was very, very' and 'He decided to go for me' – Colin Wilson to author, 23 April 1996.

'I'm sorry' – 'Marilyn was so brave but, oh so exhausted' by Edward Goring, *Daily Mail*, 19 November 1956.

'I said it just perpetuated' – Colin Wilson to author, 23 April 1996.

'a second-rate mind' – 'Marilyn leaves by the fire-escape to dodge the autographs', *Evening Standard*, 19 November 1956.

'Why not?' – 'Marilyn was so brave but, oh so exhausted' by Edward Goring, *Daily Mail*, 19 November 1956.

'The atmosphere of hysteria' – 'The British Theatre is "Hermetically sealed"', *Stage*, 22 November 1956.

'I have no more time' – 'Marilyn leaves by the fire-escape to dodge the autographs', *Evening Standard*, 19 November 1956.

'made to look completely bloody illiterate' – Colin Wilson to author, 23 April 1996.

'We lined up to say goodbye' – letter from retired member of the Surrey Constabulary, 17 July 1997.

Cary Bazalgette's memories of saying goodbye – author interview, 17 April 2021.

Dolly Stiles's memories of saying goodbye – author interview, 18 May 2004.

'I wish I could take you' – *Daily Sketch*, 21 November 1956.

'Working for Marilyn' – author interview with Alan the pianist, 3 December 2009.

'We only saw Mr and Mrs Miller' – 'Marilyn flies home', unknown newspaper, 20 November 1956.

'If she doesn't get there in time' – 'Last fling', *Daily Sketch*, 20 November 1956.

'She added a couple of cherries' – 'Farewell to the wiggle' by Cassandra, *Daily Mirror*, 21 November 1956.

'customary baggy sports coat' – *Daily Sketch*, 21 November 1956.

'The biggest thrills for me' and 'But I did have the feeling' – 'I'm going to be a wife', *Daily Mail*, 21 November 1956.

'Darling, what was that stuff?' and 'She tossed the writer's name off' – *Daily Sketch*, 21 November 1956.

'I have nothing lined up' and 'No rows' – 'Marilyn Monroe says Goodbye to Britain', *Belfast News-Letter*, 21 November 1956.

'I remember a crowded press conference' – author interview with Horace Ward, 2011.

'I hope to see you again' – 'Goodbye Marilyn!' by Hugh Baker, *Daily Mirror*, 21 November 1956.

'I've never been so glad' – 'Olivier's love and hate for Marilyn' by Margaret Hall, *Daily Mirror*, 22 May 1980.

'they were not so ready to condone' – 'These ten topped '56' by Thomas Wiseman, *Evening Express*, 25 December 1956.

Chapter Eleven – **The Prince and the Showgirl**

Film title change – Terence Rattigan files 74371c and 819c, British Library, London; it is also mentioned in 'Inside Show-Business' by David Lewin, *Daily Express*, 20 November and 4 December 1956.

'She only stuck around' – author interview with Jerry Juroe, 25 September 2020.

'only with difficulty' – 'Miss Monroe regrets . . .', *Sunday Dispatch*, 23 June 1957.

'Marilyn Monroe's honey and cream' – *'The Prince and the Showgirl'* by Penelope Houston, *Sight and Sound*, Summer 1957.

'A wonderful comedy' – 'Coming Attractions', *Screenland Plus TV-Land*, September 1957.

'Both Olivier and Sybil Thorndike' – Janet Graves, 'Let's go to the movies', *Photoplay*, August 1957.

'What has happened to Sir Laurence' – 'Prince Not-So charming' by Douglas Goodlad, *Leicester Chronicle*, 9 November 1957.

'Olivier has gilded it with stylish production' – 'Parade' by Margaret Hinxman, *Picturegoer*, 29 June 1957.

'I co-produced this with Olivier' – 'Marilyn Monroe's pet peeve is getting unwanted advice' by Hal Boyle, *Ironwood Daily Globe*, 10 June 1957.

'He's the boss' – 'Marilyn Monroe says husband comes first in "new life"' by Gay Pauley, *Coshocton Ohio Tribune*, 2 June 1957.

'I don't want to do anything' – 'Marilyn splits with the brain' by Richard Greenough, *Daily Sketch*, 12 April 1957.

'I do not aspire to being a director' – 'Monroe means (big) business' by Guy Austin, *Picturegoer*, 7 July 1956.

'I never felt before' – 'Marilyn Monroe says husband comes first in "new life"' by Gay Pauley, *Coshocton Ohio Tribune*, 2 June 1957.

'I enjoy being a wife' – 'La Monroe eager to act again' by Bob Thomas, *Oakland Tribune*, 9 November 1957.

'My Marilyn Monroe Productions company' – 'Marilyn Monroe back in town, late for work' by Vernon Scott, *Connellsville Daily Courier*, 29 August 1958.

Dissolved under the name of Jermyn Productions Ltd – letter from Sylvia Jones, Companies House, 14 March 1996.

'I'm a demon' – 'The two faces of Marilyn Monroe' by Maxine Block, *Screenland Plus TV-Land*, January 1959.

'something very special to me' – footage of Marilyn receiving the David Di Donatello award at https://www.youtube.com/watch?v=z1G3grvnd4Q, accessed January 2021.

'I can't think of anything' – 'Marilyn's acting seen improved', *Hayward Daily Review*, 29 October 1958.

'He is a wonderful man' – 'Marilyn says she is glad to be free' by Hedda Hopper, *Odessa American*, 18 July 1961.

'An actor isn't a system' – 'Monroe – as Sinatra consoles her' by David Lewin, *Daily Express*, 12 July 1962.

'What I need now' – 'The girl who took on too much' by David Lewin, *Daily Express*, 6 August 1962.

'She just laughed' – 'Marilyn laughed at sleep pill warning' by John Sampson, *Daily Herald*, 7 August 1962.

'If only she had stayed away' and the story of the newspaper under the carpet – email to the author from Fraser Penney, 17 November 2020.

'I was aware of her importance' – email to the author from Michael Knight, 17 November 2020.

'I cried and said I' – email to the author from Maureen Brown, 6 May 2021.

The death of Patricia Marlowe – 'Dead actress upset over Marilyn', *Evening Chronicle*, 7 August 1962; and 'Jack Blandiver Writes', *Well's Journal*, 17 August 1962.

'It was a Sunday afternoon' – email to the author from Ray Johnson, 12 April 2021.

'And she saddened the place' and 'diamond bright' – 'The Marilyn Monroe I remember' by Donald Zec, *Daily Mirror*, 6 August 1962.

'When I talked to her afterwards' – 'The tragic story behind Marilyn's death' by Andrew McKenzie, *Newcastle Journal*, 6 August 1962.

'A superb performer' – 'The girl who took on too much' by David Lewin, *Daily Express*, 6 August 1962.

Letter from Anna Freud to Ralph Greenson – Elisabeth Young-Bruehl, *Anna Freud: A Biography* (New York: Summit Books, 1988), pp. 412–13.

Greenson's replies to Freud – Anna Freud papers, container 37, Library of Congress, Washington, DC.

'Marilyn Monroe was lonely' – 'The rare interview' by Marjorie Proops, *Daily Mirror*, 7 September 1962.

'the complete victim of ballyhoo' – 'The bitter truth about Hollywood – as revealed by Sir Laurence Olivier', *Newcastle Journal*, 7 August 1962.

'She could be incredibly sweet' – 'Marilyn Monroe: "It looks like suicide"' by Stan Mays and John Edwards, *Daily Mirror*, 6 August 1962.

'the best of all' – Laurence Olivier, *Confessions of an Actor* (New York: Simon & Schuster, 1982), p. 213.

'married to the camera' – Dame Sybil Thorndike on *Panorama*, 6 August 1962, quoted in 'Telecrit', *Liverpool Echo and Evening Express*, 7 August 1962.

'She may have had a lot of experiences' – Dame Sybil Thorndike on *Panorama*, 6 August 1962, quoted in 'Last Night's TV', *Daily Mirror*, 7 August 1962.

'For us, Marilyn was a devoted' – 'DiMaggio weeps for Marilyn' by John Sampson, *Daily Herald*, 9 August 1962.

Milton Greene's reaction to Marilyn's death – Joshua Greene and James Kotsilibas-Davis, *Milton's Marilyn* (Munich: Schirmer/Mosel, 1998), pp. 91–2.

Letter from Arthur Miller to Joshua Logan – 14 August 1962, Joshua Logan Papers, Logan Box 29, Folder 17, Manuscript Division, Library of Congress, Washington, DC.

'If she was simple' – 'Luck . . . That is what Marilyn needed' by John Gold, *Aberdeen Evening News*, 7 August 1962.

'It was a tremendous shock to me' – 'Why I say Marilyn did not kill herself' by Arthur Miller, talking to Robin Stafford, *Daily Express*, 7 August 1962.

'She is not really there anymore' – 'Marilyn laughed at sleep pill warning' by John Sampson, *Daily Herald*, 7 August 1962.

'It seemed to be raining the whole time. Or maybe it was me' – Tom Hutchinson, *Marilyn Monroe* (Leicester: Galley Press, 1982), p. 53.

Selected Bibliography

Baker Miracle, Berniece and Mona Rae Miracle, *My Sister Marilyn* (London: Weidenfeld & Nicolson, 1994).

Bigsby, Christopher, *Arthur Miller* (London: Weidenfeld & Nicolson, 2008).

Buchthal, Stanley and Bernard Comment, *Fragments: Poems, intimate notes, letters by Marilyn Monroe* (London: HarperCollins, 2010).

Cardiff, Jack, *Magic Hour: The Life of a Cameraman* (London: Faber and Faber, 1997).

Casson, John, *Lewis and Sybil* (London: Collins, 1972).

Christie's, *The Personal Property of Marilyn Monroe* (New York: Christie's, 1999).

Clark, Colin, *My Week with Marilyn* (London: HarperCollins, 2000).

——, *The Prince, the Showgirl and Me* (London: HarperCollins, 1995).

Coleman, Terry, *Olivier* (London: Bloomsbury, 2006).

Cowles, Fleur, *Friends and Memories* (London: Jonathan Cape, 1975).

——, *She Made Friends and Kept Them* (London: HarperCollins, 1996).

Croall, Jonathan, *Sybil Thorndike: A Star of Life* (London: Haus, 2008).

Drogheda, Lord, *Memoirs* (London: Weidenfeld & Nicolson, 1978).

Gottfried, Martin, *Arthur Miller: A Life* (London: Faber and Faber, 2005).

Greene, Joshua and James Kotsilibas-Davis, *Milton's Marilyn* (Munich: Schirmer/Mosel, 1998).

Guiles, Fred Lawrence, *Norma Jean: The Life of Marilyn Monroe* (Nashville: Turner, 2020).

Harris, Radie, *Radie's World* (London: W. H. Allen & Co., 1975).

Hutchinson, Tom, *Marilyn Monroe* (Leicester: Galley Press, 1982).

Julien's Auctions, *Catalogue for Nov 17–19, 2016 sale; four volumes* (Los Angeles: Julien's Auctions, 2016).

Juroe, Charles Jerry, *Bond, the Beatles and My Year with Marilyn: 50 Years as a Movie Marketing Man* (Jefferson: McFarland, 2018).

Logan, Joshua, *Movie Stars, Real People, and Me* (New York: Delacorte Press, 1978).

Martin, Pete, *Marilyn Monroe* (London: Frederick Muller, 1956).

Miller, Arthur, *After the Fall* (Harmondsworth: Penguin, 1985).

——, *Timebends: A Life* (London: Bloomsbury, 2012).

Mitchell, John, *Flickering Shadows: A Lifetime in Film* (Malvern Wells: Harold Martin & Redman, 1997).

Morgan, Michelle, *The Girl: Marilyn Monroe, The Seven Year Itch, and the Birth of an Unlikely Feminist* (Philadelphia: Running Press, 2018).

——, *Marilyn Monroe: Private and Undisclosed: New Edition* (London: Robinson, 2012).

Olivier, Laurence, *Confessions of an Actor* (New York: Simon & Schuster, 1982).

——, *Laurence Olivier on Acting* (Kent: Hodder & Stoughton, 1987).

Quayle, Anthony, *A Time to Speak* (London: Barrie & Jenkins, 1990).

Rattigan, Terence, *The Prince and the Showgirl: The script for the film* (New York: Signet Books, 1957).

——, *The Sleeping Prince: An Occasional Fairy Tale* (London: Samuel French, 1956).

Riese, Randall and Neal Hitchins, *The Unabridged Marilyn* (London: Corgi, 1988).

Rosten, Norman, *Marilyn: A Very Personal Story* (London: Millington, 1974).

Shellard, Dominic, *Kenneth Tynan: A Life* (New Haven: Yale University Press, 2003).

Sinden, Donald, *A Touch of the Memoirs* (Futura McDonald & Co., 1983).

Spoto, Donald, *Laurence Olivier: A Biography* (London: HarperCollins, 1991).

——, *Marilyn Monroe: The Biography* (London: Chatto & Windus, 1993).

Sprigge, Elizabeth, *Sybil Thorndike Casson* (London: Victor Gollancz, 1971).

Strasberg, Anna and Bernard Comment, *Marilyn Monroe: Girl Waiting* (Paris: Éditions du Seuil, 2012).

Strasberg, Lee/Strasberg Estate, *The Lee Strasberg Notes*, ed. Lola Cohen (Abingdon: Routledge, 2010).

Strasberg, Susan, *Marilyn and Me: Sisters Rivals Friends* (London: Doubleday, 1992).

Taylor, Roger G., *Marilyn in Art* (London: Elm Tree Books, 1984).

Vickers, Hugo, *Vivien Leigh* (London: Pan Books, 1990).

Weatherby, W. J., *Conversations with Marilyn* (London: Robson Books, 1976).

Young-Bruehl, Elisabeth, *Anna Freud: A biography* (New York: Summit Books, 1988).

Ziegler, Philip, *Olivier* (London: MacLehose Press, 2013).

Zolotow, Maurice, *Marilyn Monroe* (London: W. H. Allen & Co., 1961).

Index

285